INSIDE TRACK

INSIDE

A PHOTO DOCUMENTARY OF

TEXT BY
BENNY PARSONS

PHOTOGRAPHS BY
GEORGE BENNETT

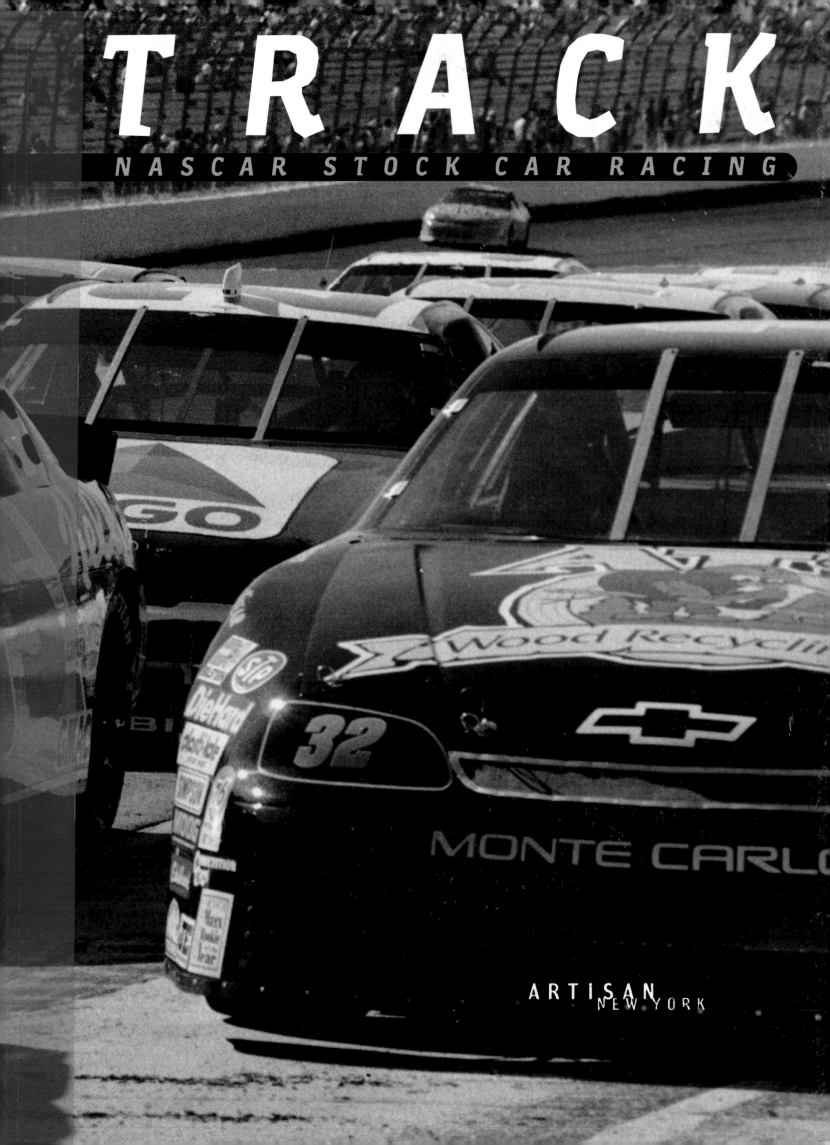

TRACK

NASCAR STOCK CAR RACING

ARTISAN
NEW YORK

Text editor: Roger Vaughan
Production director: Hope Koturo

Published in 1996 by Artisan,
a division of Workman Publishing Company, Inc.
708 Broadway, New York, NY 10003-9555

Library of Congress Cataloging-in-Publication Data
Parsons, Benny.
Inside track: a photo documentary of NASCAR
stock car racing / text by Benny Parsons;
photographs by George Bennett.
ISBN 1-885183-59-3
1. Stock car racing—United States—Pictorial
works. 2. NASCAR (Association)—Pictorial works.
I. Bennett, George, 1945– . II. Title.
GV1029.9.S74P37 1996
796.7'2'0973022—dc20 96-9468 CIP

Printed in Italy
10 9 8 7 6 5 4 3 2 1
First Printing

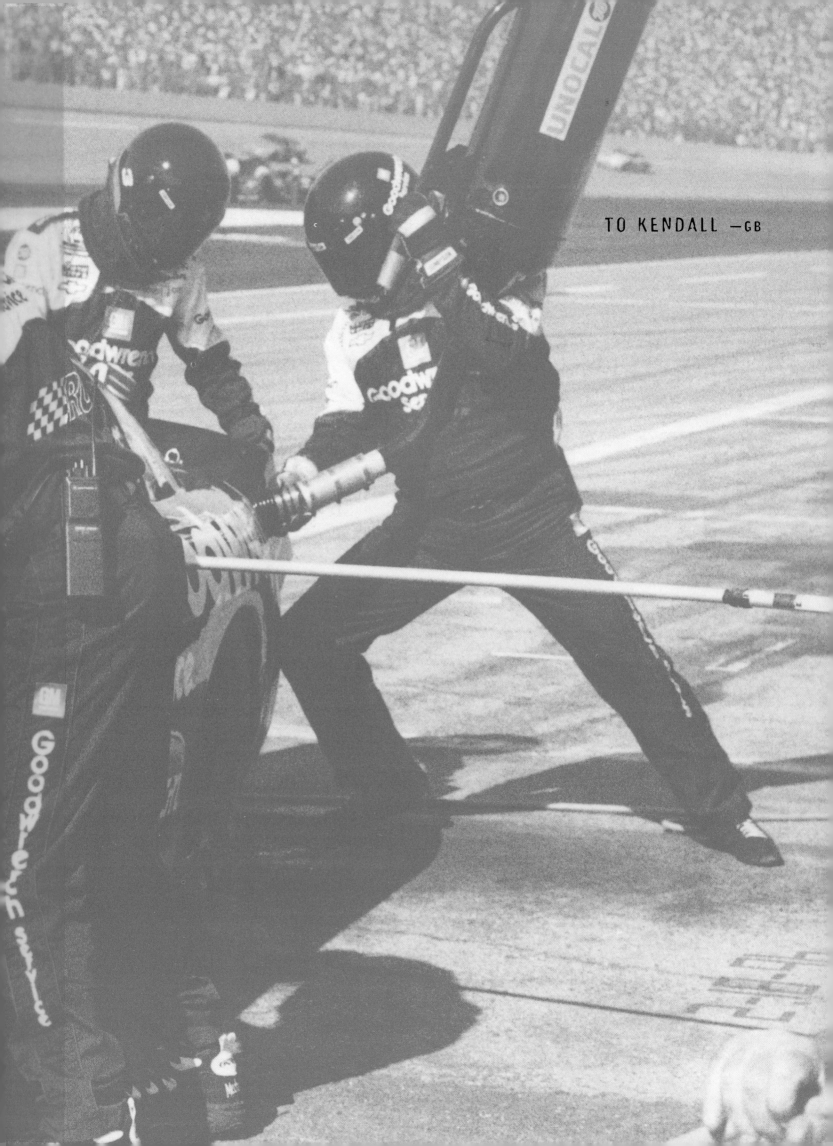

TO KENDALL —GB

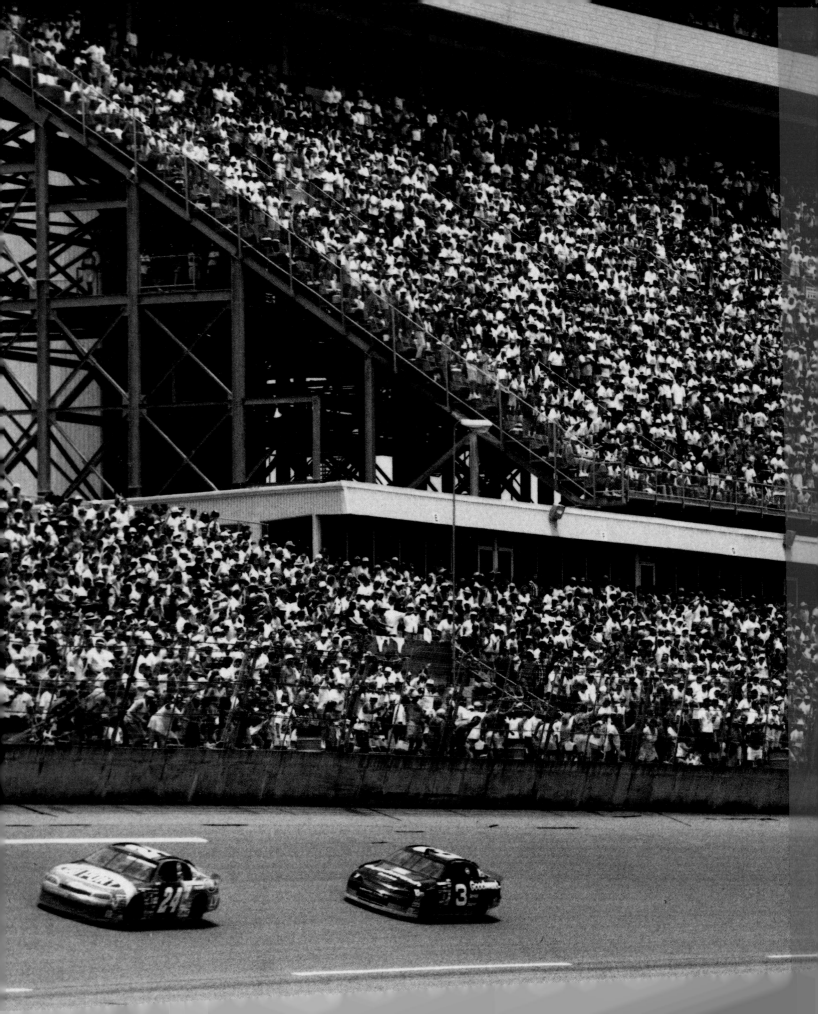

CONTENTS

AMERICANS LOVE SPEED, no question about that. Throughout history, we've raced everything that moves, from clipper ships to turtles. When horses were the fastest means of transportation, Americans raced horses, and not necessarily on tracks. We raced them down Main Street. We even raced a horse against a train. The horse won.

When the first automobile appeared, it was a cinch that as soon as the second one got built there would be a race. When the automobile became a way of life—as our preferred means of transportation, a status symbol, a personal statement, a treasured possession, a collector's item—racing became a natural extension of highway driving. Now, with 400 million miles of roads in this

there were arguments about who the best drivers were, and whose car was the fastest. So they started racing the liquor cars at local fair grounds. The racing soon graduated to dirt tracks complete with grandstands.

In the summer of 1947, a sixteen-year-old named Junior Johnson, whose daddy made whiskey, displayed his considerable driving skills for the first time at the North Wilkesboro, North Carolina, Speedway. He drove a 1940 Ford liquor car. Soon he was on tour with a traveling stock car show that included other famous leadfoots: Fireball Roberts, Little Joe Weatherly, and Curtis Turner. They played as hard as they drove, and that's saying a lot.

Things happened fast after that. Bill France, Sr., had

M A D E I N

country and hundreds of different vehicles of all shapes, sizes, models, speeds, capabilities, and colors for us to choose from, auto racing is the ultimate version of an activity we probably spend more time doing than anything but working and sleeping.

In America, we race every motorized vehicle on wheels—motorcycles to midgets to Indy and Formula I cars. But the motor sport at the top of the heap is the Winston Cup Series run by NASCAR, the National Association for Stock Car Automobile Racing. "Stock" refers to the factory-made vehicles of the American road: Fords, Chevrolets, Pontiacs, Oldsmobiles...good old Detroit iron like so many of the cars parked in people's driveways. Or almost the same. These souped-up, flashy, 200 mph versions of the family sedan lured 5.5 million fans to the Winston Cup Series in 1995 and bumped NASCAR's television ratings to the highest they've ever been.

NASCAR is rooted in the practical application of highway speed and expert car handling by southern moonshiners in their efforts to outrun the revenuers who were trying to catch them. Back in the 1930s and 1940s, when the private manufacture of whiskey was a thriving industry, the farmers in the mountains of North and South Carolina, Virginia, and Tennessee had "liquor cars." These were modified sedans and roadsters with extra power and stiffer suspensions for delivering trunks full of white lightnin' to the cities. Naturally

been promoting races on Daytona Beach since 1938. And I mean on the beach, with the surf pounding not a hundred feet from the packed-sand backstretch. During World War II, racing was suspended. But in 1948, France and friends founded NASCAR, and the following year NASCAR raced its first season. Red Byron beat Lee Petty (the famed Richard's dad; his driver/son Kyle's granddad) for the first championship. The rules had been helter-skelter before NASCAR. Now cars were required to be full-size, American-made cars with complete bodies, and all parts used were required to be listed in the manufacturers' catalogs.

The sport grew along with the country in the postwar years. In 1959, Bill France realized his vision of a track so large the drivers never had to let off on the accelerator. He built Daytona Speedway, the first of the "super speedways." The cars got faster as technology improved. Racing was more competitive as the sport became established and able to support professional drivers backed by well-organized teams. And of course more rules were instituted along the way to make stock car racing as safe as possible at the higher speeds, for both drivers and fans.

Auto manufacturers have been in and out of NASCAR sponsorship over the years. There were pitched battles over the rules—engine sizes and the like—that caused manufacturers' boycotts. And on occasion they would fret about linking their names with such a dangerous

display of their products. Today we'd call that the "political correctness" factor.

The year 1970 was one of those times when NASCAR and the manufacturers weren't seeing eye-to-eye. And now coincidence came into play, because that was the year it became taboo for cigarette companies to advertise on television. On one side, NASCAR was in dire financial straits. On the other side, the cigarette companies were looking for a home for their big advertising dollars. The two got together, and from that moment on, NASCAR has never touched the brakes. No longer would the manufacturers' whims have such a powerful effect on NASCAR.

The 1971 season was called The Winston Cup series, thanks to R. J. Reynolds Tobacco Company's sponsorship. Their participation seemed to open the eyes of corporate America, and all sorts of enthusiastic new sponsors began painting their logos on the cars: Coca-Cola, Citicorp, Shoney's Restaurants, Skoal, Kodak.... It is all money from the private sector that fuels this sport. There's no tax money supporting stock car racing. Unlike professional football teams that expect franchise cities to build them $200 million stadiums, a track like Dover Downs, which is probably worth $50 million, was built with private dollars. That's why the cars are so decorated with colorful sponsor logos.

NASCAR's Winston Cup Series is the fastest growing sport in the country. Attendance has tripled in the last five years. People love to go out to the track and pull for their Chevy against their neighbor's Ford, and have a party while they're doing it. And it's for big money, now. Team budgets are around $6 to $7 million a year. Combined driver earnings in 1995 were $45 million. Today, the Championship is worth $1.5 million, plus another $3 million in product endorsements and appearances. Just for comparison, when I won it back in 1973, the Championship was worth about $200,000—total.

Stock car racing has southern origins, but it wasn't long before drivers from the Midwest and the Southwest joined the fray. I got into it by chance. I grew up in Detroit. In 1963 I was working in my dad's taxi company garage when a fellow pulled in hauling a race car. He wanted to buy gas, so I pumped it for him. When he saw me ogling the car, he came over and said the words that changed my life: "Wanna go?" Did I! Off we went. It wasn't long after that he asked me if I wanted to drive. I started driving on dirt tracks, and pretty soon he sold me the car—for $50.

But if you don't think the South still rules stock car racing, look at this list of top drivers and where they're from: Rick Mast–Virginia; Rusty Wallace–Missouri; Dale Earnhardt–North Carolina; Sterling Marlin–Tennessee; Mark Martin–Arkansas; Lake Speed–Mississippi; Ricky Rudd–Virginia; Derek Cope–Washington State; Darrell Waltrip–Kentucky; Loy Allen–North Carolina; Michael Waltrip–Kentucky; Kenny Schrader–Missouri; Elton Sawyer–Virginia; Steve Grissom–Alabama; Kyle Petty–North Carolina; Bobby Hamilton–Tennessee.

Today's drivers are different from the old dirt track guys, who thought nothing of jumping out of their busted-up cars and punching out the guy responsible for putting them into the wall. And of course the current crop of drivers don't run whiskey. They not only have to have the talent to compete on the track, they must be willing and able to handle the media, and even more important responsibilities like sponsor appearances.

But that's just the price of making the big time. And it's not really much of a price. Because the cars have never handled better or been more powerful, and the drivers have never been so collectively talented. New teams like "The Cartoon Network" join the circuit each season. The racing gets better every year. NASCAR's Winston Cup Series is one great show. And we have yet to reach the pinnacle of this sport.

Not long ago, detractors of stock car racing used to refer to the NASCAR Winston Cup cars as "taxi cabs." That used to grate us a little bit, me especially. But the popularity that NASCAR is enjoying has eased the sting. And when the Smithsonian Institution decided to put one of Richard Petty's race cars in its permanent collection, that was the best retort we could have hoped for.

It's hard to say how big this sport will become. One thing is sure: as long as stock cars exist, people will race them.

ATLANTA

A WEEKEND

4

AT THE RACES

A typical NASCAR race weekend is a three-day affair. It begins Friday at 6 AM when the transporters arrive. Right away the pecking order is established. As the cars are unloaded, they are parked in garage spaces according to car-owners points, with the defending Winston Cup Championship team always first in line. At 7 AM, the crew members arrive for check-in and registration. Work begins in earnest to prepare the cars for NASCAR inspection, then practice.

The first practice of the weekend is underway by mid-morning. First-round qualifying begins in the early afternoon. Positions one through twenty-five are established in that first round, with the rest of the drivers allowed to either keep their round-one times or try to work some magic overnight that will trim precious seconds in the second round on Saturday.

Saturday morning, more practice, with the second round of qualifying following immediately. The track has to be cleared by Saturday afternoon for the companion race that usually takes place. This is either one of the NASCAR Busch Series or a race sanctioned by the Automobile Racing Club of America or some other motor sports organization. After that

race concludes, the Winston Cup cars are allowed one final hour of practice everyone calls "Happy Hour." This is the last chance drivers and teams have before the race to make changes—improvements, they hope. This is not always a happy hour.

Different drivers follow different routines on Sunday morning, but there are some things that never change. The drivers' meeting takes place two hours before the green flag, and it is mandatory. Miss it, and your car is moved to the end of the field, no matter if you've qualified for the pole and set a track record. The drivers' meeting is followed by a church service for drivers and fans. Thirty minutes before the race, with the cars lined up in the familiar two-by-two order, the drivers are introduced. Then, with drivers strapped in, "Gentlemen, start your engines" rings out over the speaker system, bringing a roar from both cars and fans that continues until the green flag is waved.

After a brief warm-up, followed by a couple of pace laps, the green flag flies and the race is underway.

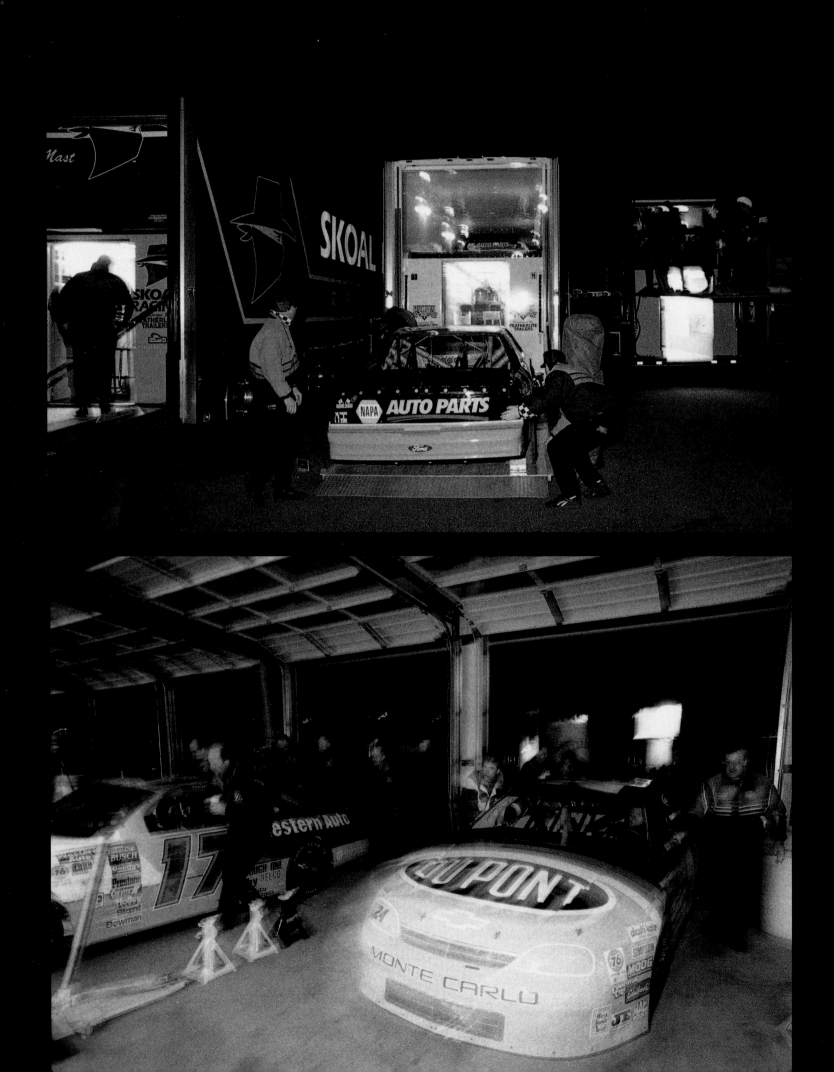

THURSDAY

When there are six or seven members of the crew standing around the trailer at 6 AM half asleep in the pitch black, you know the race weekend has started. The crew chief is on hand, along with the transporter driver and mechanics. The transporters enter the garage area in order, by point standings, so there's no confusion. After unloading the car, the guys push it into its stall, also assigned by point standings. NASCAR has followed this orderly procedure forever. This race is in Atlanta. Geoff Bodine's crew (opposite top) is unloading his car. Jeff Gordon's and Darrell Waltrip's crews muscle their cars in (opposite bottom) while Mark Martin's crew pushes #6 into the garage.

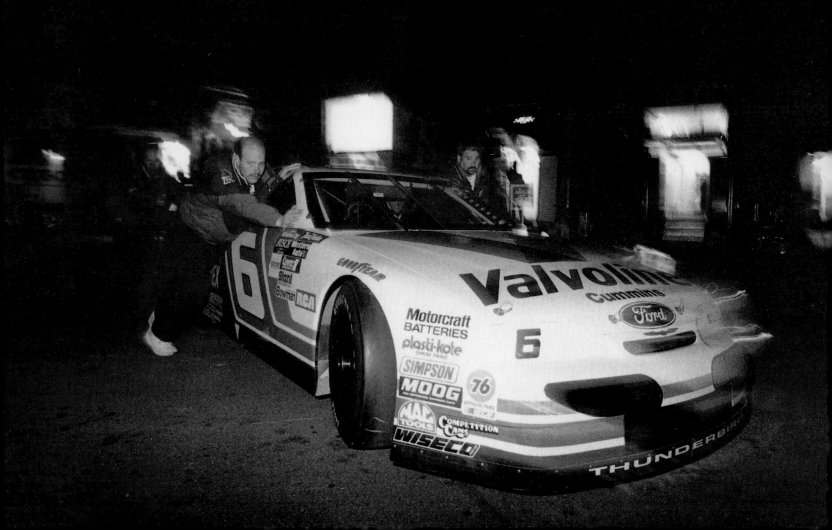

The guy with the cart is on his way to get
his team's weekly allotment of qualifying
tires from Goodyear. There used to be tire
competitions. Firestone ruled in the 1960s,
and Hoosier in the late 1980s, early 1990s.
But now it's just Goodyear.

difficult to stretch the rules, even a little bit. Every team polices itself, and no one is shy about helping NASCAR officials check possible rules infractions. It's tempting to gain a competitive advantage by, say, removing reverse gear from the transmission to lighten the car. But it wouldn't take long for someone to notice that a car was being pushed every time it had to move backwards. And the rule says a car must have all its gears.

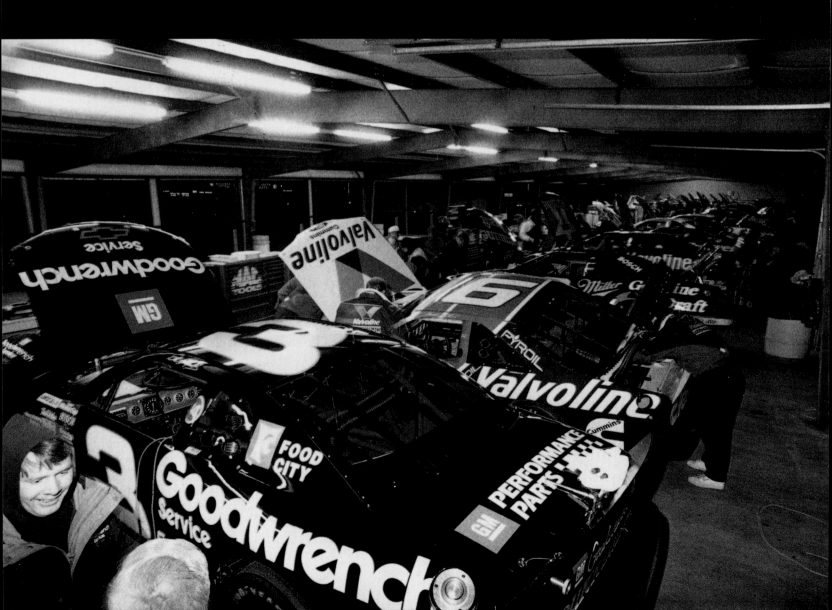

Sunup. For a while the Atlanta Motor
Speedway is peaceful as a back-country
road. There was a time you'd see drivers
out walking the track in the early morning,
looking for inspiration or maybe even divine
intervention. Like in the old racing movies.
The dirt track drivers walked with purpose,
checking for ruts and potholes. Then the
tracks got paved and all that went away.

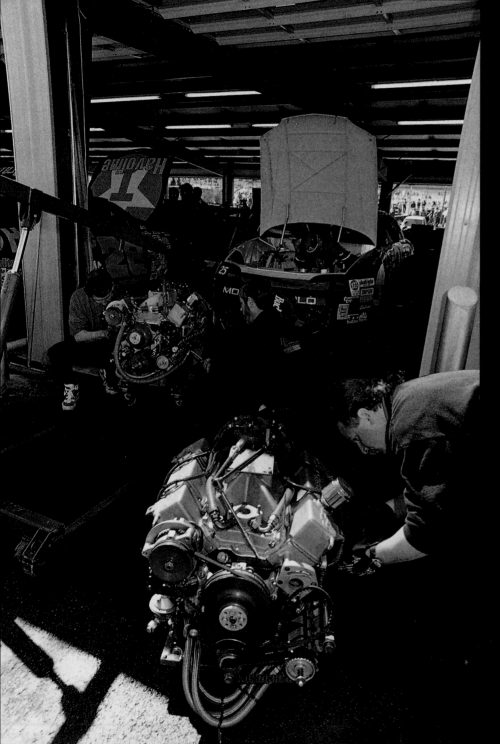

Ken Schrader's mechanics working on his car. Most cars arrive at the track with a qualifying engine in place. It's been run 500 miles or so. Engine builders take chances with a qualifying engine since they only need it for a limited number of laps, practice and qualifying. The main thing the qualifying engines do is limit the amount of air to the radiator. The small intake makes the car aerodynamically faster, and increases the water temperature. If you run hotter you get a little bit more power. To a point. The pistons are aluminum, good for 1200 to 1300 degrees. But you hit 1400 and the aluminum starts to melt. Just before it melts, you get maximum horsepower. Finding the edge is what you want for qualifying. Adjust the fuel mix, turn it 400 rpms faster than the race engine ... you only get 5 or so more horsepower, but **every click counts** when you're **looking** for that **advantage.** Once qualifying is over, they install the race engine. They treat that baby with respect because it's got to last 500 miles, 600 at Charlotte.

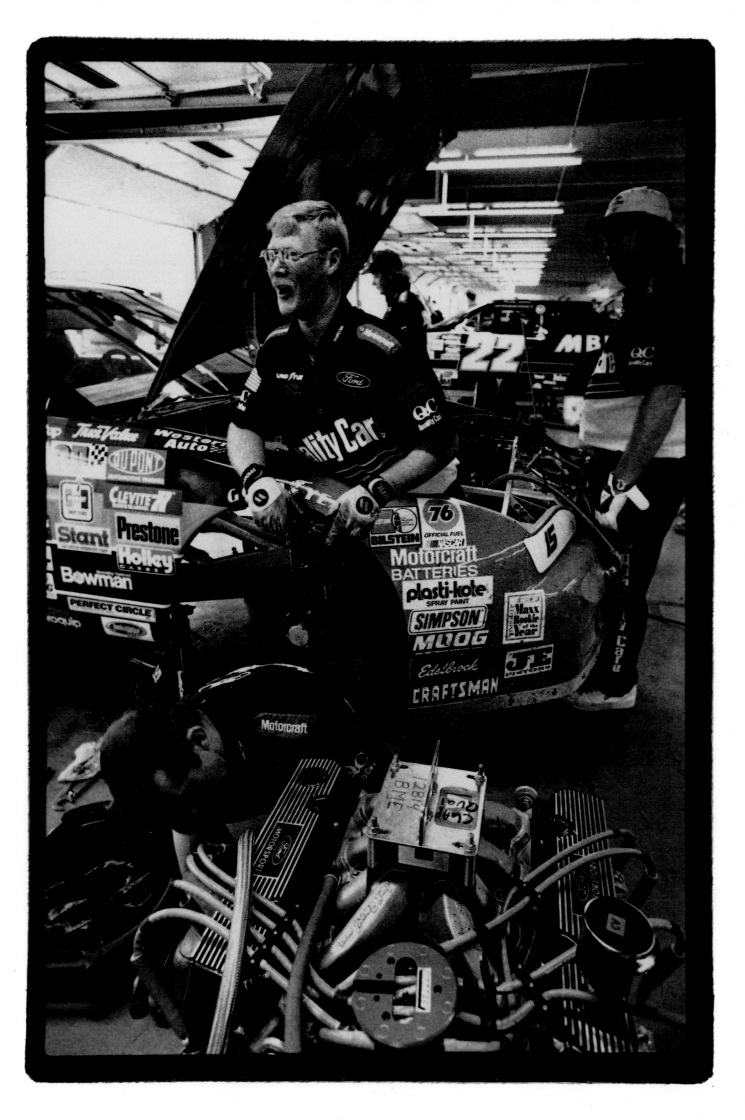

FRiDAY

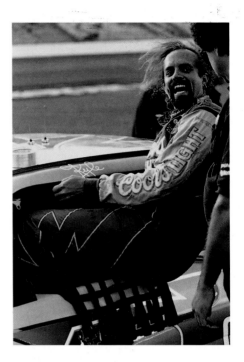

LEFT: Kyle Petty's got the long hair, the ear-rings, his own definite style. It's his way of being known as himself, not "Richard's kid." Kyle is just Kyle. BELOW: An inspector gives Kyle Petty's Pontiac the once-over with one of a dozen templates he uses to make sure it conforms to street shapes. All these Fords, Chevys, and Pontiacs are "stock" cars.

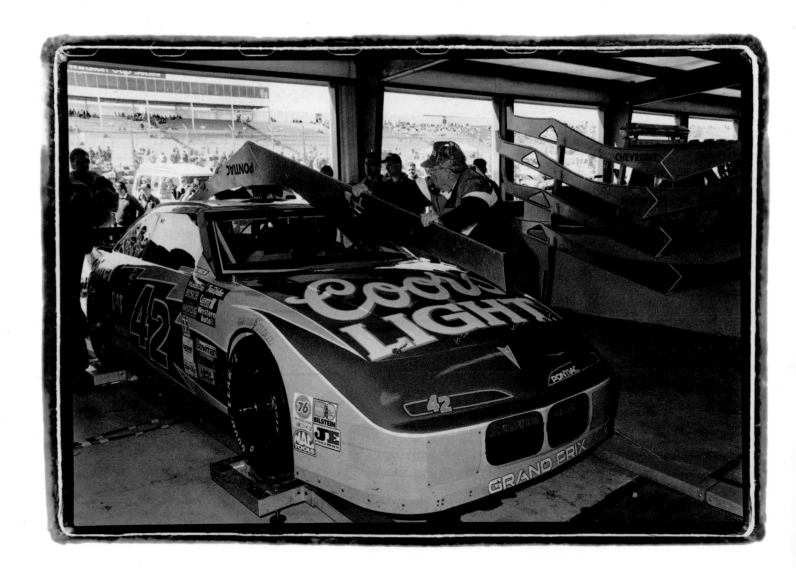

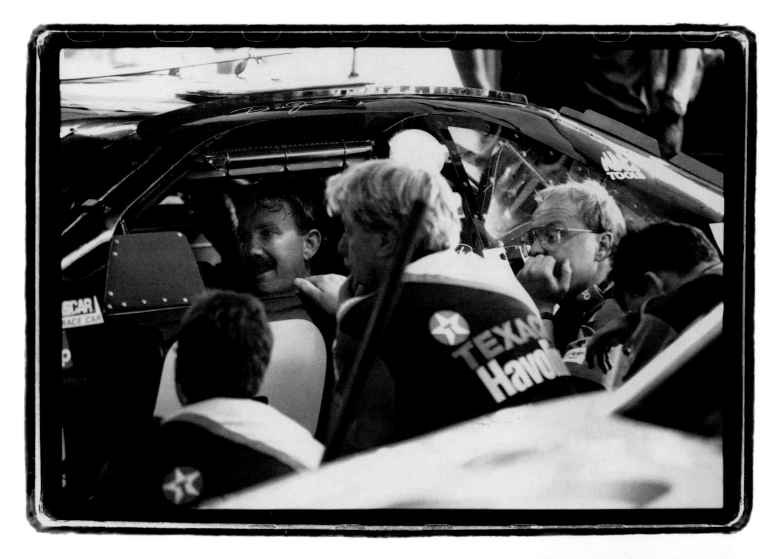

Dale Jarrett is getting used to Ernie Irvan's car, which he took over when Ernie was injured and couldn't compete. You can tell by the concerned faces and the powwow that there are problems. The car isn't performing right, and there are a million variables to sort through to find out why. Maybe it's "pushing," wanting to go straight through a corner even when you're leaning on the wheel; or wanting to go into the wall when you're accelerating out of a corner. Or maybe it's "loose," meaning the back end wants to lead, as if it's on ice. When you push, you hit the wall with the front end. When you're loose, you hit the wall with the back end.

Either way, it's not pretty.

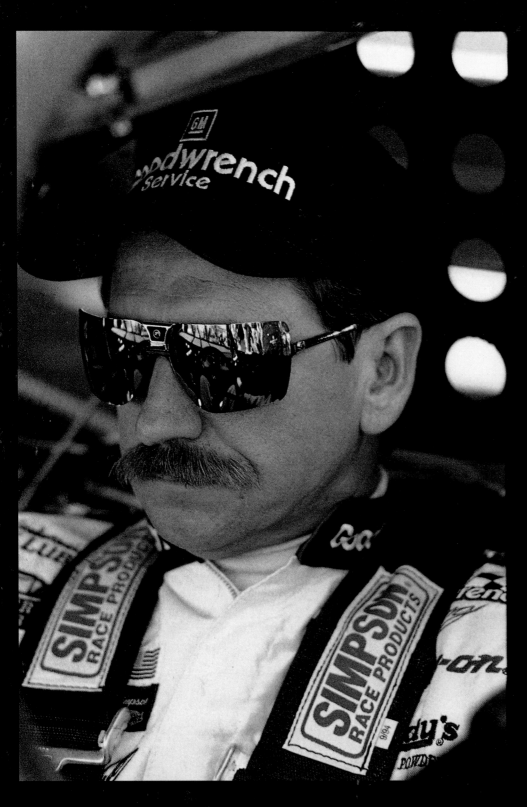

From a driving standpoint, I'm a Dale Earnhardt fan. I first saw him in 1980 in Charlotte. He was sideways at 160 miles an hour on that 1.5-mile racetrack, driving like he was running on dirt. I hoped I didn't get in a wreck with him. But he kept it up all day, and won. He does everything he can to intimidate. Black glasses, black car, black hat, and he scrunches down in the seat where you can barely see him. But it's no put-on. If Dale's running fifth, he's digging, shoving, and gouging to run fourth. **If you're in front of him, running slower, he lets you know it . . .**

with his front bumper. Dale is not shy.

The qualifying process determines where you line up at the start. Qualifying well gives you confidence. And being in the top ten is important if there's an early wreck involving a car back in the pack. Dodging a wreck is hard, especially on the first couple of laps when the field is bunched together. A little luck helps. If you're in the top ten, you avoid that situation. If you qualify poorly, you've got time to work on the car. That old stopwatch is real important. It tells you if you can compete with the field. If you're a half second off, you've got your work cut out for you, right up to Sunday morning. Once I was so bad off I changed four springs and four shocks just hours before the start. If it didn't help, it made me feel better.

BELOW: Geoff Bodine in today's high-tech head gear. A ventilating hose enters the helmet near his left ear. The air first passes through a cooler full of ice strapped to the passenger side floorboards. The padded head clamp that ends at the "i" in Exide cradles the back of the helmet, stabilizing it. Without the clamp, the driver would be fighting the centrifugal force of the turns with his neck muscles and risk getting cramps. Behind the helmet is an outlet to power an electric "blanket" that heats the oil. A 20-quart oil reservoir takes up the back seat space. It's thick stuff, usually 20w50. Pre-warming it with the blanket makes start-up easier on the engine, and brings the oil to temperature faster.

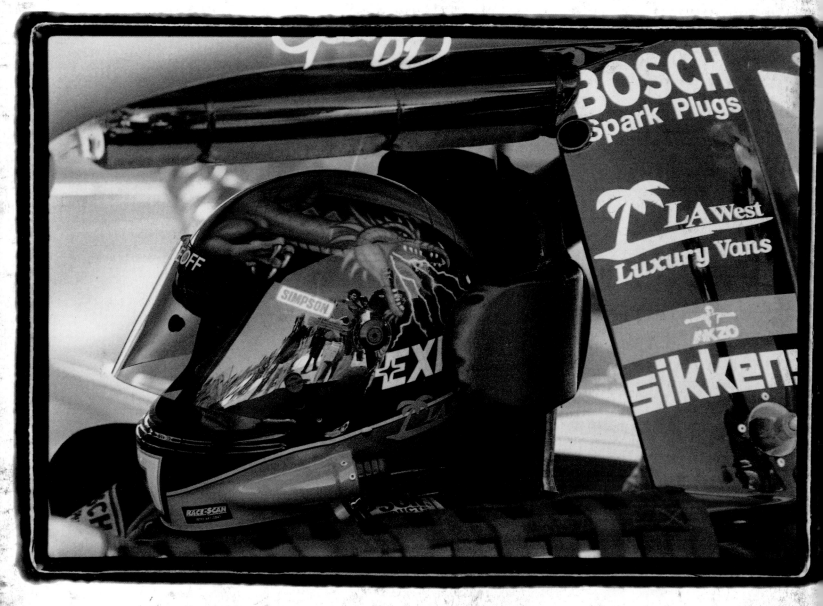

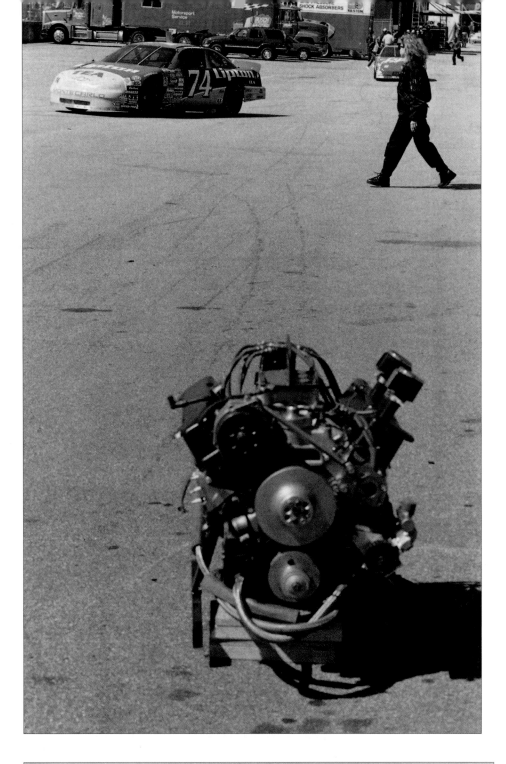

SATURDAY

Saturday is busy. Three things are going on. Some of the twenty-five drivers who qualify on Friday are practicing. The rest are trying to make the final thirteen who will qualify on Saturday, so they're out running, trying to find that last ounce of speed. And the support race is on Saturday. Qualification goes on just before the support race. Many of the Friday qualifiers are changing engines, checking fuel mixtures and other details, and watching the race to see what else they can learn about the track.

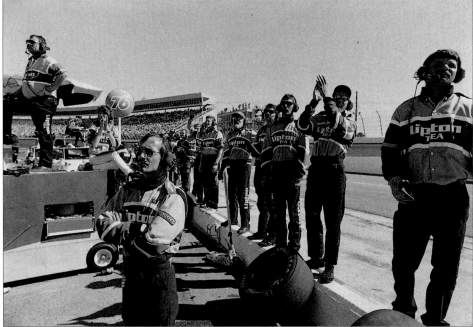

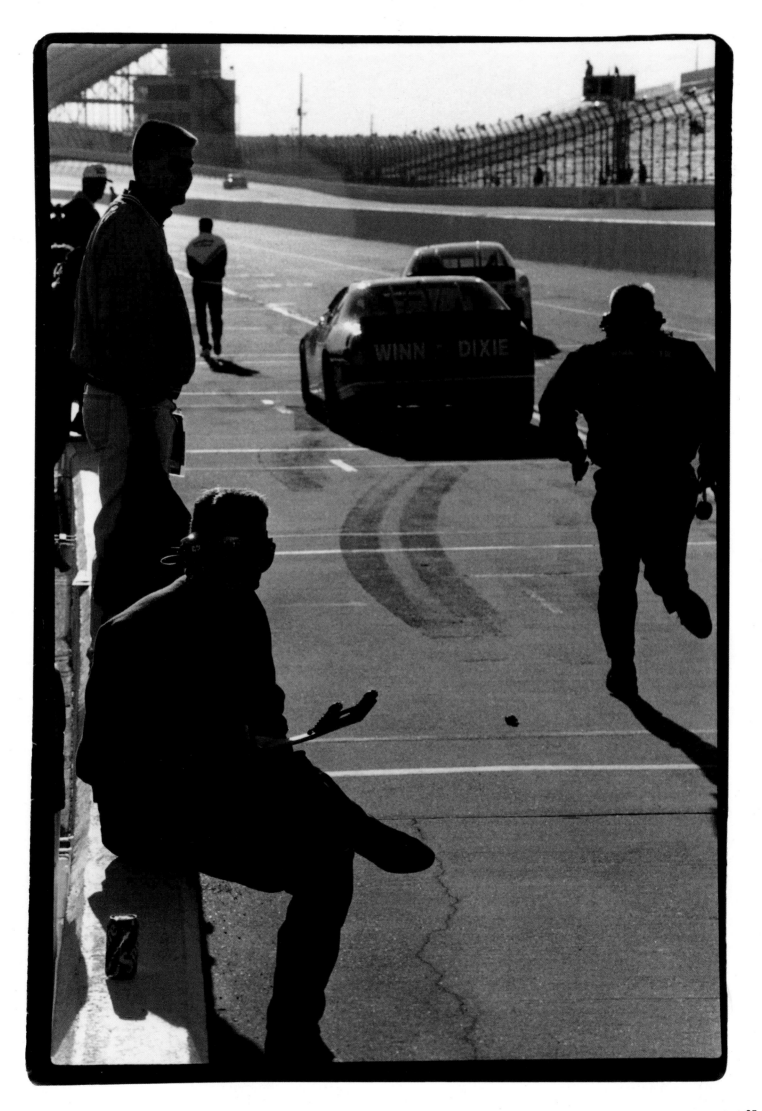

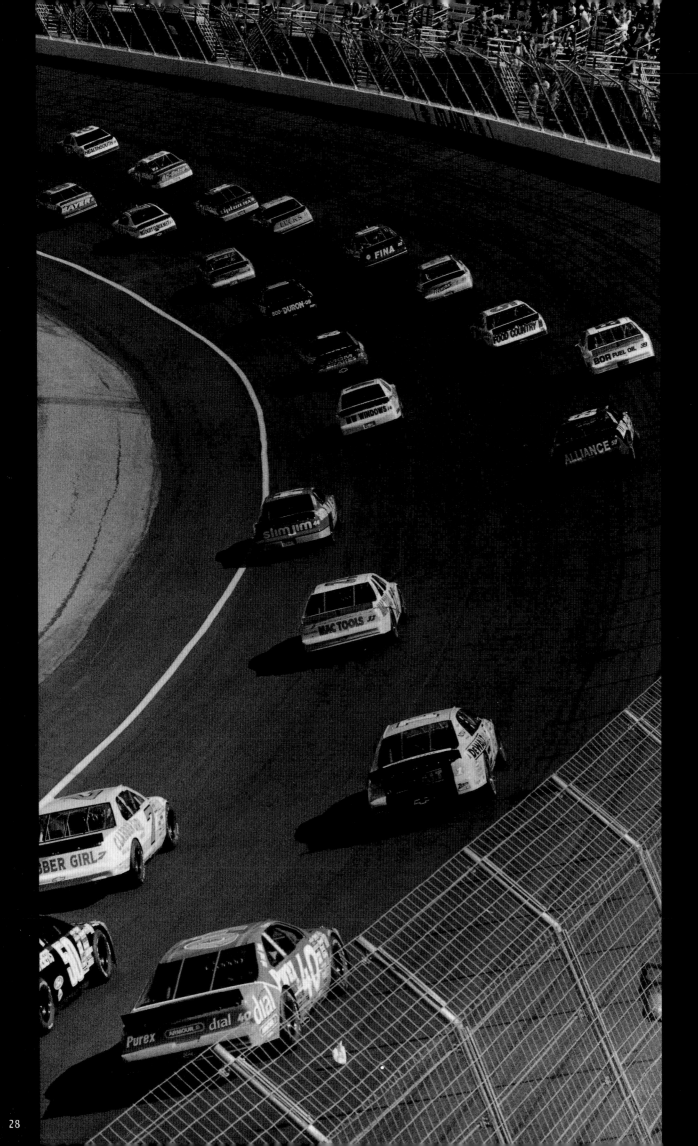

OPPOSITE: A NASCAR/Busch Grand National race on a Saturday morning.

These support races bring revenue to the tracks. Fans are in town to see auto racing. Why not give it to them on Saturday too? And support races provide experience for forty more drivers per weekend. There's no substitute for experience. In fact, you cannot jump directly from running short tracks to the Winston Cup level. You must go through the other levels, which include support races. Busch cars are similar to Winston Cup cars, but they are 100 pounds lighter, with about 200 less horsepower. The Busch drivers get experience at Daytona, Taladega, Atlanta, Rockingham, Charlotte, Dover, Darlington, Bristol—all the important tracks. When Winston Cup owners need new drivers, here's where they look. In fact, a lot of Winston Cup drivers own Busch cars. It's one way to build a team, like having a Triple-A baseball franchise. Mark Martin is one who has done well at it. Some Winston drivers race on Saturday to learn how the track may have changed. But that can be exhausting, especially if it's a hot weekend.

RIGHT: Johnny Benson won enough Busch races to take the championship. After that he graduated to driving the Pennzoil Winston Cup car.

PAGES 30-31: Atlanta Motor Speedway.

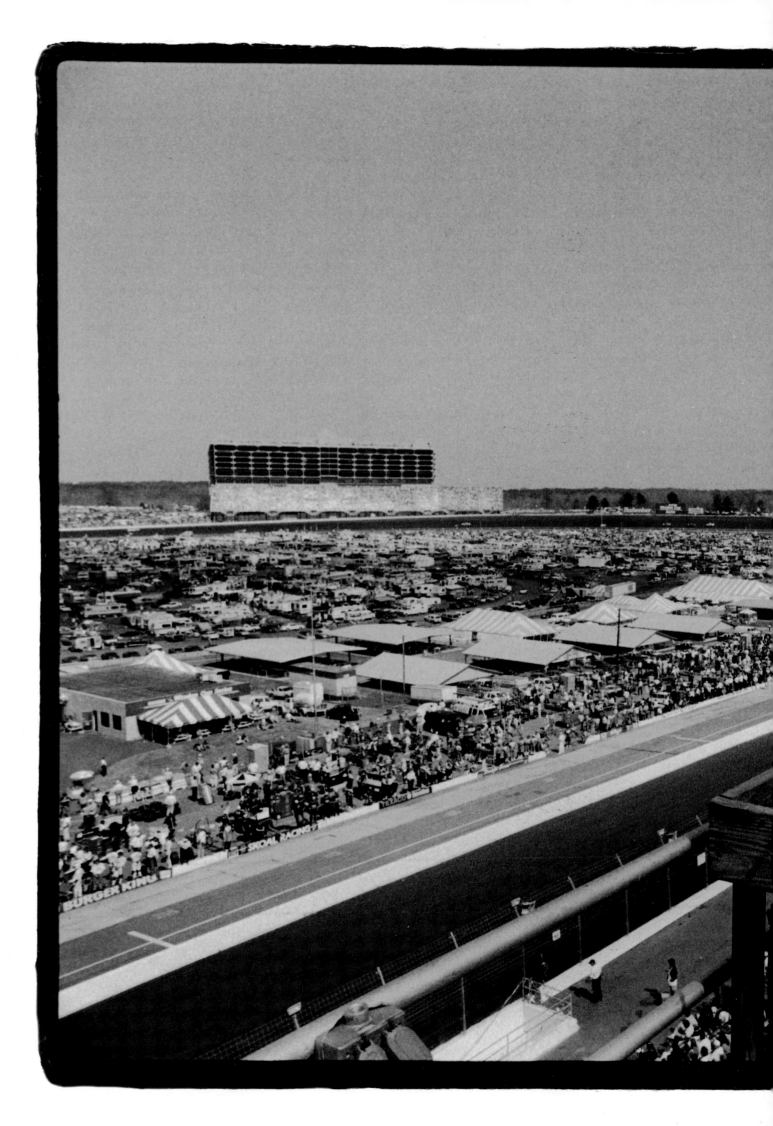

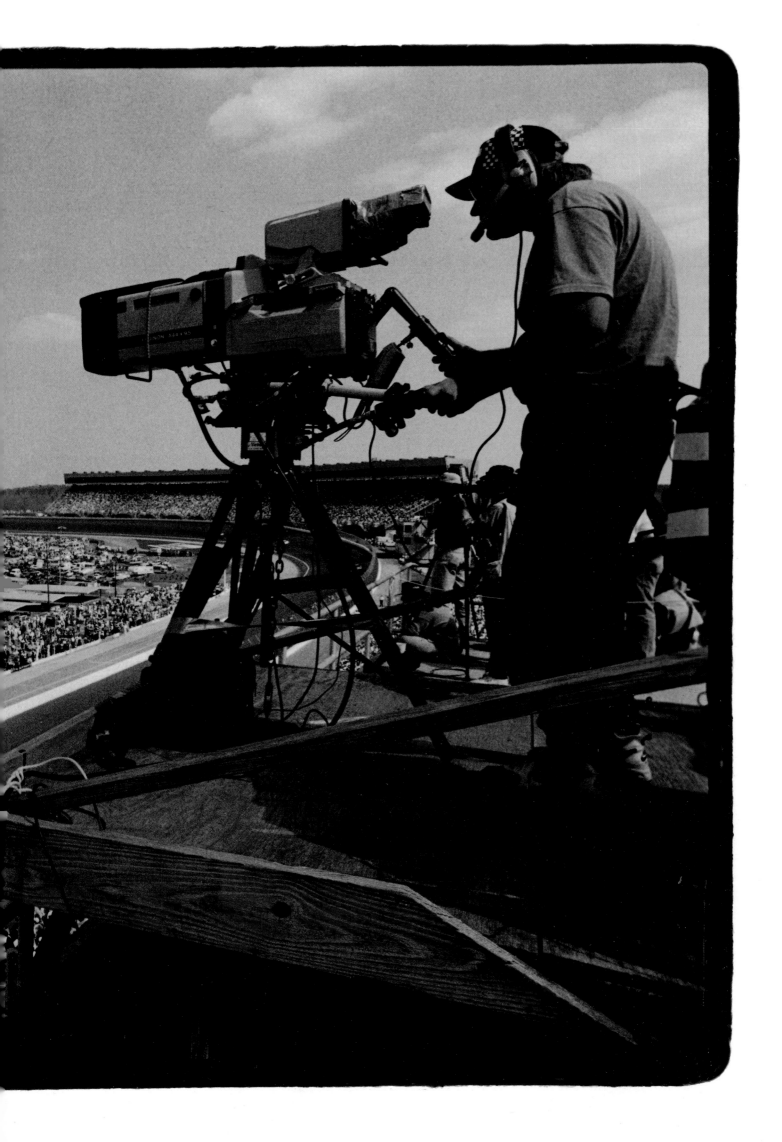

SUNDAY

The sights of Sunday in the infield: a fully outfitted mobile lounge; a couple of beauty queens; even a wedding. The guys in the pick-up can't afford to fly in and rent motel rooms, so they drive in and pay their $25 or $30 for a ticket. They bring along the rig: a sheet of three-quarter plywood, a couch, an easy chair, a big umbrella, and a ladder to get up there. They're happy as can be. The other folks in the infield are there for a good time, yelling at the girls—or the boys—drinking a few, having a party.

OPPOSITE: How disappointing is this! Mike Wallace has his tail in the fence before he crosses the starting line. The start's tricky. The cars are inches apart. If something happens to the guy in front, you're going to run into him, and then probably someone will run into you. And it's illegal to pass until you cross the starting line. Somebody in front of Mike got slow, Mike had to brake, and the guy behind ran into Mike and spun him out.

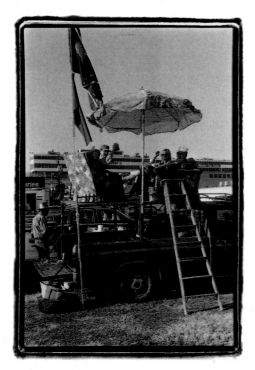

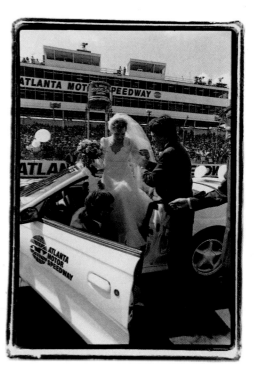

PAGES 34-35: Thursday at sunup this grandstand was deserted. Now it's jammed to the rafters. The comfortable, air-conditioned VIP suites up top are owned by companies that entertain clients on race days with gourmet food and drink.

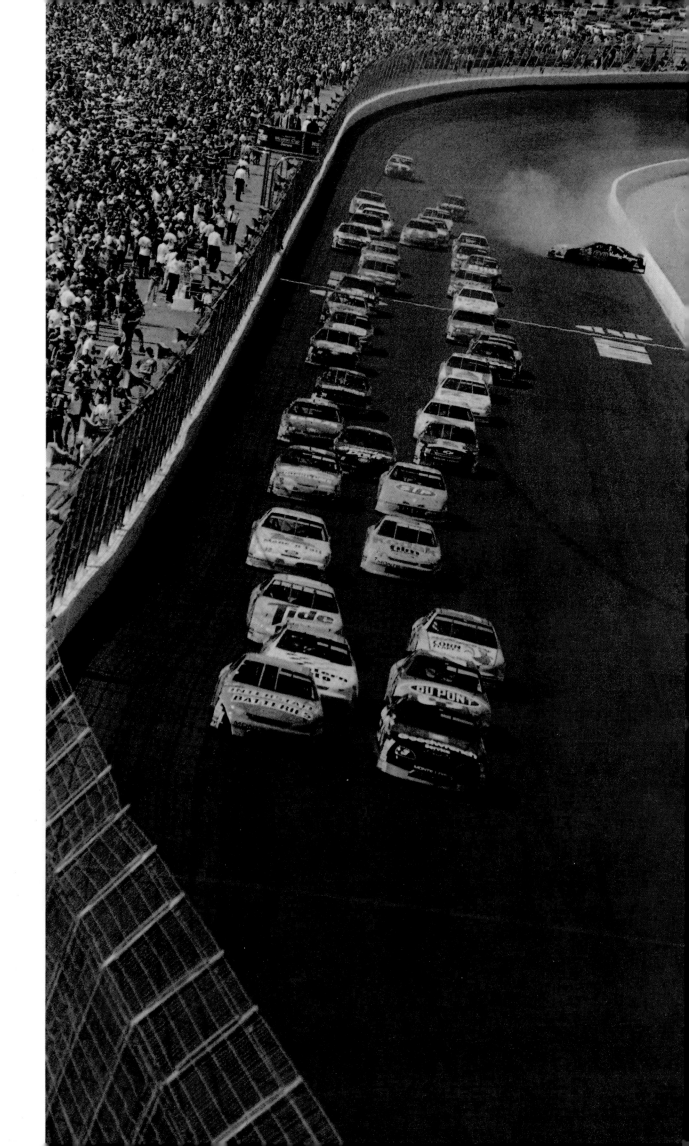

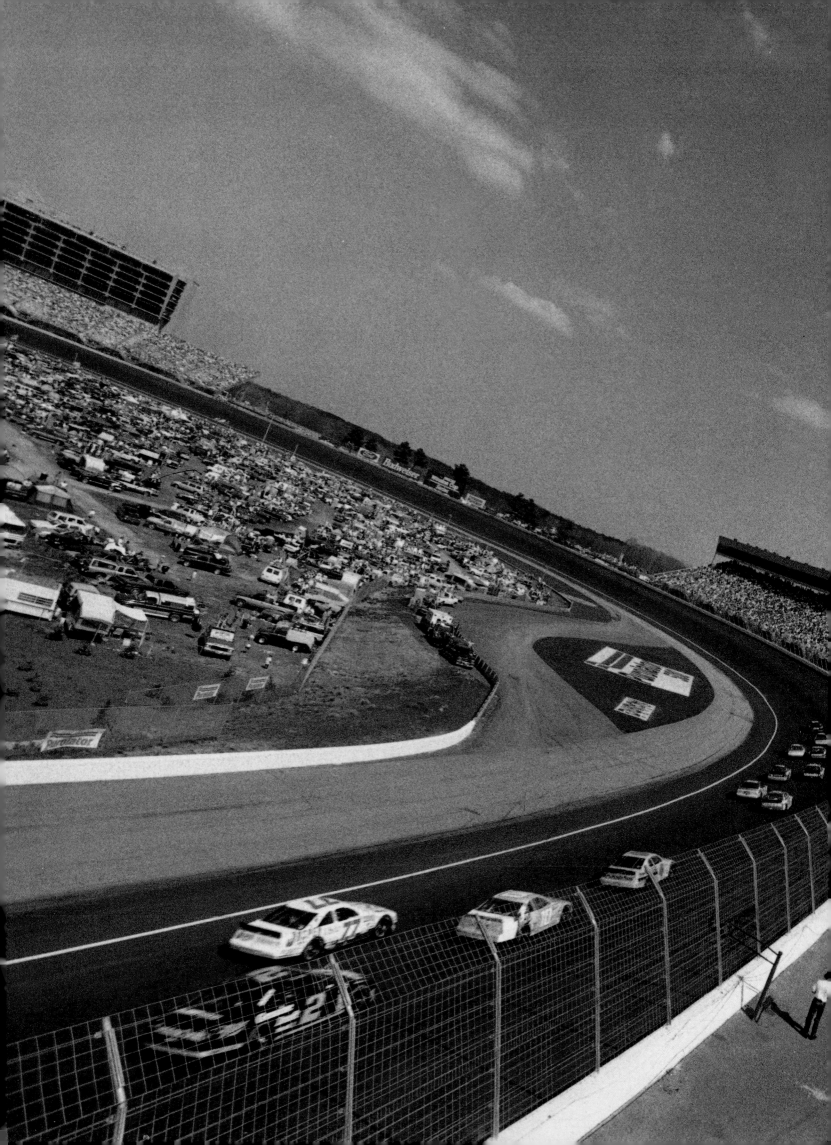

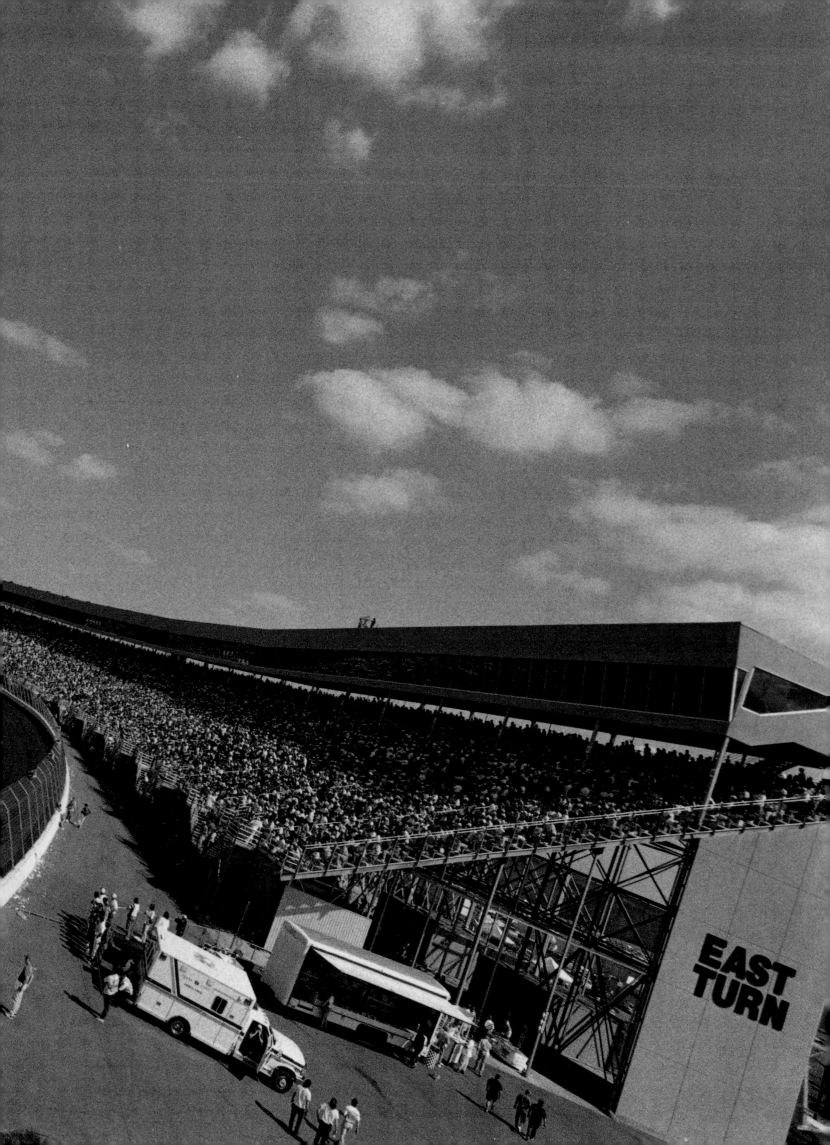

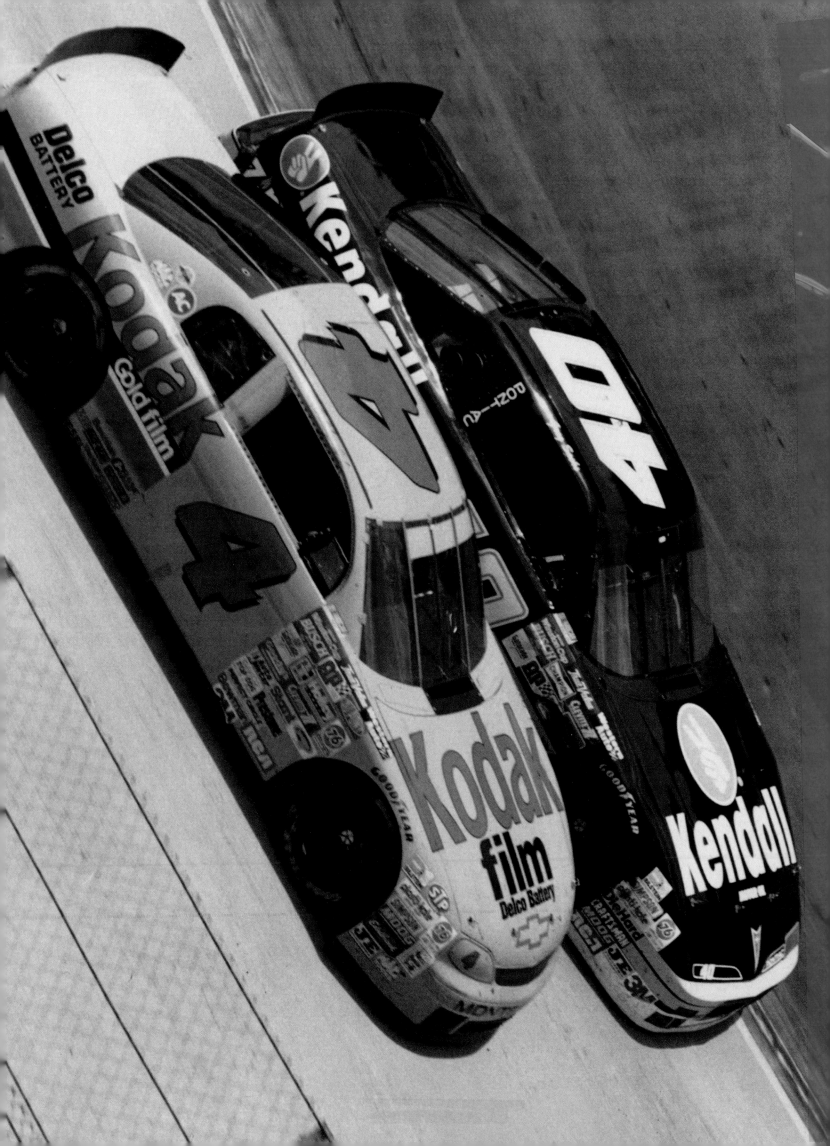

OPPOSITE: Private dollars at work. Each company decal on these cars is bought and paid for. There are a variety of deals. Companies can pay cash—sometimes contingent upon winning—or with product. The larger the name (Kodak and Kendall in the cases of cars #4 and #40), the more money that has changed hands. BELOW: The thick white line painted across the track is a scoring line for the pit area. Officials determine what order cars return to the track by the order of their arrival. The NASCAR official at lower left holds a "stop" and "go" sign. He determines if any race car beats a pace car out of the pits. If his paddle reads "stop," you either stop or face a penalty.

PAGES 38-39: Pit stops begin with fractions of inches, and end in tenths of seconds. Fifteen men (only six at a time are allowed over the wall) working like a high-compression drill team can produce a miracle faster than you can change pants. It begins with the driver, who must stop on the dime indicated by that white cross on the ground. The pole man positions the cross for the driver to see. Everything is precisely measured from that white cross—where the jack will be, for instance. This is a four-tire change because of the distance left between car and wall for the jack handle. If it's just a right-side tire change, they'll bring the car in closer. The left-front tire man is on his knees, ready to remove the lug nuts. The tire carriers are on the move. The guy vaulting the wall will clean the windshield. There's a limit to how many men can be over the wall. When a tire carrier returns, the gas man will jump in.

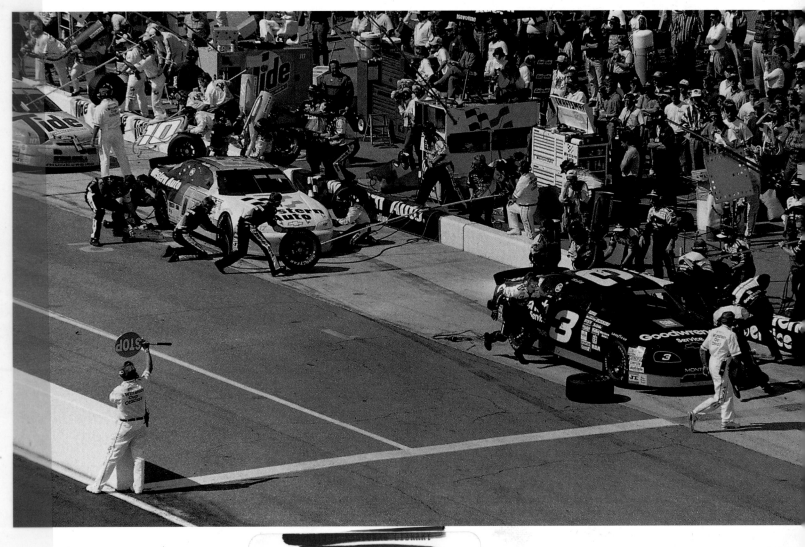

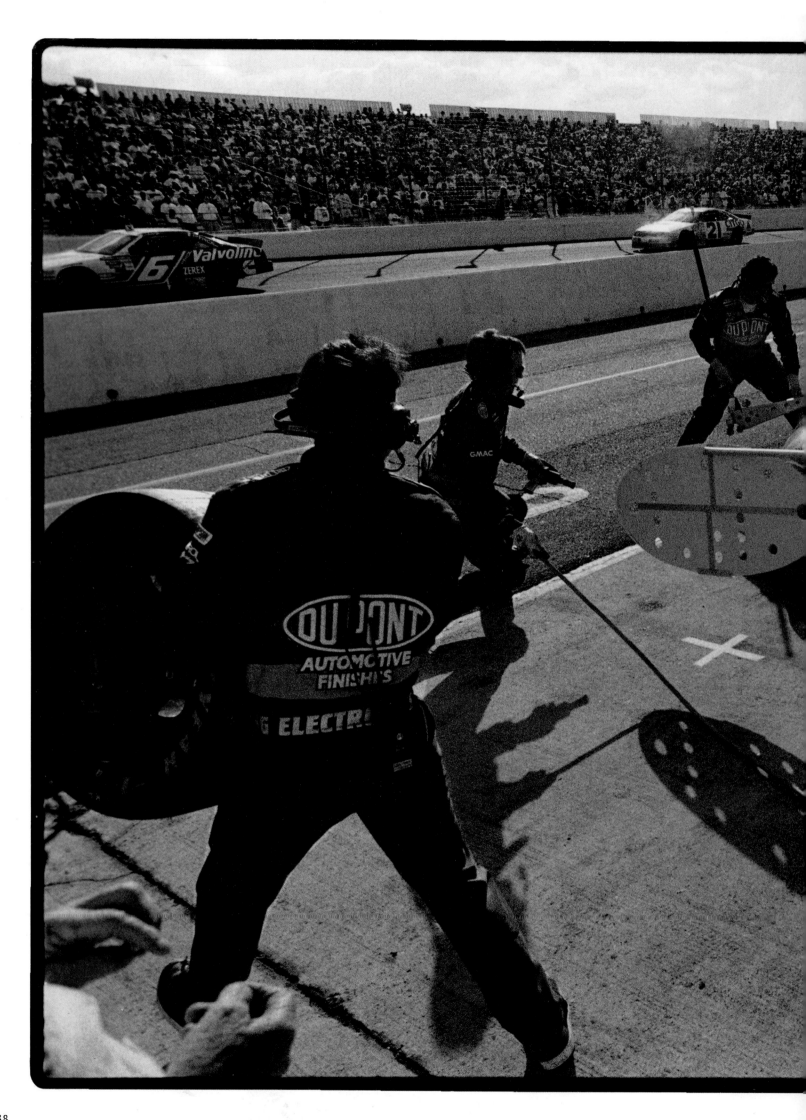

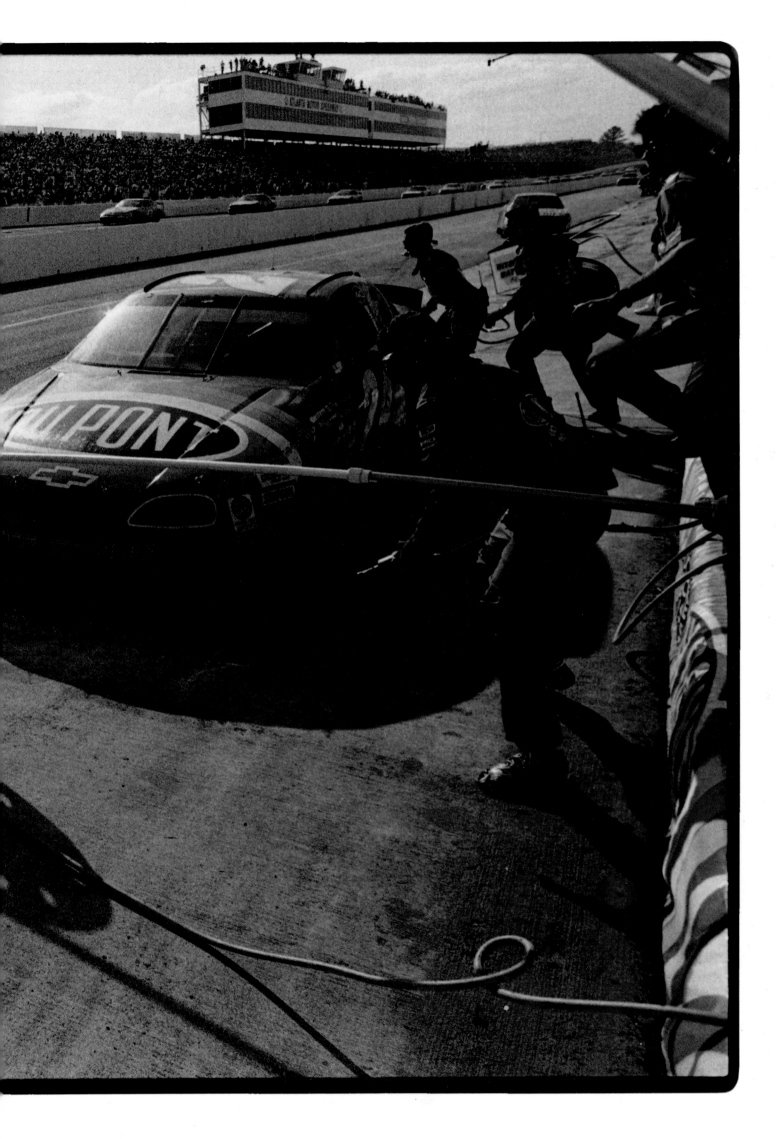

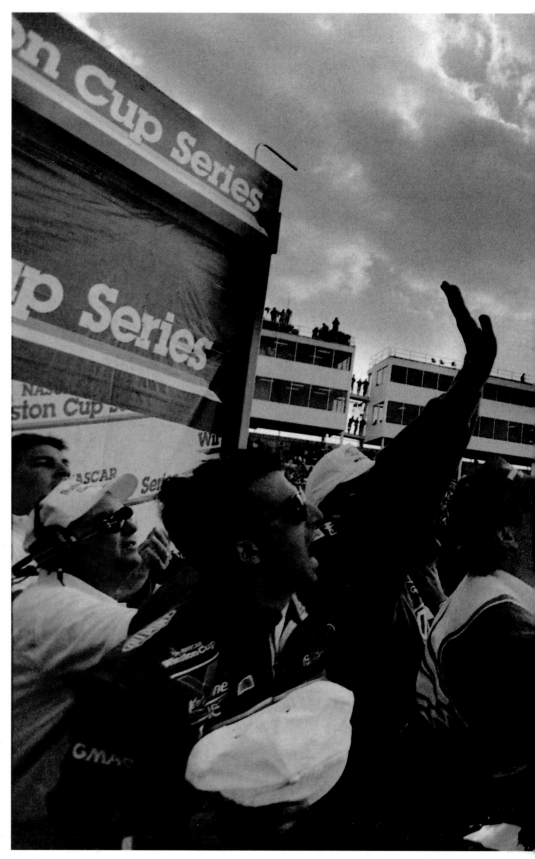

Jeff Gordon is where every driver wants to be, with the checkered flag girls in Victory Lane. Jeff is a breath of fresh air for auto racing. A young guy with a lot of success, he's dropped the average age of race fans by several years. That's important to any business out to attract the eighteen-to-thirty year olds. Jeff's young (twenty-five) to be so good. You've heard about the victors getting the spoils; well, Mr. Gordon has been spoiled pretty well over the last few years.

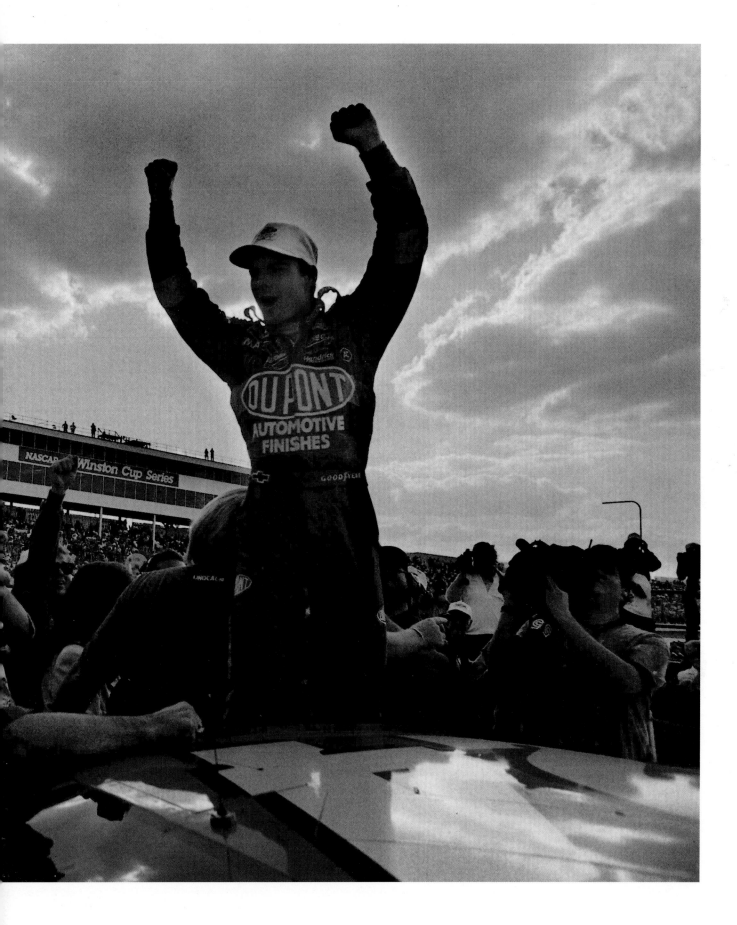

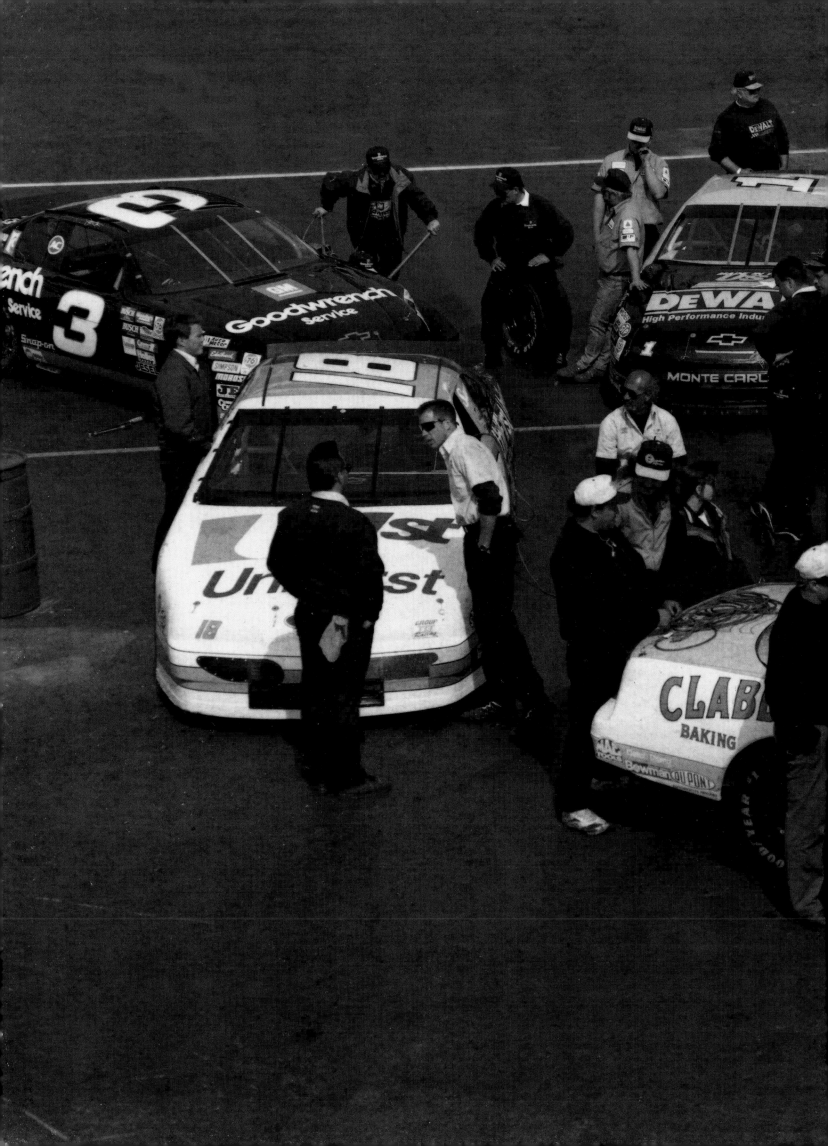

BRISTOL
INTERNATIONAL
RACEWAY

Four turns and a half mile in 15 seconds, that's what the short tracks are all about. By the time you exit one turn, you have less than 2 seconds before you enter the next one. If it weren't for a wreck every 20 laps or so, and the yellow caution flag, you'd never get to slow down and relax on the short tracks.

There are only four short tracks left on NASCAR's Winston Cup Series schedule. Richmond (Va.) and Bristol (Tn.) International Raceways; and North Wilkesboro (N.C.) and Martinsville (Va.) Speedways. They are the smallest tracks on the circuit, but even so they seat between 75,000 and 80,000 fans in a high-rise arrangement. Bristol is considering doubling its capacity by the year 2000. That's because the fans love the short tracks. Almost every seat is a good seat. There's barely room in the infield for all the transporters and pits, let alone people. Everybody crams in and has a big old time at the short track races.

RICHMOND
INTERNATIONAL RACEWAY

Short track racing has its own personality and problems. Horsepower and aerodynamics, key elements on the bigger Winston Cup tracks, aren't very important on short tracks. What counts the most here is how the car handles. If you can set your car up so you can have the accelerator on the floor just before you come out of the turn, as opposed to waiting until you hit the straightaway, you'll usually win.

There's a lot more contact among the race cars in this atmosphere, but usually the damage isn't significant. Tempers flare more on these tracks, which is understandable, but conflicts are generally resolved during the weekend or at least by the beginning of the next race weekend. Grudges are rarely, if ever, carried in Winston Cup Racing. It's too dangerous a game for grudges.

Bristol. This place is notorious among short tracks. Bristol used to be like North Wilkesboro, with 8 to 10 degrees of bank in the corners. In 1969, they put in high, 36-degree banks and that increased the speed substantially. Even the straightaways are banked at 16 degrees! The higher speed makes driving very physical. **When you enter the corner at 130 mph and hit that high bank, the car literally tries to heave you out the passenger-side window.** The seat belt prevents that, but your head takes an awful beating. You're trying to hold your head upright against the force, and it wears your neck muscles out completely. Drivers have devised all kinds of straps and braces trying to solve this problem, but nothing works perfectly. The chiropractors keep busy at Bristol.

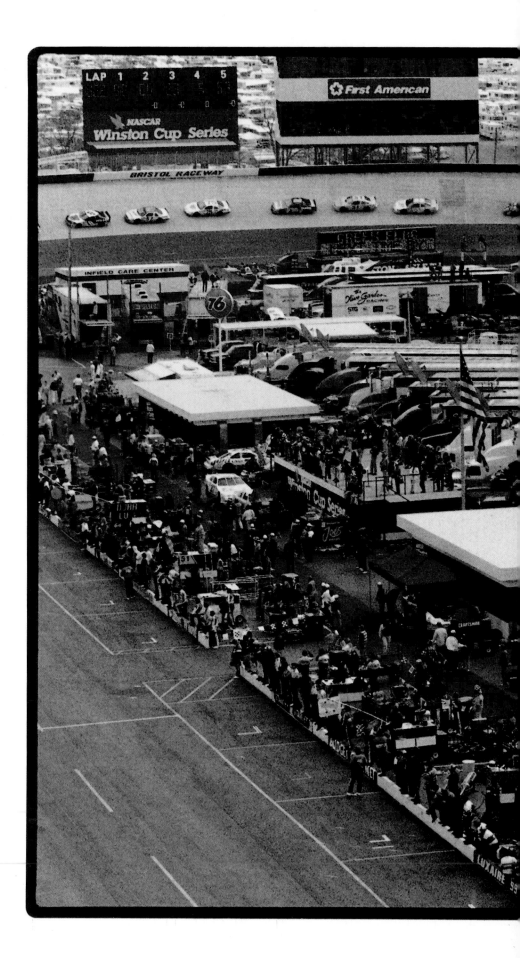

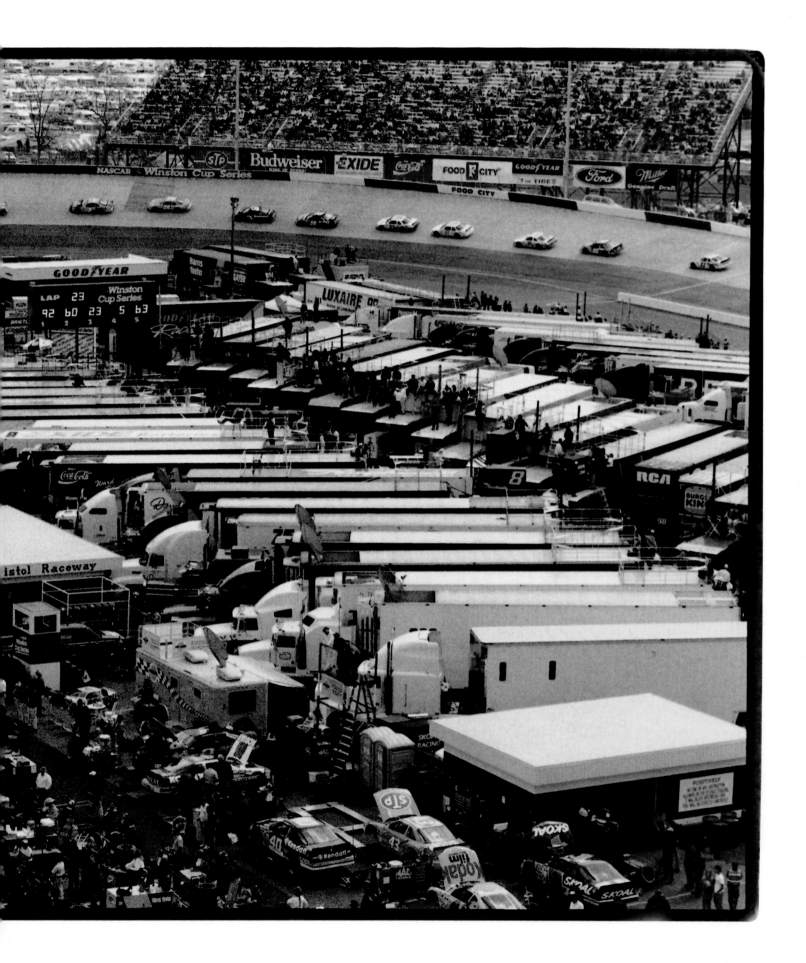

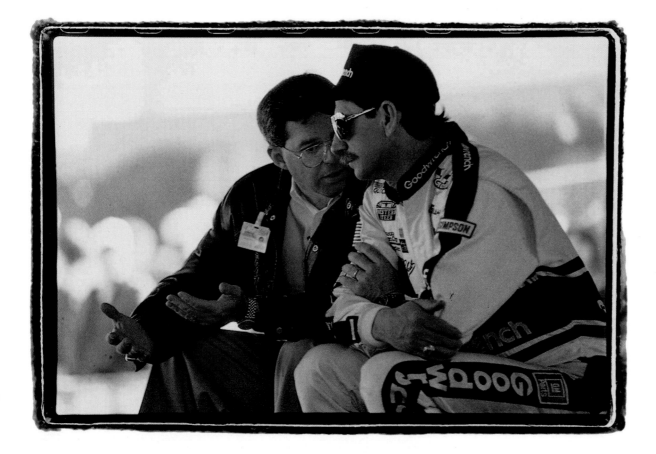

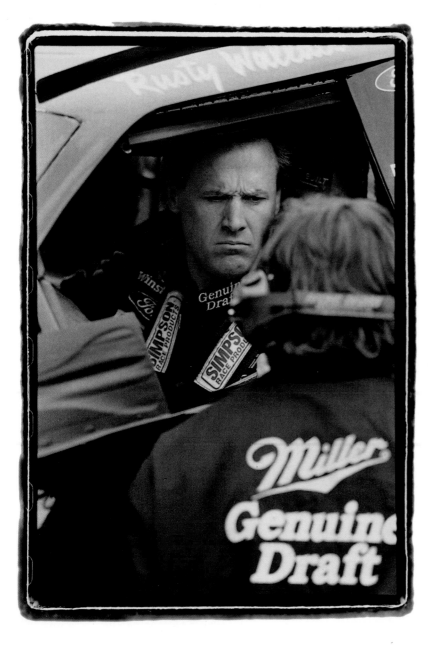

ABOVE: Dale Earnhardt (right) takes time out to talk business with Don Hawk, president of Dale Earnhardt Enterprises. Dale is involved in several businesses. LEFT: From the look on Rusty Wallace's face, I wouldn't want to be his crew chief. But someone has to deliver the bad news. That's why he's called the Crew Chief.

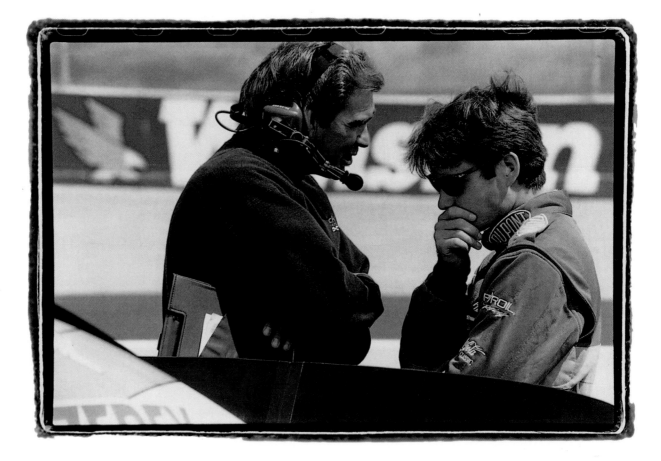

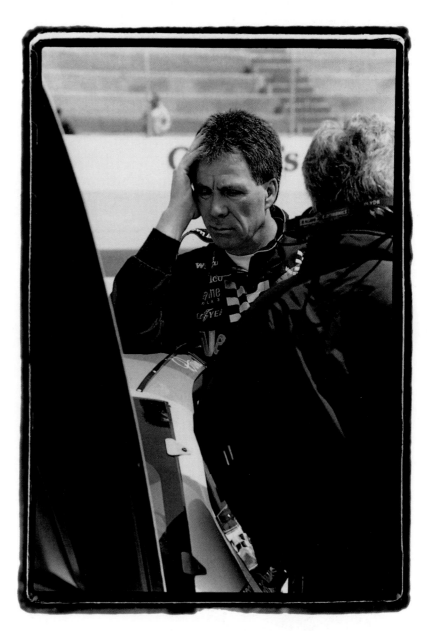

ABOVE: Crew Chief Ray Everham (in headset) is running something by Jeff Gordon. A solution to some problem, no doubt. And Jeff is mulling it over, wondering if it will work.

RIGHT: Darrell Waltrip with a headache. Darrell has had great success at Bristol, winning seven races in a row between 1981 and 1984. But today he knows his car isn't good enough to win.

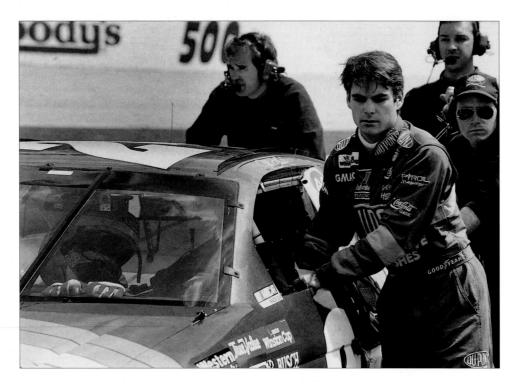

hot day. But now there are a lot of smaller drivers doing well. The driver adds weight, after all. If the engine has to pull 100 pounds less coming off a corner—and there's 100 pounds less force trying to pull the car sideways—that's a tactical advantage. Someday I'm sure driver and car will be weighed together to make minimum weight.

BELOW: Richard Petty, now an owner. Is that intimidating for driver Bobby Hamilton, or an advantage? Probably a little of both. Petty's records of 200 Winston Cup victories and 127 pole positions won will probably never be broken. But a driver has to like an owner who has been in the cockpit. He knows that some days you just don't hit it. He's out there with you in spirit all day. And no one knows the game like Petty, the all-time greatest.

ABOVE: Drivers didn't used to be built like Jeff Gordon. They used to be big, robust guys because the cars were so hard to handle. Prior to the 1960s, the cars had no power steering, no air conditioning. It took a lot of physical strength and stamina to drive a race. A driver would lose 5, 10 pounds on a

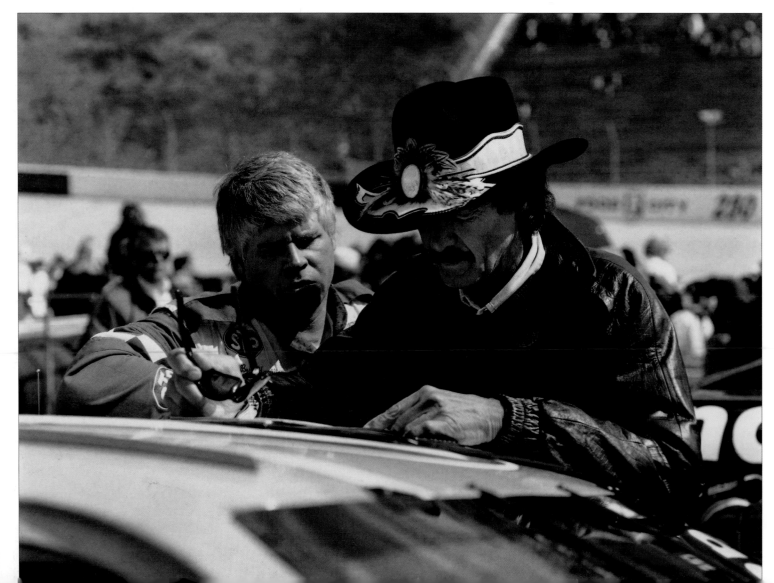

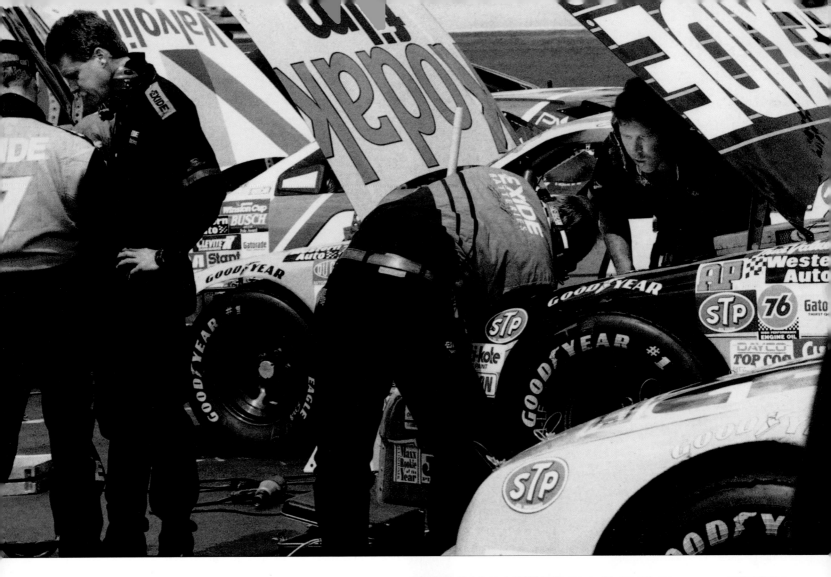

ABOVE: In auto racing, movable weight is illegal. You hear stories of cars that get lighter as the race goes on. One trick: fill a frame rail with 75 pounds of BB-shot for weigh-in. When the race starts, the driver pops a little door, and out they come. Fortunately, they roll down to the low side of the track. RIGHT: Rusty Wallace trying to lose that headache by working on the chassis. He'll keep adjusting shocks, springs, and air pressure until he gets a combination that works.

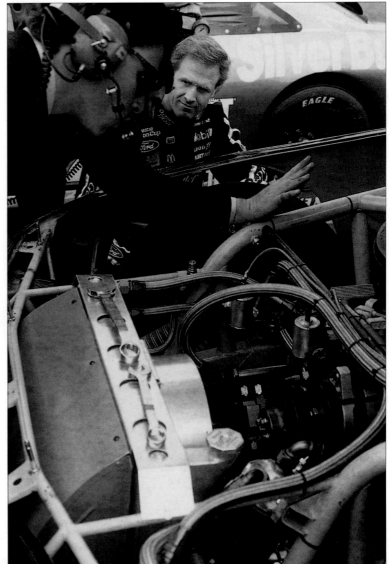

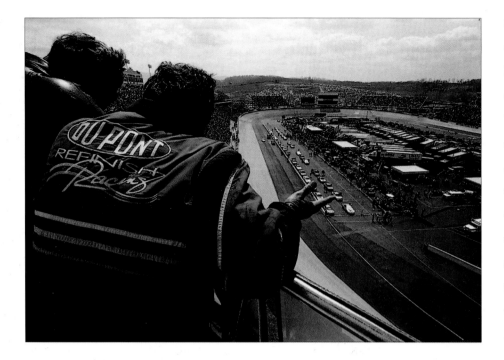

LEFT: Spotters atop the grandstand watch the cars line up for a race at Bristol. With their bird's-eye view of the whole track, a spotter can radio his driver of trouble in front of him. They keep one eye on their guy, the other on what's developing so they can steer him around problems. BELOW: A final chance to gab with the press before the track is cleared for business. OPPOSITE: Green flag, the start of 500 laps at Bristol. The engines are screaming, the crowd is on its feet, adrenalin is pumping overtime. The drivers want to run, they want to win. But there's a downside: 500 laps at Bristol is a hard day's work.

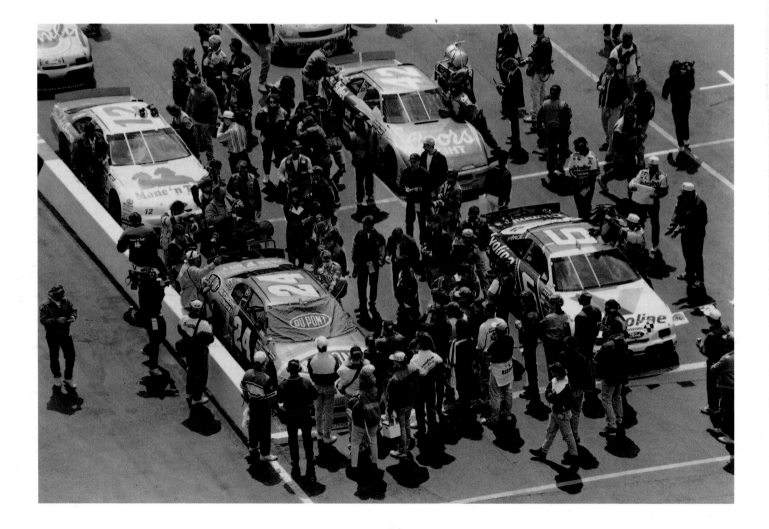

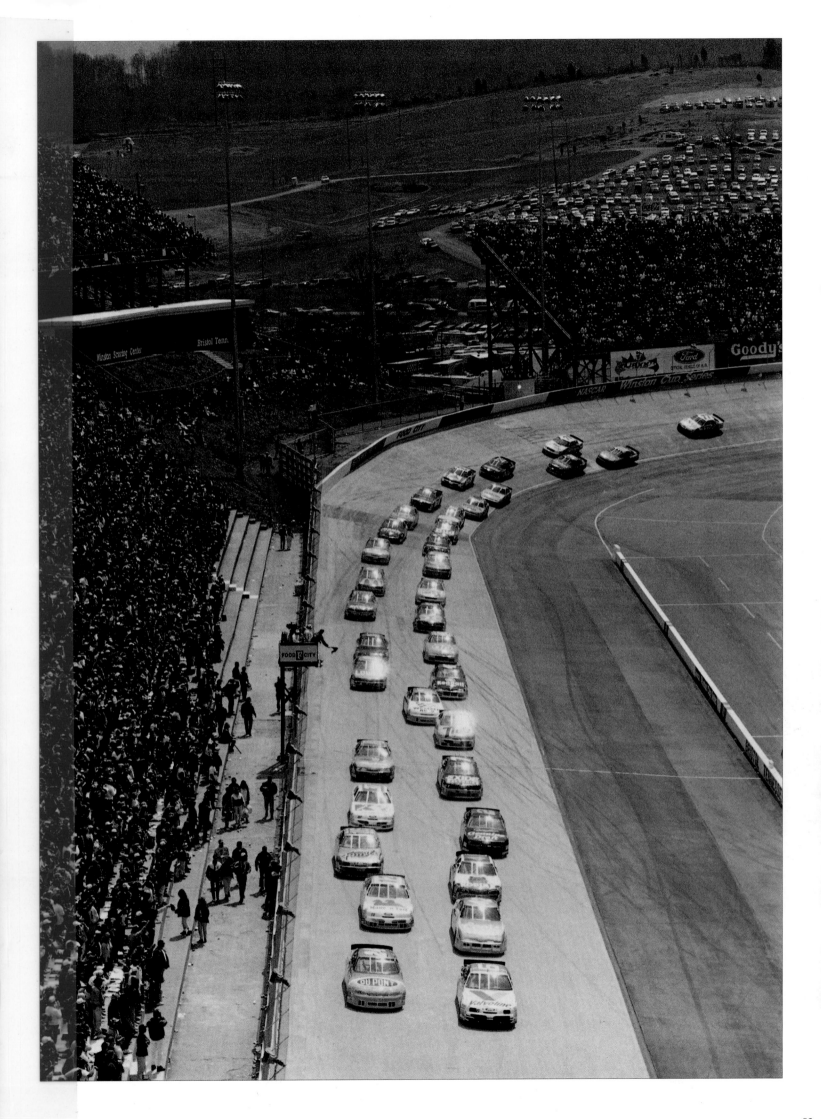

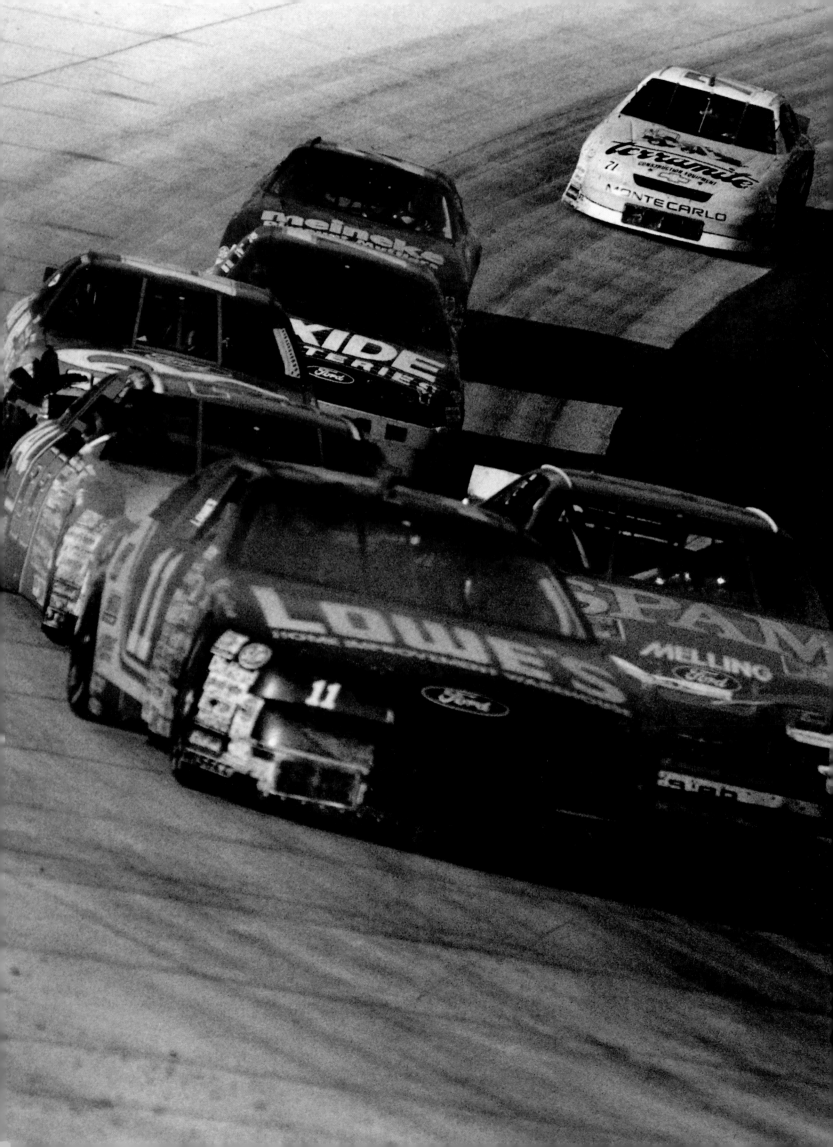

OPPOSITE: It's tight out there: nose to tail, door to door. The "groove," the fastest path around the track, is 12 feet wide at Bristol. Two cars take up 16 feet. **Something's got to give.**

RIGHT & BELOW: Traveling around the track at 15 seconds per lap, if something happens on the backstretch and you're in turn one, there's no way you're going to avoid wrecking unless you have a spotter. Those guys have prevented a lot of bent metal—and drivers. Dale Earnhardt is into the wall. Going into turn three, Earnhardt was on the outside, trying to pass. Either he turned too soon, or the inside car didn't back off quickly enough. **Contact.** The inside car's right front fender touched Earnhardt's left rear, which spun him out. He hit the wall and damaged the front end.

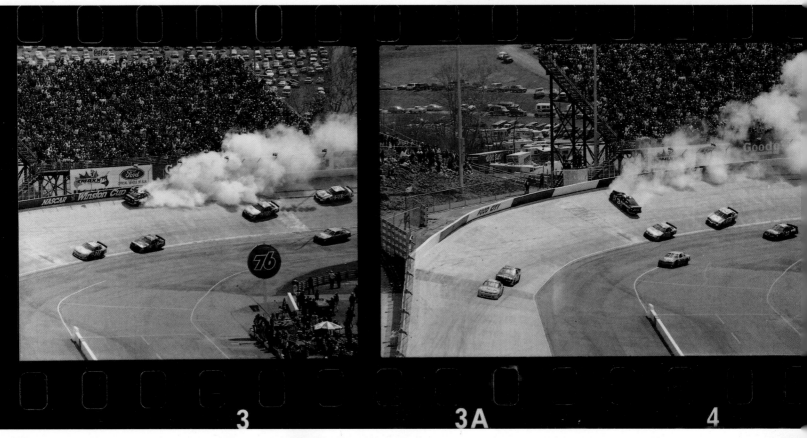

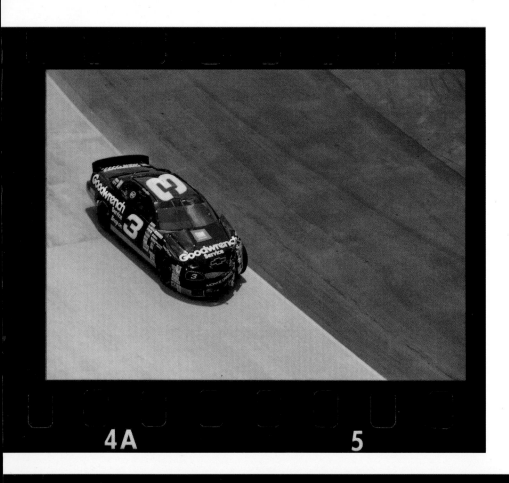

4A 5

LEFT & BELOW: Earnhardt limps to the pits. Damage is serious by the look of the huge crowd working on the car. They'll change suspension, steering arms, water cooler, and whatever else is broken. You bet Dale came in hot. Check out those skid marks where he braked to a stop. OPPOSITE: The #3 car is back in business, almost. It's missing a lot of sheet metal, and Dale's way down in the pack, but now he's running for points that will keep him up there in overall standings.

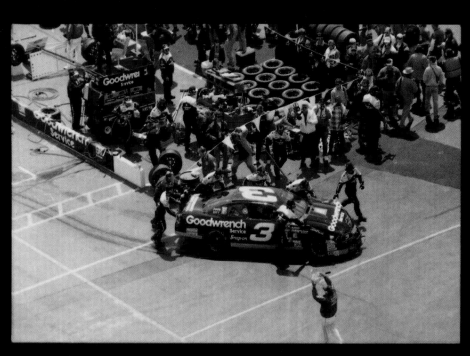

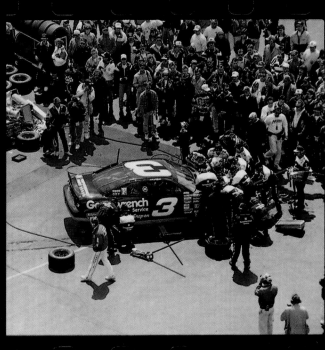

8A 9 9A

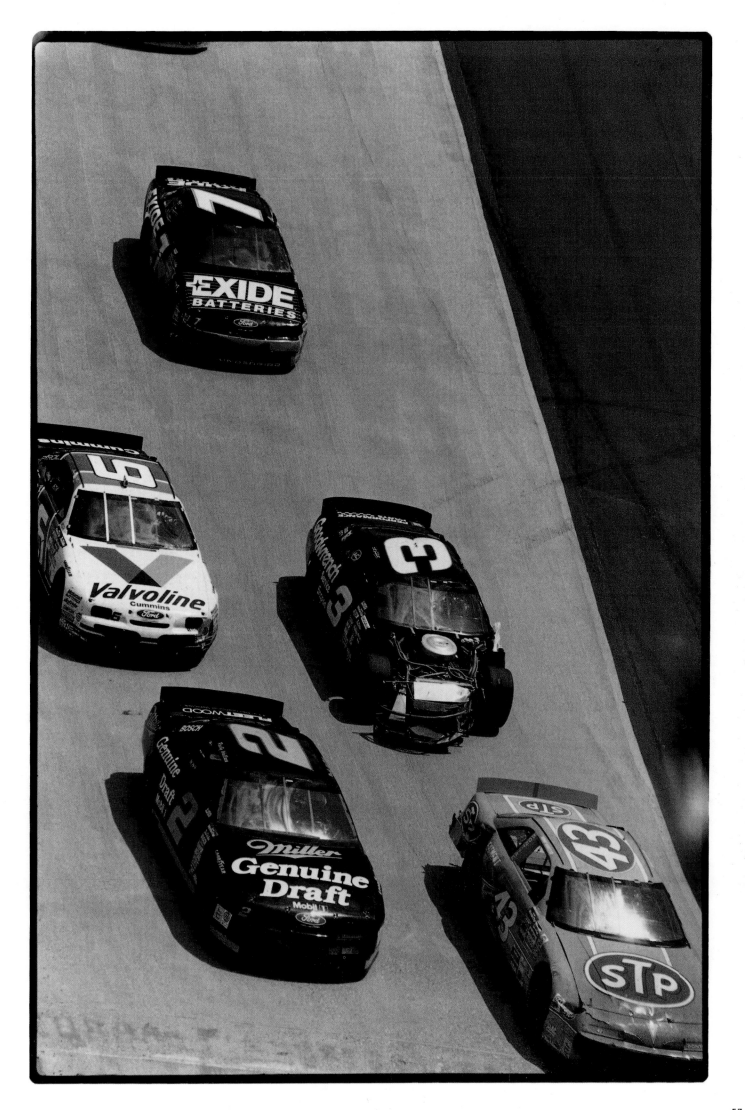

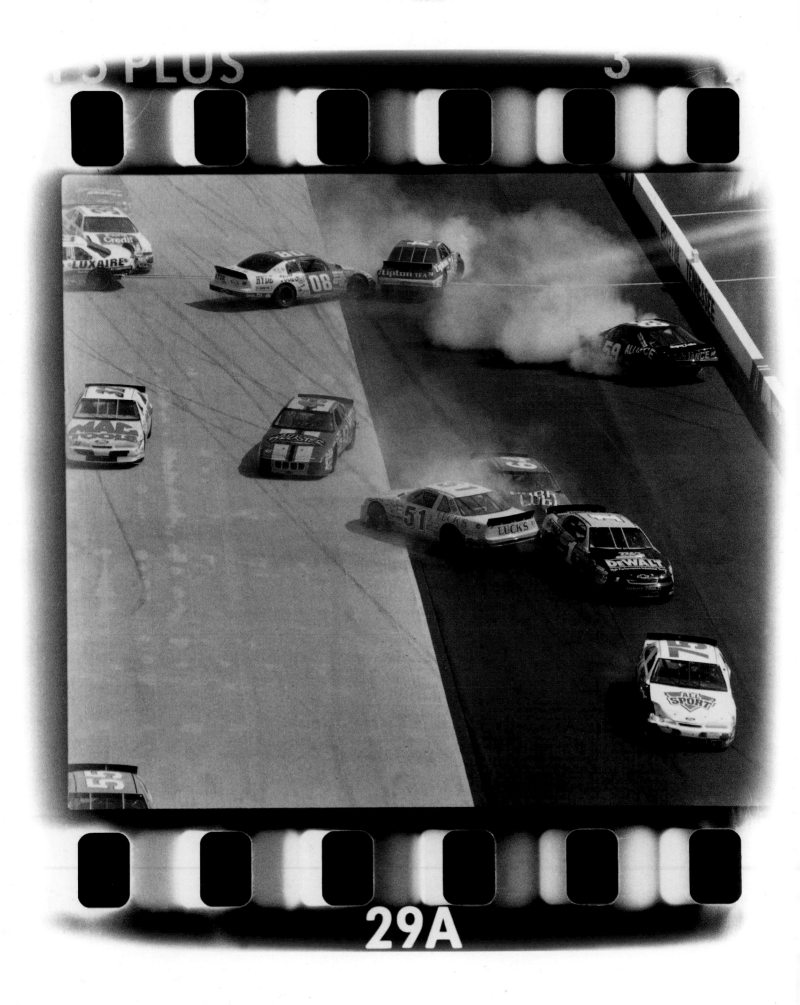

OPPOSITE: **The peril of a wreck at Bristol:**
all dressed up and no place to go. With the
high speeds and the small track, it's like the
thruway at rush hour. If you are anywhere
near the wreck, you're in the wreck. If you're
coming up on it, what do you do? Well,
**you pick out a
car that's moving,**
like #8, **aim at him,
and hope he's
gone when you
get there.** My little brother
Phil is in the "Luxaire" car, top left. He's
been racing twenty years. He's in the wreck.
No place to go.

The third or fourth race of my rookie
NASCAR season, I was running fifth behind
Richard Petty at Bristol. On lap ten I tried to
pass him around turn one. We made contact, I
spun him out, and we both crashed. All he
ever said to me was, "Where were you
going?" So I had a little meeting with myself
and said, "You know, it was 500 laps." There
was no need to take such a risk on lap ten.

RIGHT: **It looks like my brother in the #99 car**
finds a way past this wreck. The #42 car got
sideways in the turn, and #75 has his brakes
locked by the look of the skid marks, but
he's going to hit him, no question.

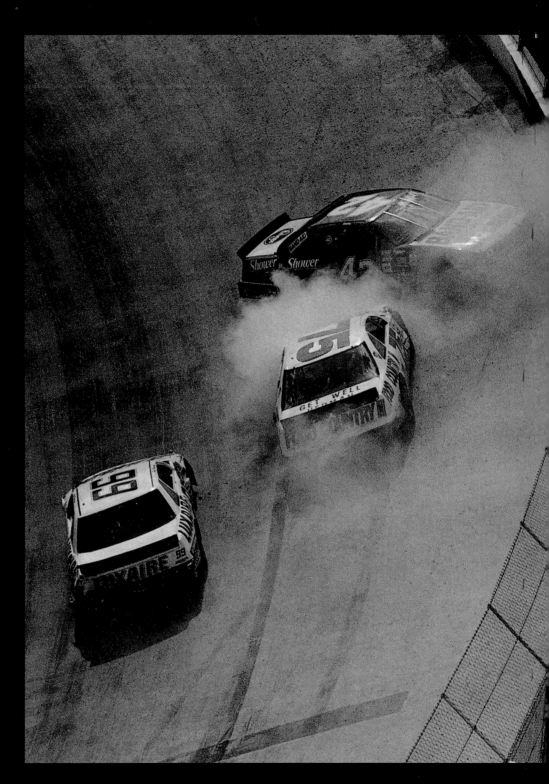

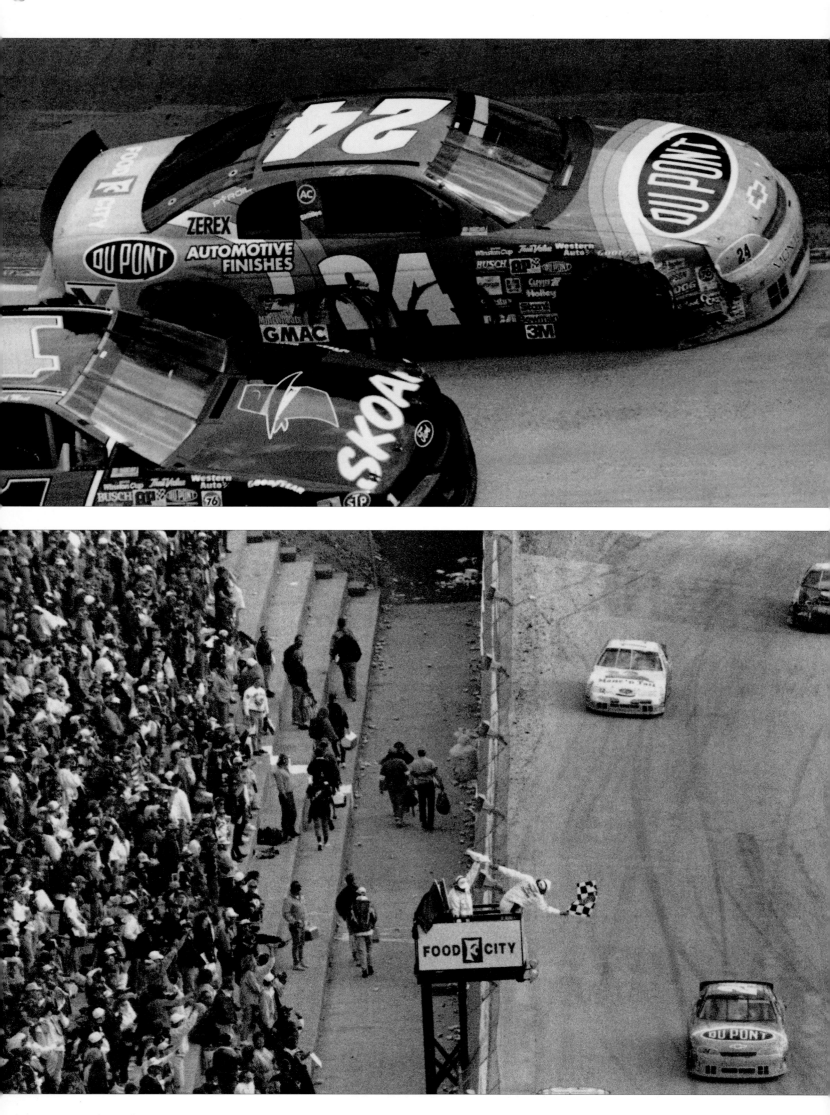

OPPOSITE: **From the low-rider look of Jeff Gordon's front end, he's got to be running on a flat tire. It's just one of the hazards of crowded conditions on a short track. The scuff marks on Jeff's numbers are tire rubber from another car that contacted him. His right front fender is creased from a friendly nudge. That's short track racing. One lap is about all you can get out of a flat.**
BELOW & RIGHT: **Jeff must have pitted well and gotten new tires, because he takes the checkered flag and the trophy.**

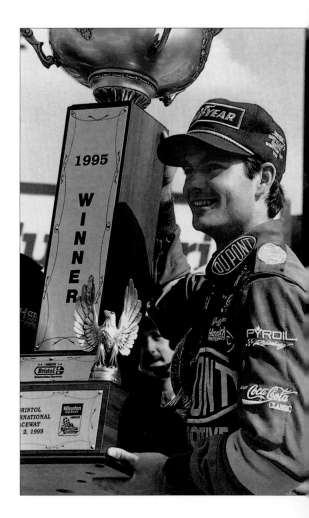

Note the light, concrete track surface. Bristol has had no luck paving it. Every time they've tried, the cars tear it up. The concrete is a little bumpy, and the groove is narrow, but it holds up. The officials at Dover admired Bristol's concrete so much they converted to it. Dover is a 1-mile track, a so-called intermediate circuit.

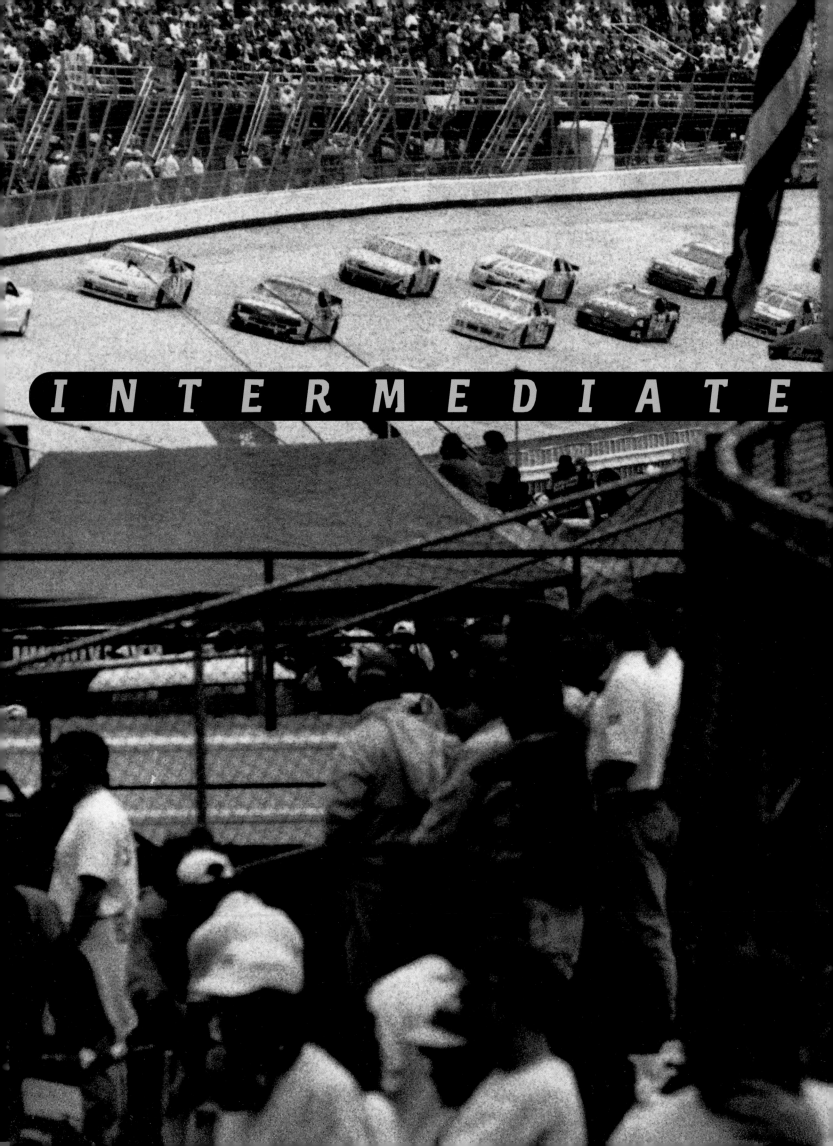

INTERMEDIATE

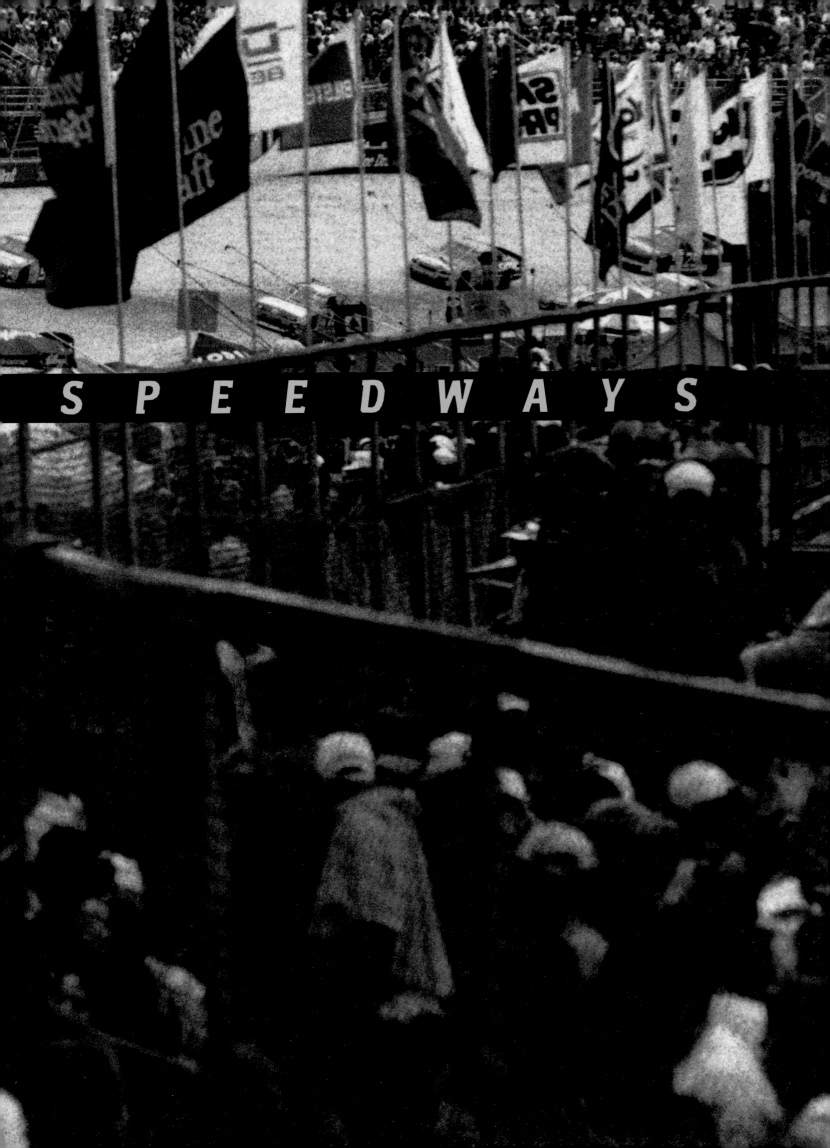

SPEEDWAYS

vary in length from New Hampshire, the shortest intermediate track at 1.058 miles, to Indianapolis and Pocono, which are both 2.5-mile tracks. New Hampshire is a flat track with long straightaways and tight corners. Charlotte, Atlanta, and Michigan are all high-banked tracks allowing speeds approach-

ing 200 mph on the straightaways. Darlington is longer than New Hampshire (1.36 miles) with even tighter, trickier corners, but with steeper banks—25 degrees instead of New Hampshire's 12 degrees. Pocono offers the longest straightaway in Winston Cup racing. And Indianapolis is one of the top tracks on the circuit. The facilities are great, and it is a prestige place with good money-earning capability.

Because each of these tracks demands something different in the way of top speed, acceleration, and handling, no team runs the same car, or even the same type car, on any three of these tracks unless they have to.

You can bet those who finish well on the intermediate tracks are doing well overall. Jeff Gordon dominated the intermediate tracks in 1995 on his way to the Winston Cup Championship. Check the weekly results on these tracks. Whoever is running in the top three or four, week to week, should be on or near the top at season's end.

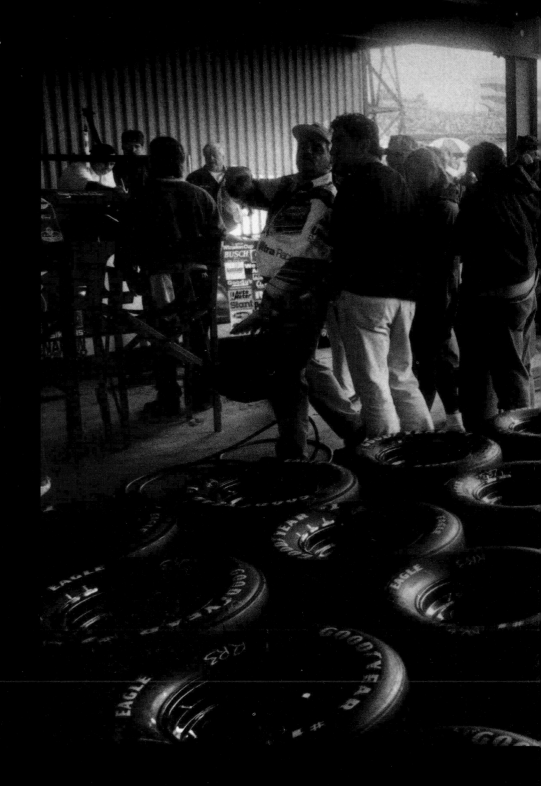

A rainy day means no racing. That means the crews get a chance to talk with one another. And that means there's a lot of lying going on. Because you wouldn't want to tell each other the truth about anything, would you?

You can't race when it rains

because there's no tread on a race tire. If you ran your car on dry pavement all the time, you wouldn't need tread. On a race day 40 cars traveling 500 miles each will use a total of 2,000 tires. After you run a tire even three or four laps and remove it, you never use it again. Tires are best right out of the mold. A two-week-old tire is better than a two-month-old tire. It's an expensive part of the sport—race tires cost about $300 each —but tires are what meet the road. Every chassis and weight adjustment is aimed at making the tires grip the road better.

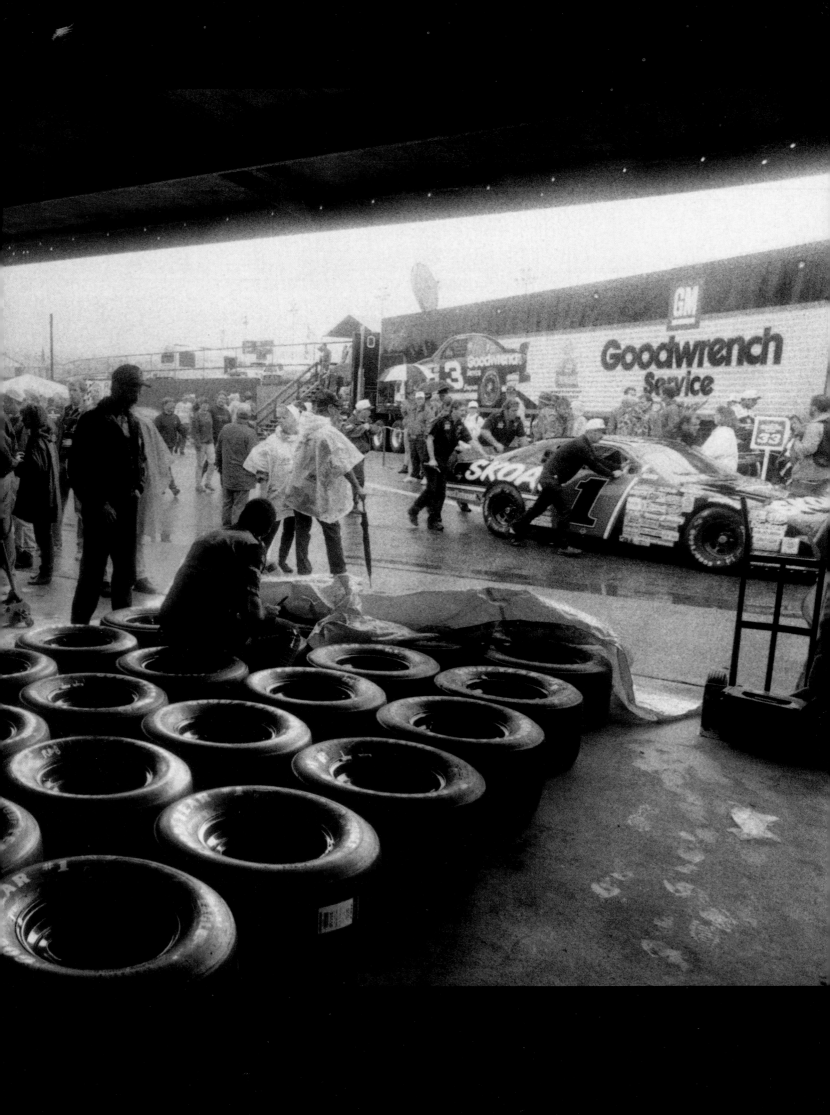

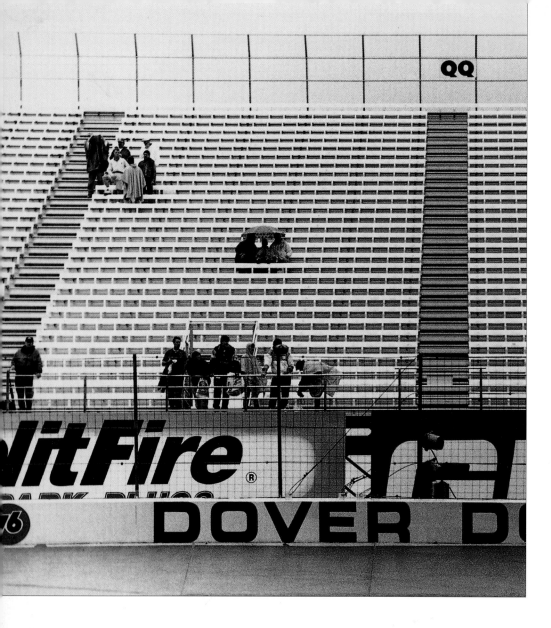

QQ

itFire ®

DOVER D

LEFT: A rain-delay at Dover, with a few hard-core fans determined to wait it out. This is how it used to look at Dover all the time. For years, horse racing kept the track open. But as the popularity of stock car racing increased, Dover became one of the showplaces of the circuit. Eighty miles from Philadelphia, a hundred miles from Washington and Baltimore, it's a prime location that packs 'em in these days. OPPOSITE: It's amazing how people pay good money for seats and then stand up. You never have to guess who the fans are pulling for, or what make car they favor. They wear their favorites on their shirts or hats, and all that paraphernalia is big business. It's estimated that Dale Earnhardt's company, Sports Images, sold $30 million worth of goods bearing his name, his #3, and GM Goodwrench last year.

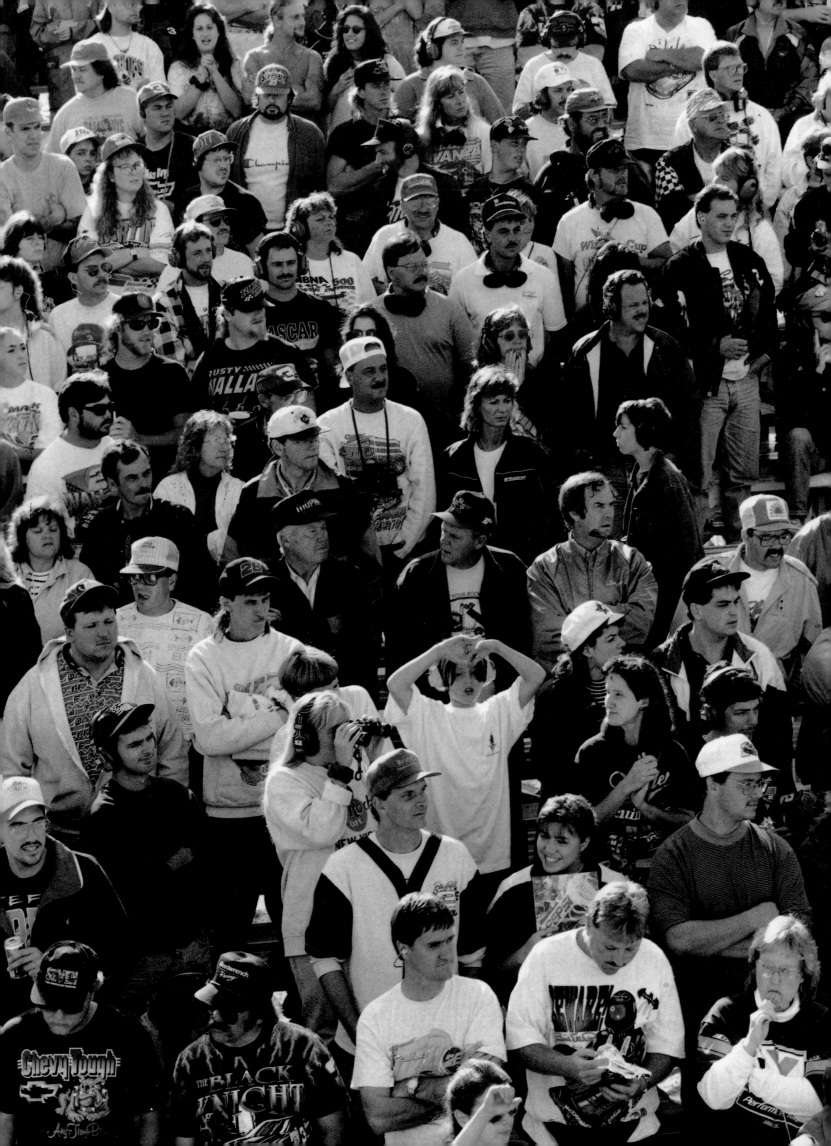

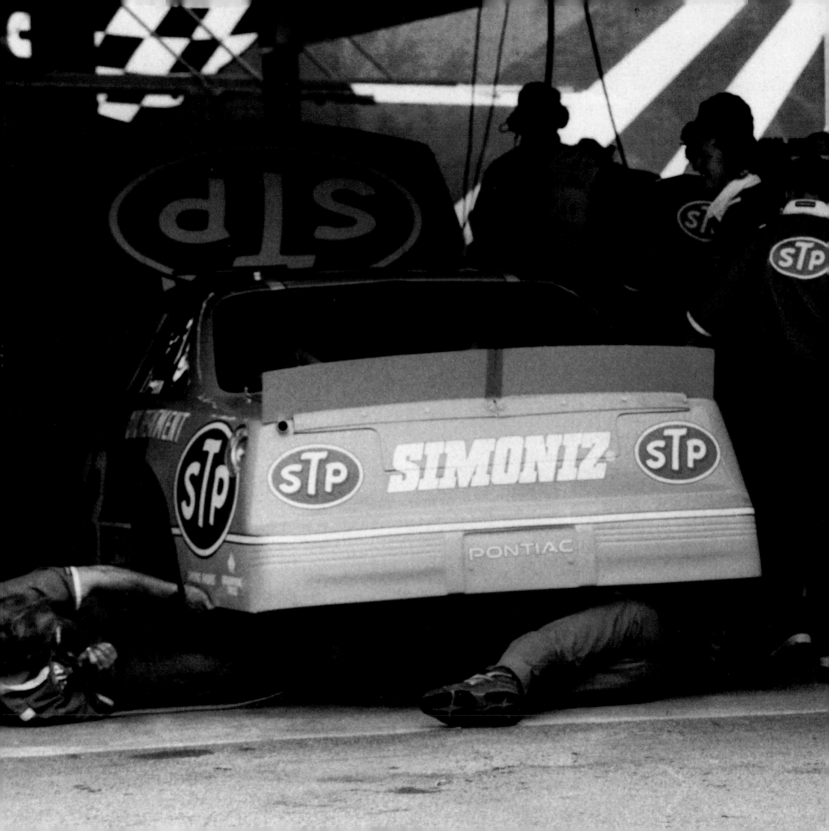

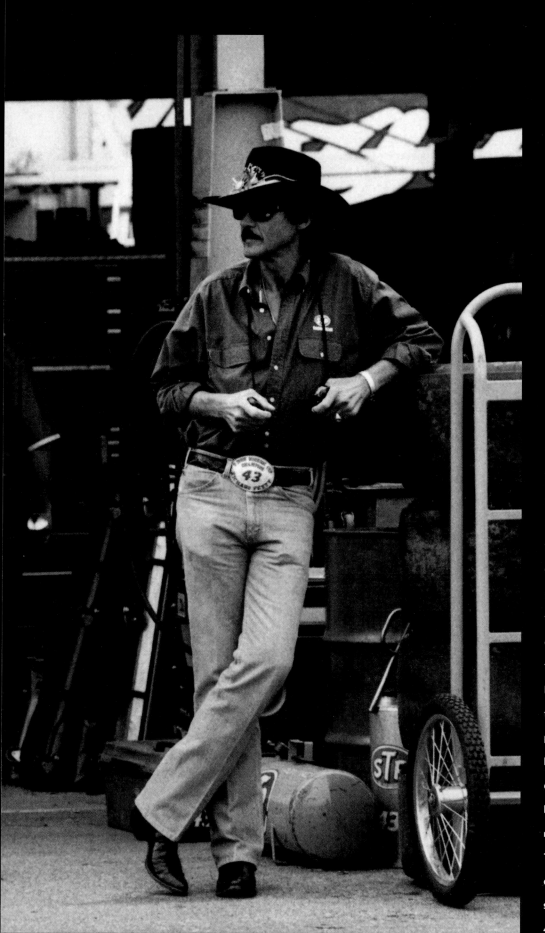

The long jaw line, trimmed mustache, sunglasses, cowboy hat with the exotic feather band, the #43 belt buckle—who else could it be but Richard Petty, "the king." From the mid-1960s to around 1980, Richard was definitely the king: seven Winston Cup Championships, seven Daytona 500 wins, most wins in a season (27), most consecutive wins (10), most races started (1,185), most consecutive starts (513), and more. But that's yesterday. What's important to Richard Petty today, as an owner, are the two stopwatches he's holding. No pencils, no paper—just those watches. The rest is in his head. He's looking at elapsed time as the cars practice. Time is the thing. Miles per hour mean nothing. Ask Richard how he's running and he might say, "We ran a 70." That means a 47:70. If some other car is doing 47:64, that's okay, just 6/100ths of a second better. But if another car is running 46:70, Richard has problems.

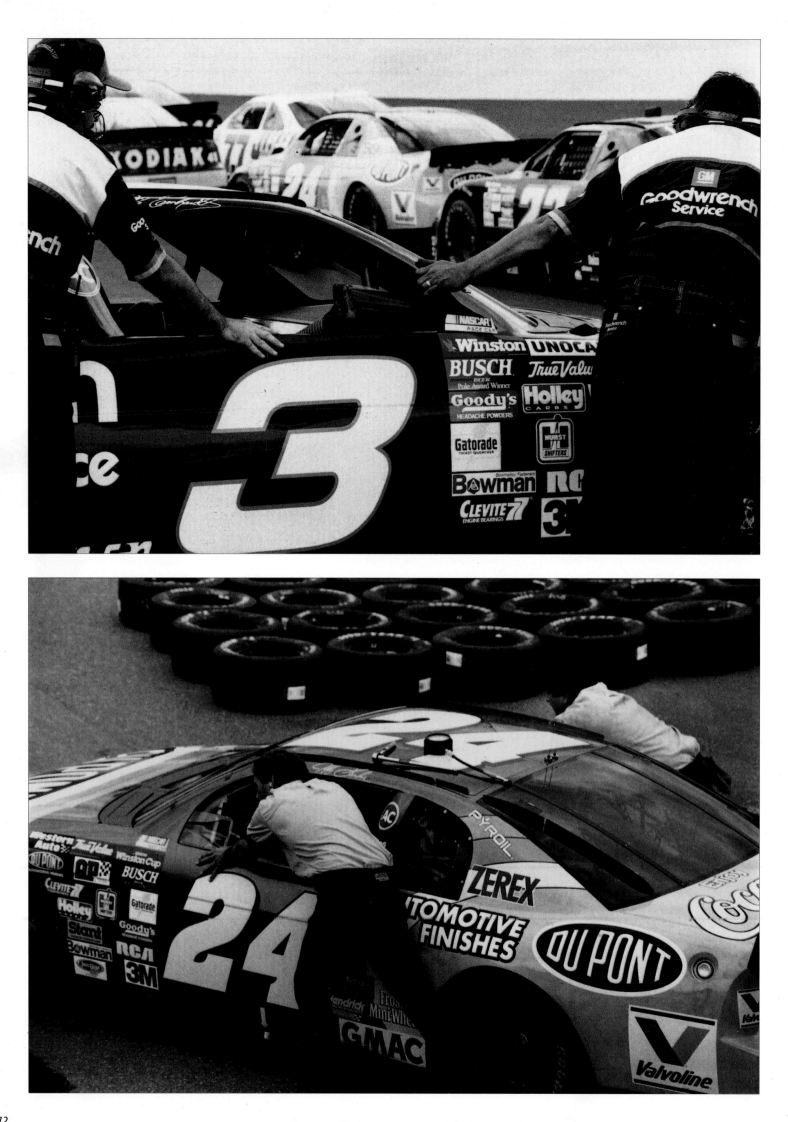

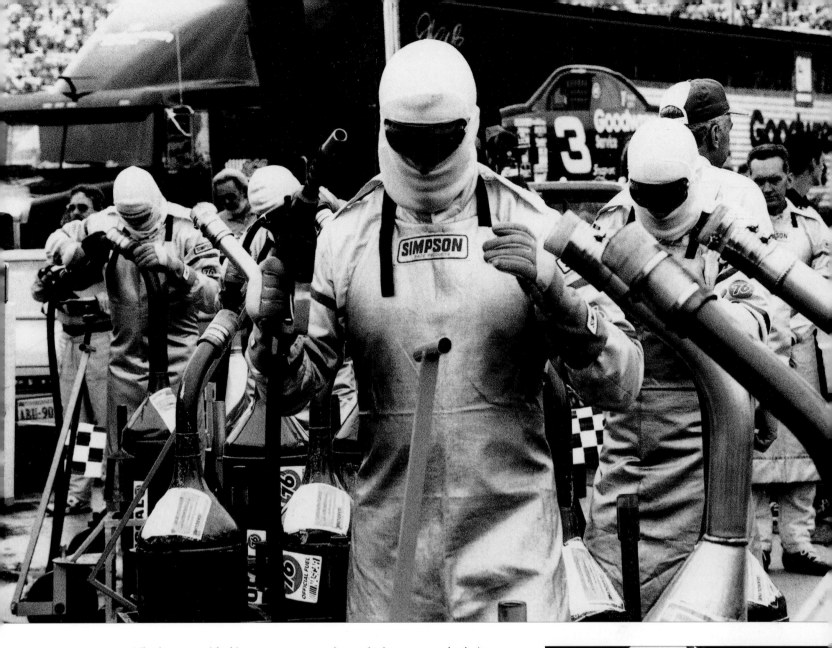

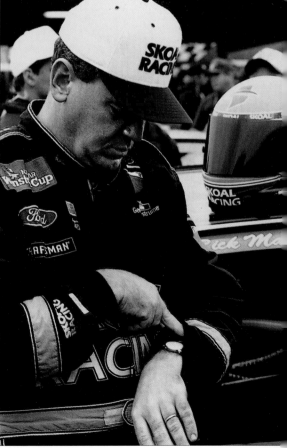

OPPOSITE TOP: What's wrong with this picture? A 700-horsepower car that has to be pushed everywhere. Must be a Winston Cupper. OPPOSITE BOTTOM: Judging by the tools on the roof, this car is on the way to inspection. The rachet drive with the extension is for adjusting the chassis, cranking down the bolts on top of the springs if the car is too low. The air gauge measures tire pressure within half a psi. Before the weekend starts, each team calibrates its gauge with the Goodyear engineer's gauge. As tires get hot during the race, the air pressure increases and changes the way the car handles. A team might start with the tires a touch low for that reason. The first thing that happens at a pit stop is tire pressure check. Atop the rear window are the two-way radio antennas. The driver has a headset and mike in his helmet so he can communicate with his spotters and crew at all times. ABOVE: Looking like astronauts in their regulation, flame-proof gear, the gas men take their cans to the station just prior to the start. Each can holds 11 gallons. The cars hold 22 gallons maximum and get about 5 miles a gallon. The racing fuel is blended by UNOCAL, and it's 105 to 108 octane, close to aviation-quality fuel to feed the high-compression engines. RIGHT: Rick Mast, the pole sitter, checks out the length of the rain delay.

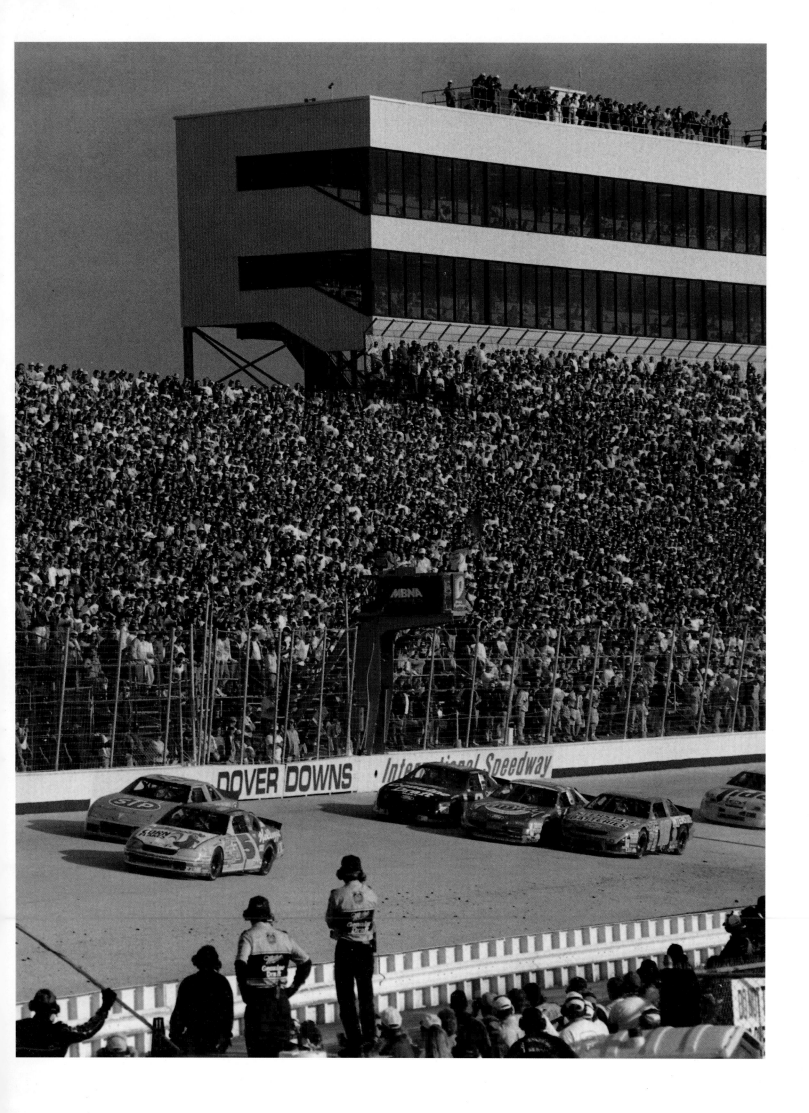

OPPOSITE: The rain has stopped. Dover racetrack, bulging at the seams, unlike a few years ago. **They're running three abreast at 150 mph on the front straight-away.** Someone will have to give when they get to turn one, where there's only room for two-wide. Someone has to back out, either the outside or middle car. The inside car is in the groove, where he has the best chance of maintaining his speed. RIGHT: Some fans like to talk to the TV personalities. They think it will get them on camera, and sometimes it does. It's great the way the fans have accepted me as a commentator. I'm sure half of them don't even know I used to drive, but we do remind them from time to time.

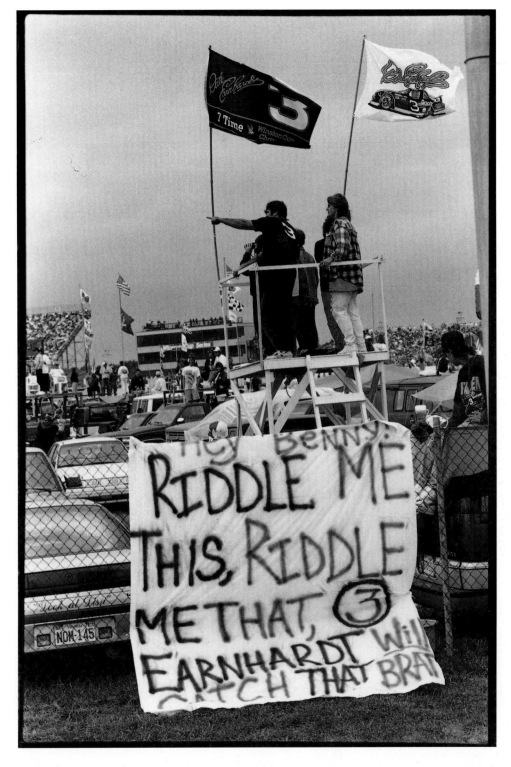

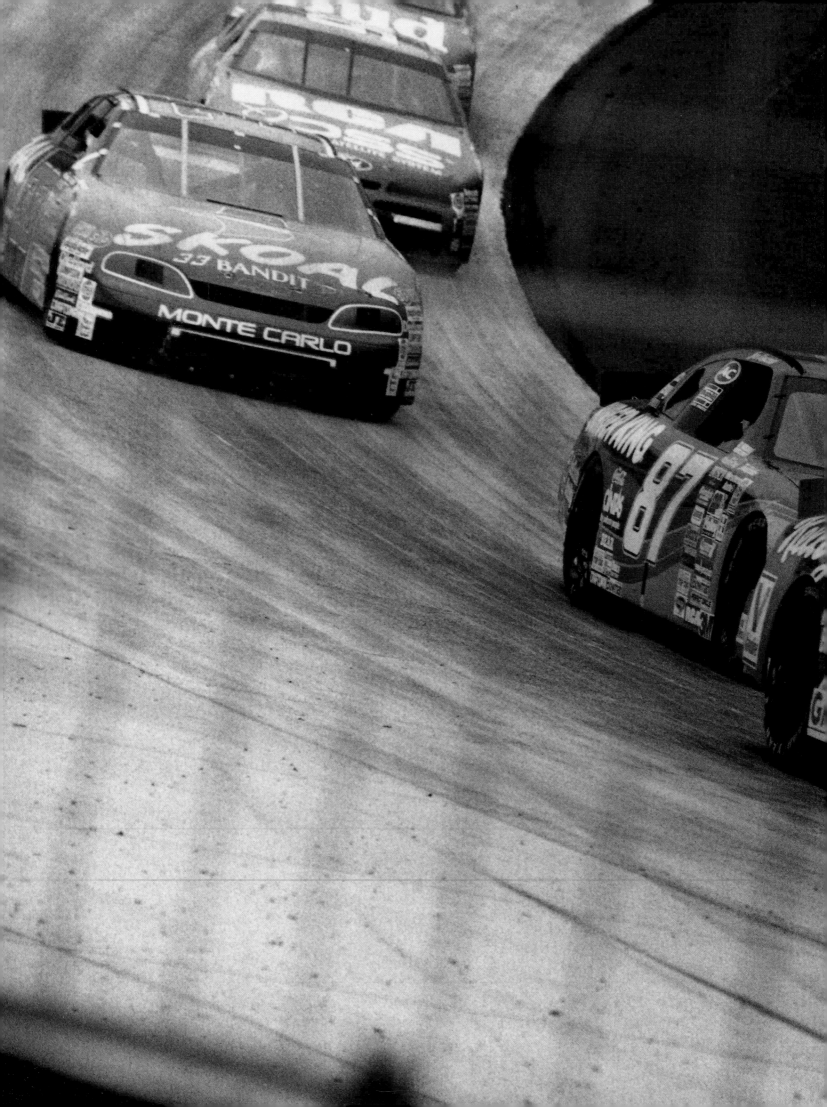

Turn two at Dover's Monster Mile. They call it that because there is a car-eating monster at Dover. You're traveling awfully fast, and you come off the corners a little blind. Especially at turn two. If something happens in front of you, good luck. **The Monster comes up and grabs you, eats you alive.** Dover's Monster has eaten a lot of race cars.

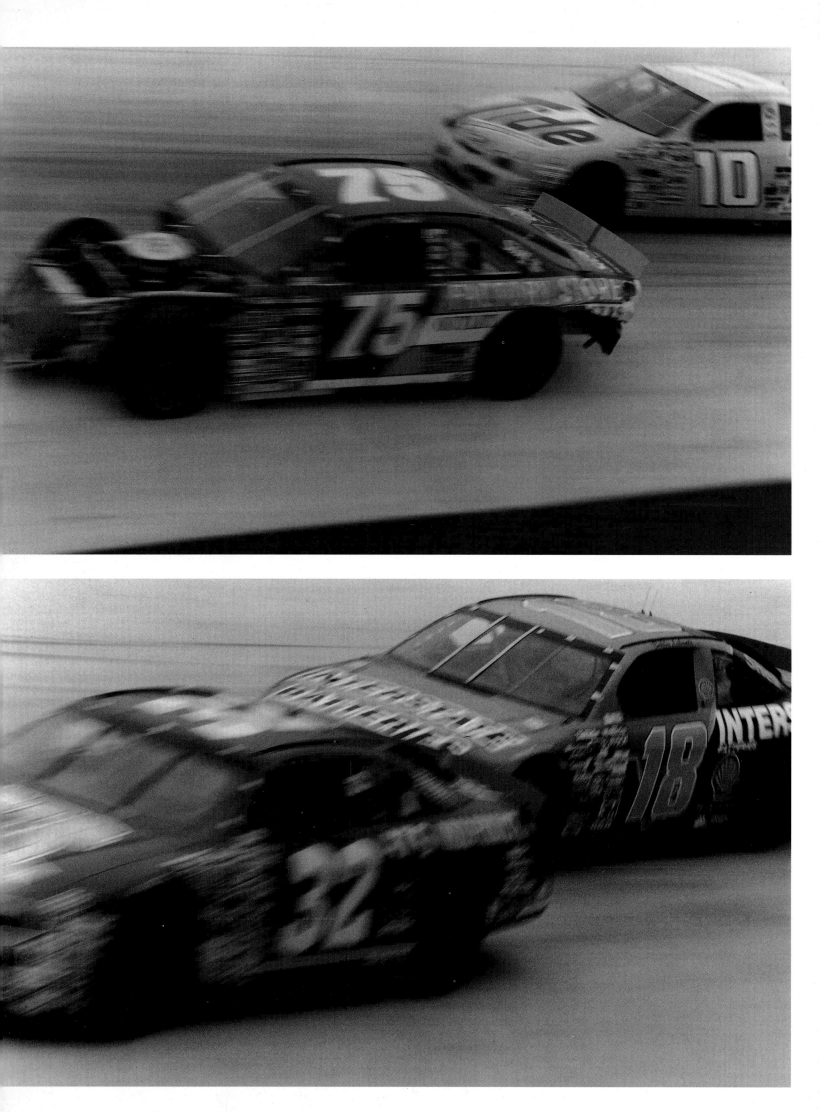

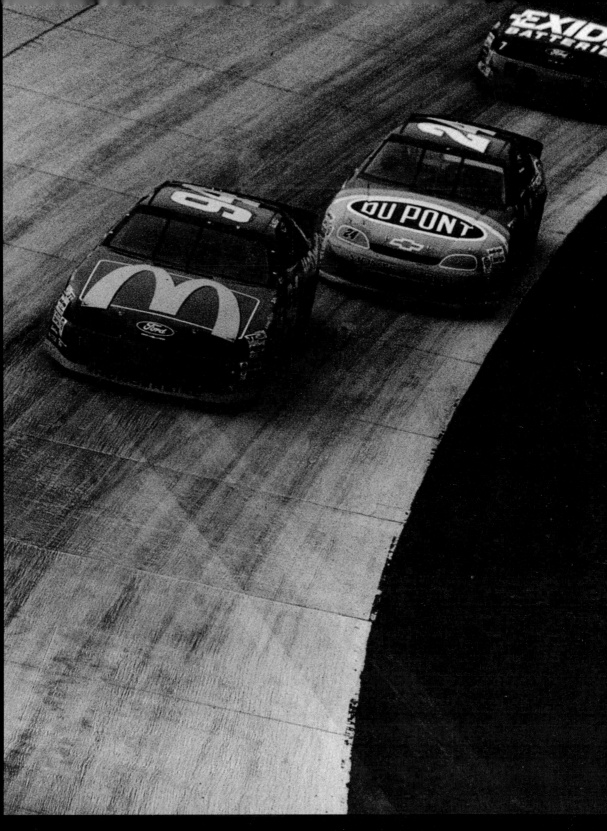

OPPOSITE TOP: Todd Bodine in #75 driving without the hood. He must have lost it during the day. But he's still out there, because every car he can beat gives him three to five points toward his overall total. OPPOSITE BOTTOM: Bobby Labonte in #18 overtaking the #32 car. The #32 car will hug the inside and let Labonte pass, which is the gentlemanly thing to do. ABOVE: The groove, the fastest line around the track, is always painted blackest by tire rubber because of its popularity. Bill Elliott in #94 is two or three feet high of it. Jeff Gordon in #24 is on the low side. No doubt they're out of it for good reason. Jeff is very tight on Bill, attacking, and Bill might be trying to shake Jeff out of his draft, that magic spot where the trailing car gets a free, aerodynamic pull that can help him pass. They'll both be

back in the groove soon.

You can't win without being in it.

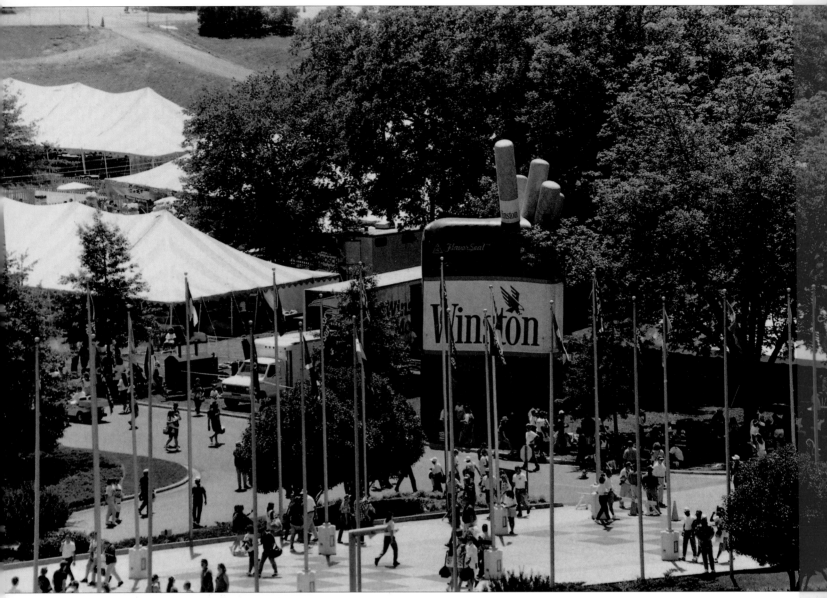

ABOVE: The entrance to Charlotte Motor Speedway. The giant inflatable pack of Winston cigarettes is front and center for good reason. Several cigarette companies—Winston in particular—came into motor racing in 1970 after they agreed to stop advertising on television. Their appearance was timely. The big car companies had withdrawn sponsorship, and the sport was struggling to make ends meet. Winston started the NASCAR Grand National Series and the Winston Cup in 1971, dumping some of that television money into NASCAR and putting people in the grandstands. Tracks began paying bigger purses, the cars improved, the racing got

more competitive, television coverage took off, and the overall economic impact for cities like Charlotte has been fantastic. It's all been done with private dollars. Not a dime of tax money has been used. The name was changed to the Winston Cup Series in 1980. NASCAR would not be in the shape it's in today without their help. It's been a good marriage. NASCAR probably couldn't accept Winston as a sponsor today, given the pressure being brought against big tobacco companies, but the grandfather clause allows the relationship to continue. OPPOSITE: Humpy Wheeler runs the Charlotte Speedway. He's the promoter, the guy who brings

this automotive circus to town and beats the drums for the fastest show on wheels. His pre-race shows are famous, like the 82nd Airborne from Ft. Bragg, North Carolina, going through a hostage rescue drill (below). The fans love to watch the military do its stuff, from helicopters at work to fly-bys of the big jets that are heart-stopping. Humpy and Bruton Smith, who owns the race track, envisioned the Charlotte Motor Speedway as the Taj Mahal of the circuit. And it is a showplace. They were first to build VIP suites in mass, increasing their numbers from three, to thirty, and now to sixty suites.

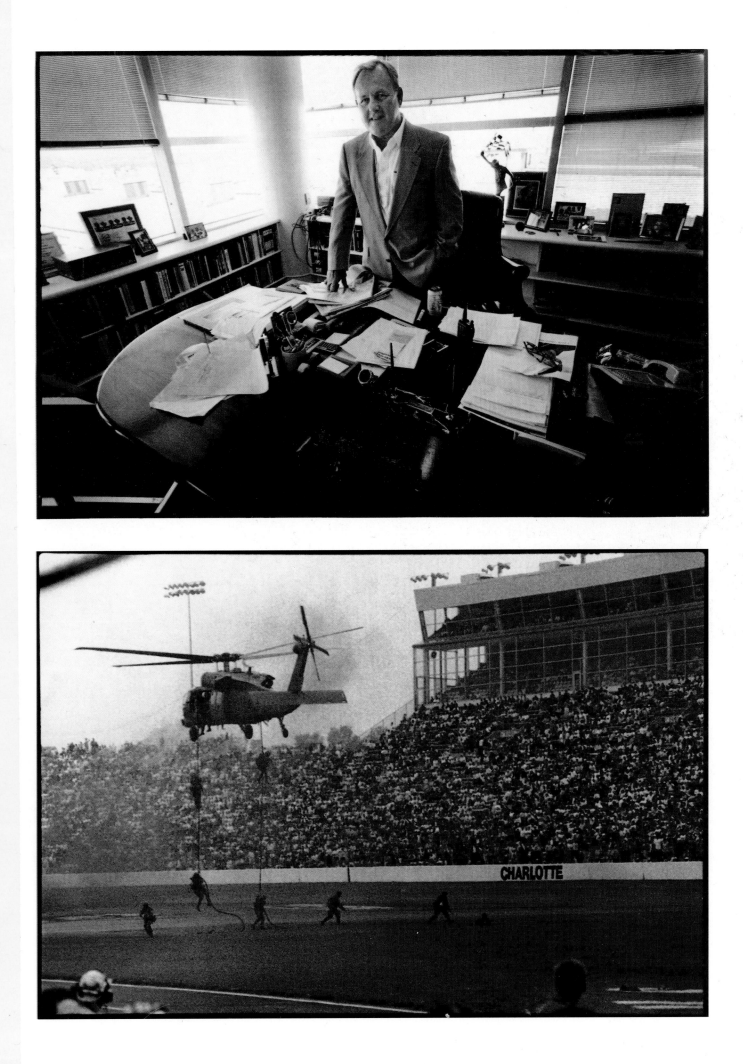

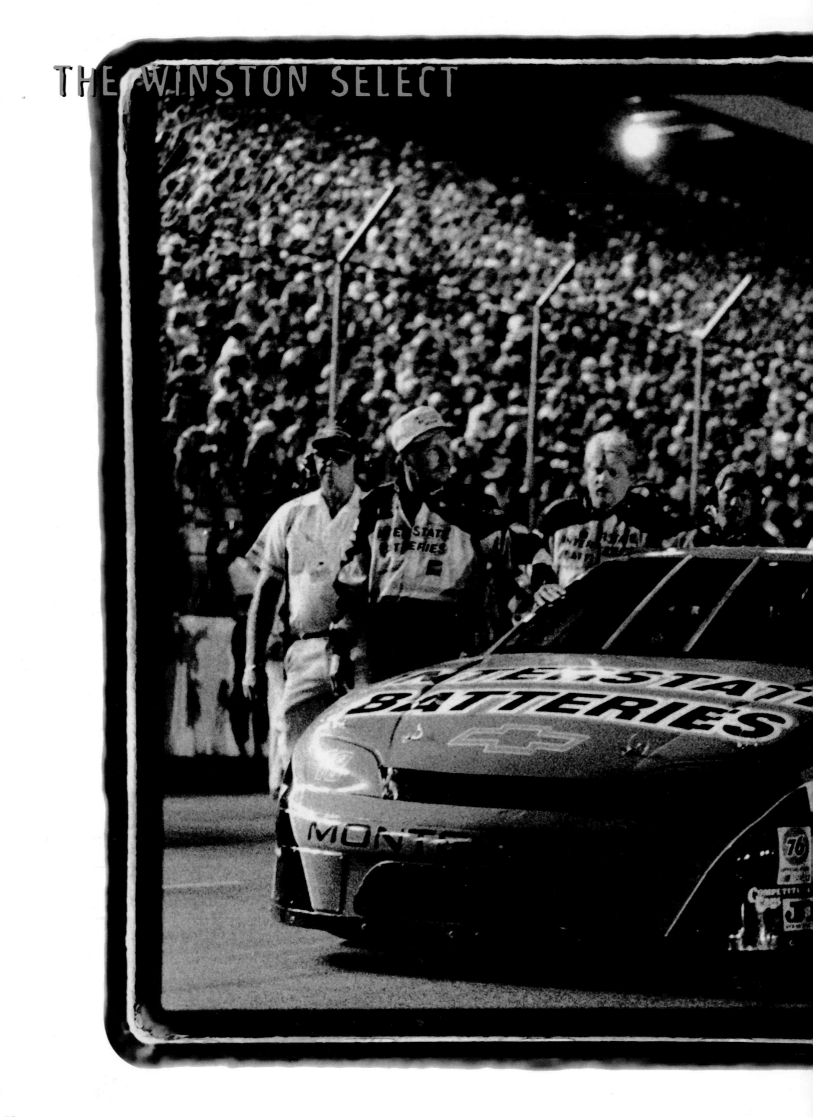

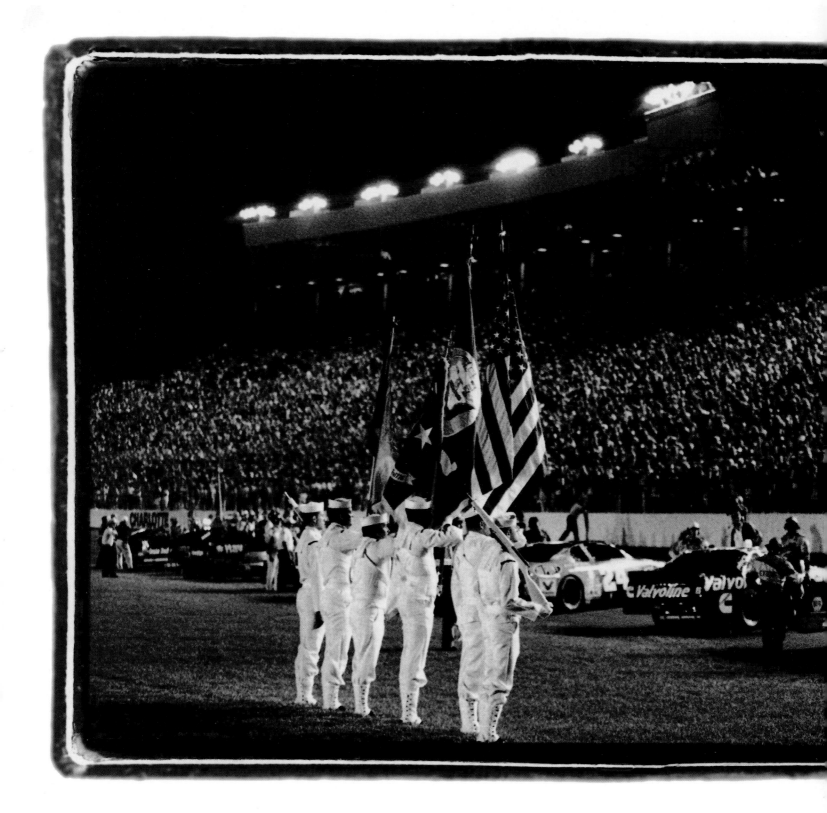

PAGES 82–83: **Bobby Labonte's Chevy is pushed to the starting line of the Winston Select, an all-star event for the top twenty drivers of the season. The cars are lined up on the front stretch, not in the pits as they normally would be, and the drivers are introduced.** ABOVE: **The introduction of the drivers is a special moment. These drivers have worked hard all year and done well. They deserve the acclaim. And right about now there's a jet fly-by that gives everybody goosebumps.**

The Winston Select is a different NASCAR format. The race is in three segments: fifty laps, twenty laps, and ten laps. The first and second segments pay a token amount of money to the winner. But those first segments are like qualifiers for starting position in the last segment, which is for all the marbles. After the first fifty laps, the field is inverted (the last car to finish starts first), the cars refuel, and off they go. After the twenty-lap segment, they refuel and then it gets serious.

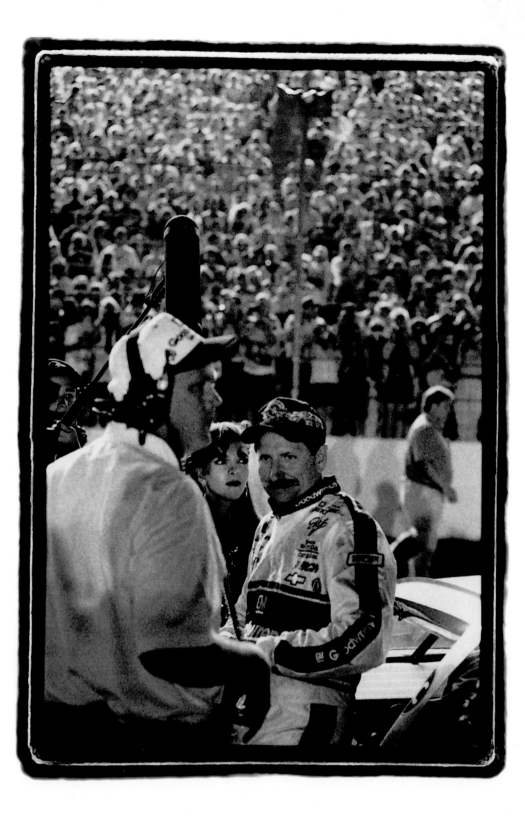

Dale Earnhardt loves the Winston Select. **Earnhardt is** probably the **greatest ten-lap** race car **driver** the sport has **ever** seen. This night he painted his car silver in honor of R. J. Reynolds' twenty-fifth anniversary of sponsoring NASCAR.

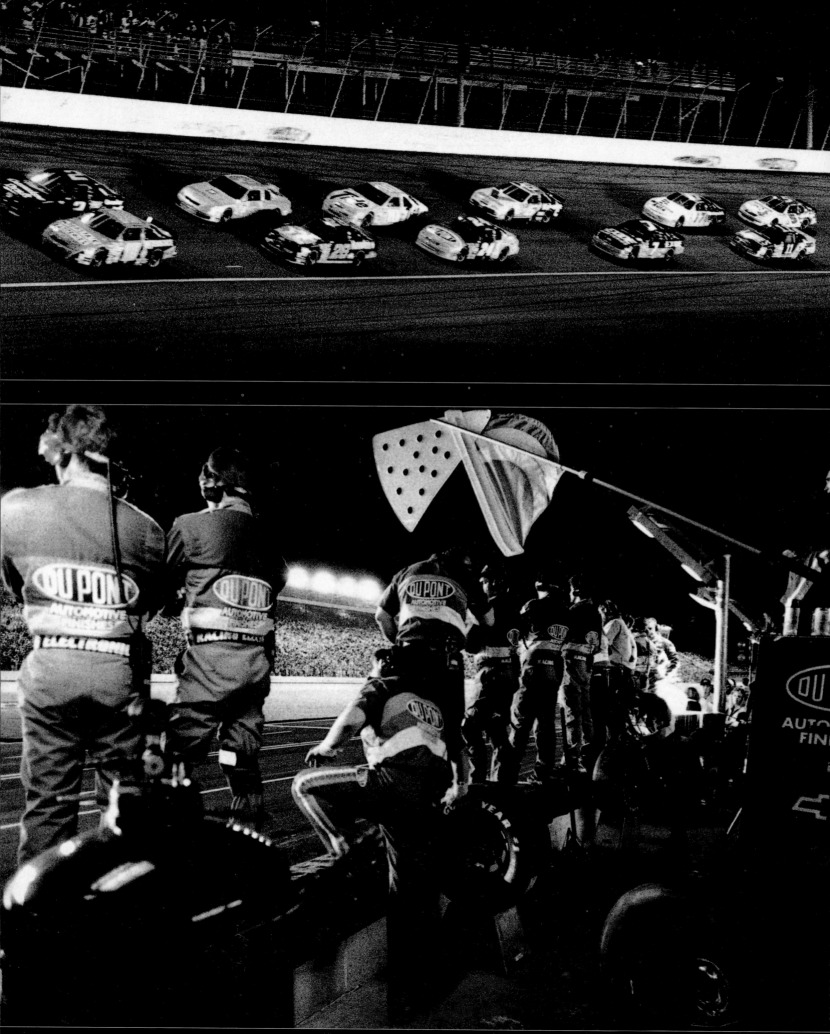

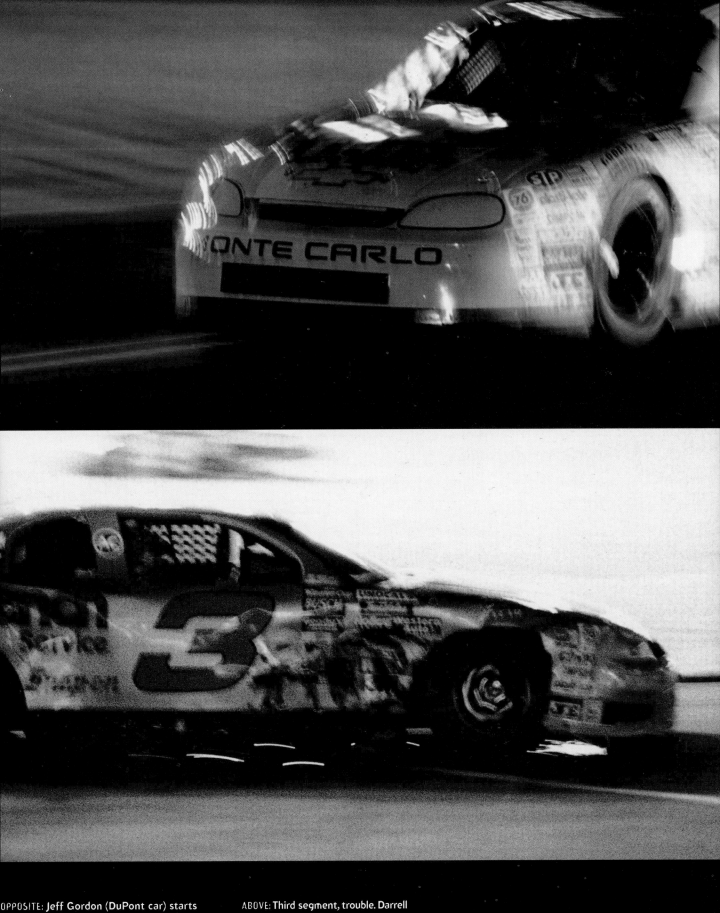

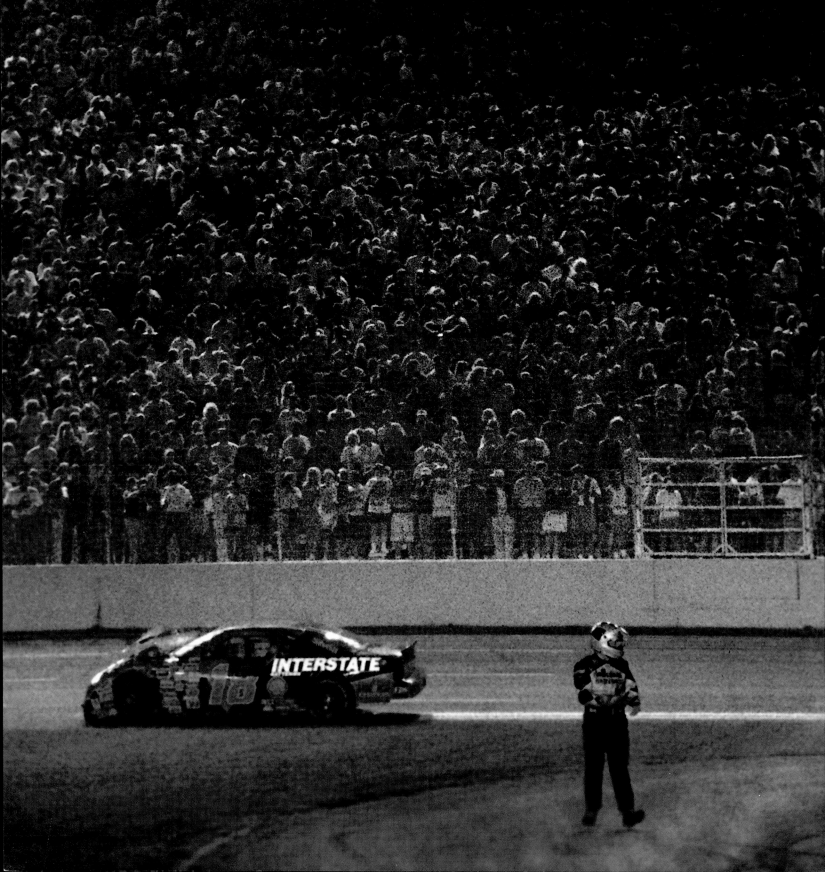

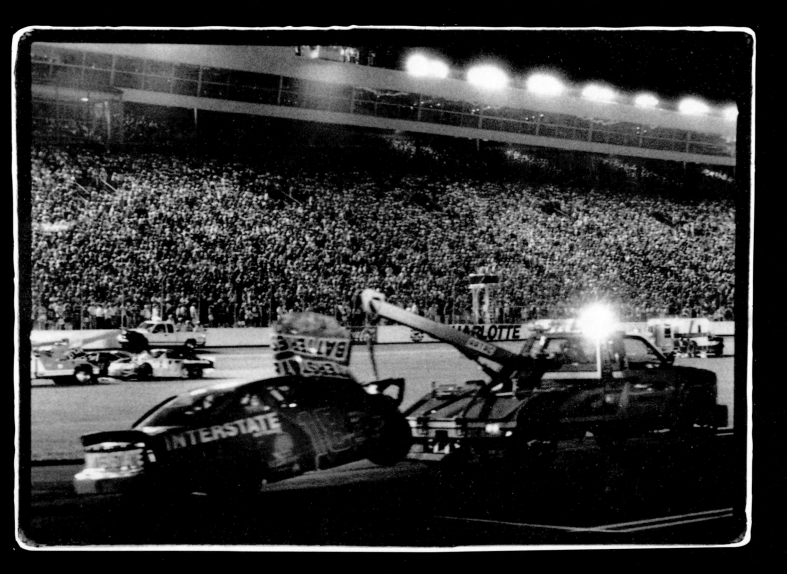

OPPOSITE: **Bobby Labonte couldn't avoid the wreck. He walks away, but he isn't happy.**
ABOVE: **Three cars ended up in the wall. That's Labonte's #18 going back to the garage behind the wrecker, never a good sign. In the background, Waltrip's car is also being hooked up. And the ambulance is over near the start / finish line to pick up Waltrip, who suffered a few broken ribs. Broken ribs are bad. They remind you of what happened for a long time.**

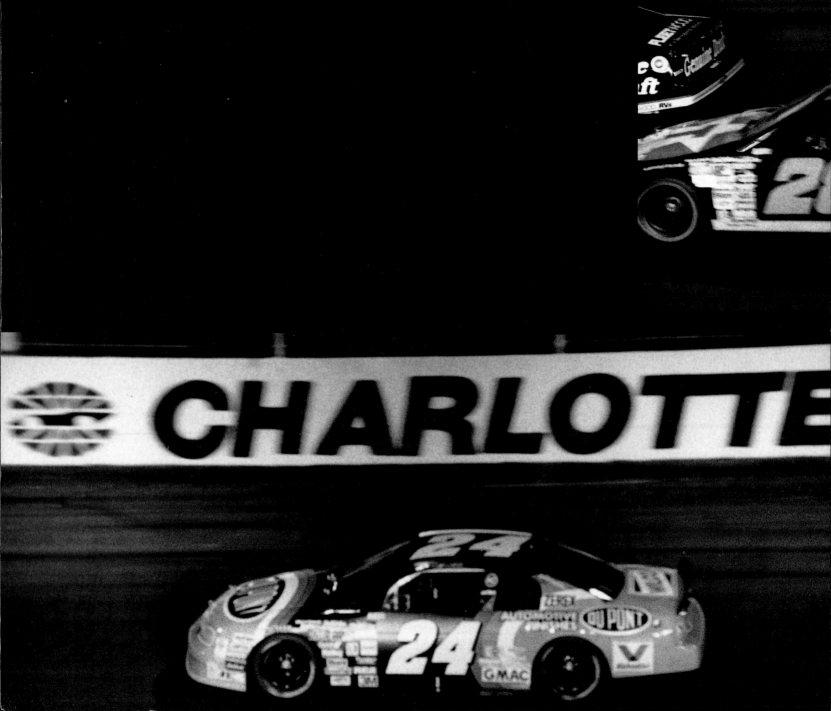

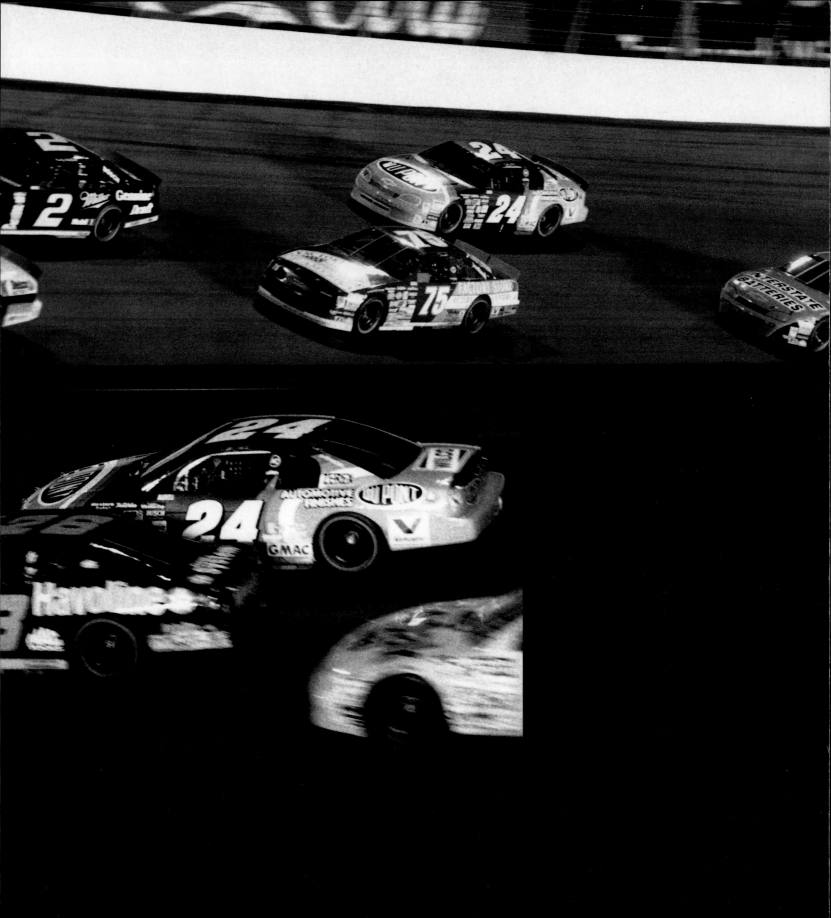

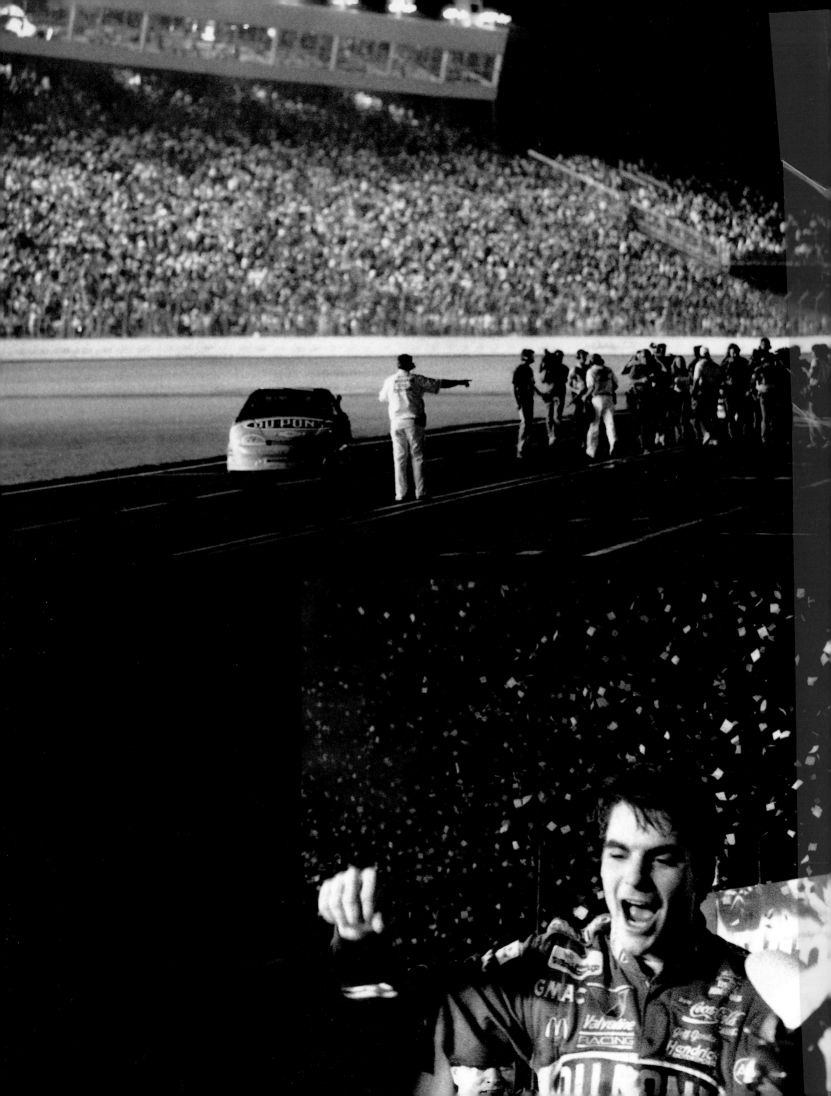

It's Victory Lane for Gordon after a clean sweep of the night. He pulls in to the joy of his crew standing by on Pit Road, ready to give his car a slap as he goes by. He looks happy as the confetti comes down on him, and he should. His night's work is worth $300,000. That brings his season earnings to $4.3 million, including the championship. Gordon (right) in Victory Lane with the trophy, a photo opportunity.

In 1973, when I won it, the Winston Cup Championship was worth $71,000. Today's championship is worth $1.5 million. The combined driver earnings in 1995 were $45 million. That's a ten-fold increase in seventeen years.

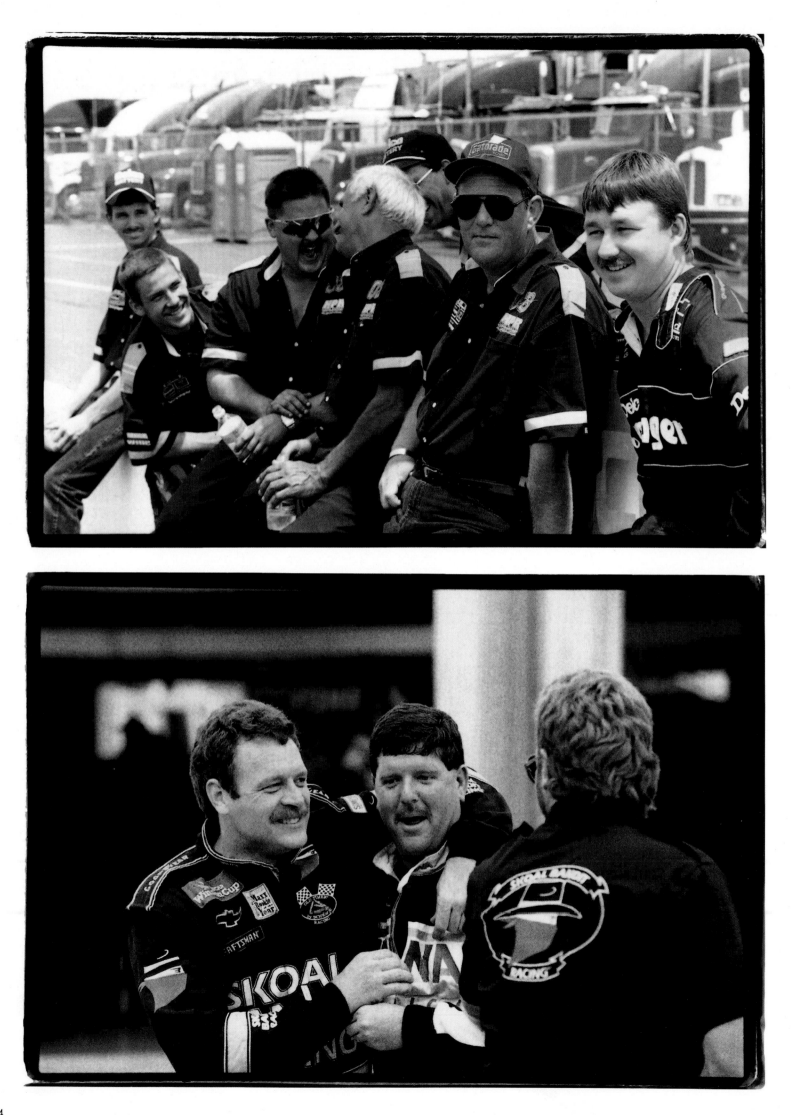

The drivers' fraternity is tight.

Crews too, but especially drivers. Theirs is a small group—maybe 100 total with backups—participating in a dangerous sport. They are a bit like fighter-jet jocks in one of those exhibition teams that fly close-formation aerobatics. Winston Cup drivers aren't going 400 mph, but they are flying low within inches of one another. If they all weren't very good at what they are doing, none of them would survive. They all know that. Their lives and limbs are in each other's hands. So underneath the competition there is a strong, mutual respect.

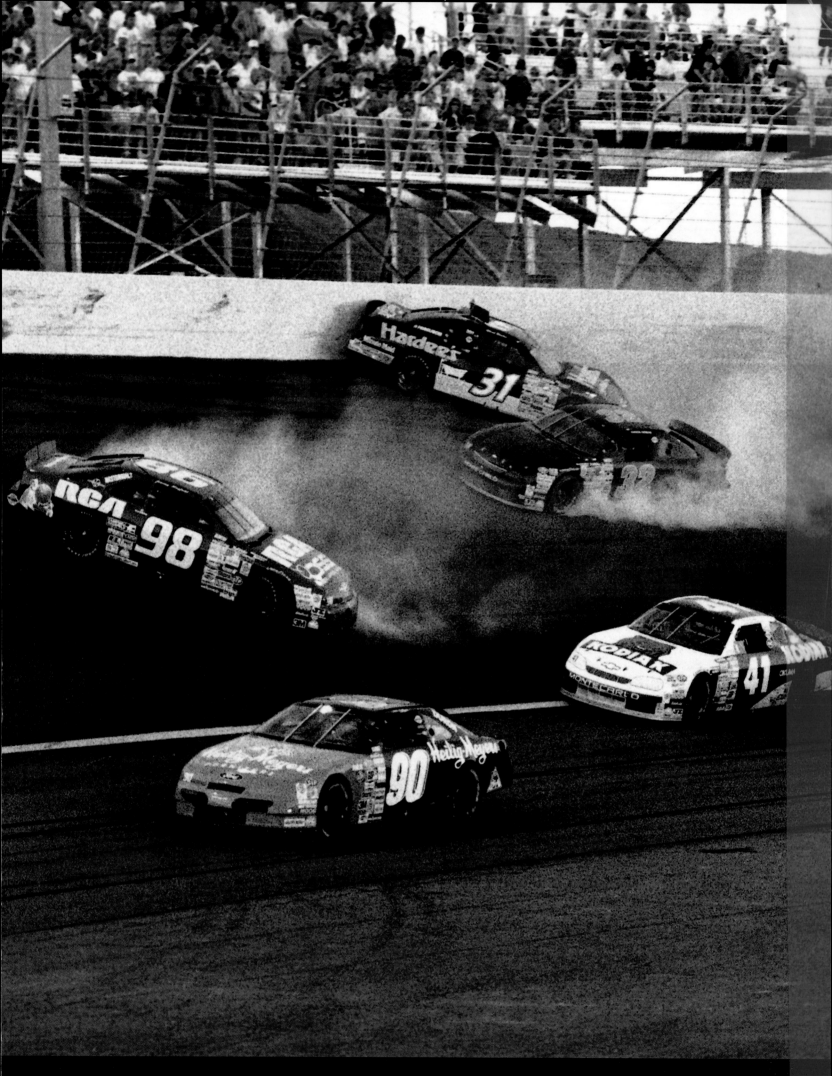

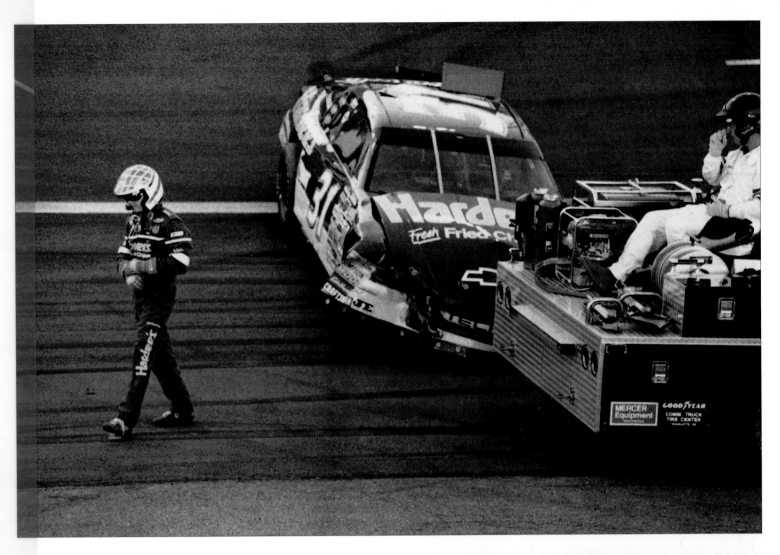

OPPOSITE: A multiple spin in the support race prior to the Winston Select. Note the flap sticking straight up on the roof of car #31. NASCAR required teams to install roof flaps after Bobby Allison blew a tire in 1987 at Talladega. Allison's car cleared the barrier and went into the catch fence. The cables held and bounced the car back on the race track. NASCAR's investigation showed that when a car is going sideways at 90 mph, air passing across the trunk, roof, and hood creates lift. Roof flaps counteract lift, forcing the car to stay on the ground. ABOVE & RIGHT: The price of hitting the wall: flat tire, bent wheel, front end damage. Wrecks are the bane of a crew's season. Not only can't you finish the race and get in the money, you can't prepare for the next race because of the time spent repairing the car. It's very time-consuming. And expensive. A team typically starts the season with ten cars. But to run the intermediate tracks of a mile or more—and those races make up 50 percent of the schedule—you only use two or three of the cars. So if you wreck at Charlotte, that car has to be made ready for Dover, or Pocono, a couple of weeks away.

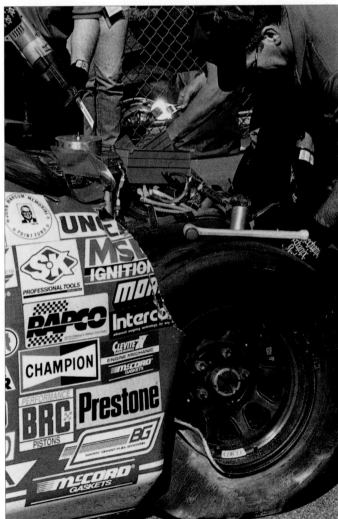

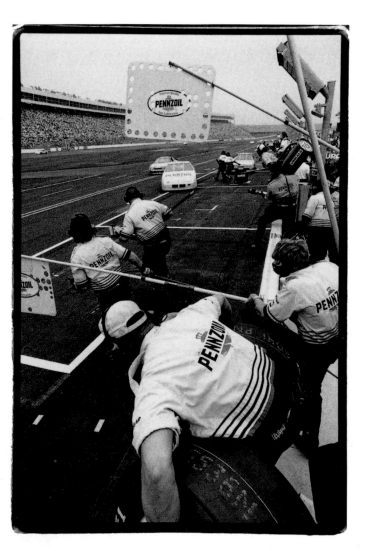

Crashing isn't the only way to lose a car. Michael Waltrip in the Pennzoil Pontiac is running fine, out there with a chance to win. He comes in for a routine pit stop (left), then a couple laps later, the trail of smoke indicates something in the engine has broken. He pits again, and the look on his face tells the whole story. Nothing to do except trudge back to the garage and spend some solitary time in the transporter lounge feeling low. The transporter is the trailer that transports race cars and spare parts from one race to another. The front part is set aside as a lounge for the team.

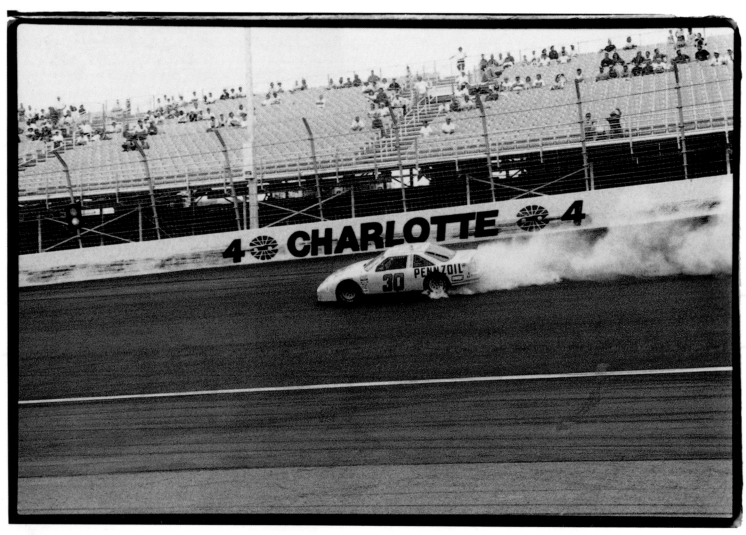

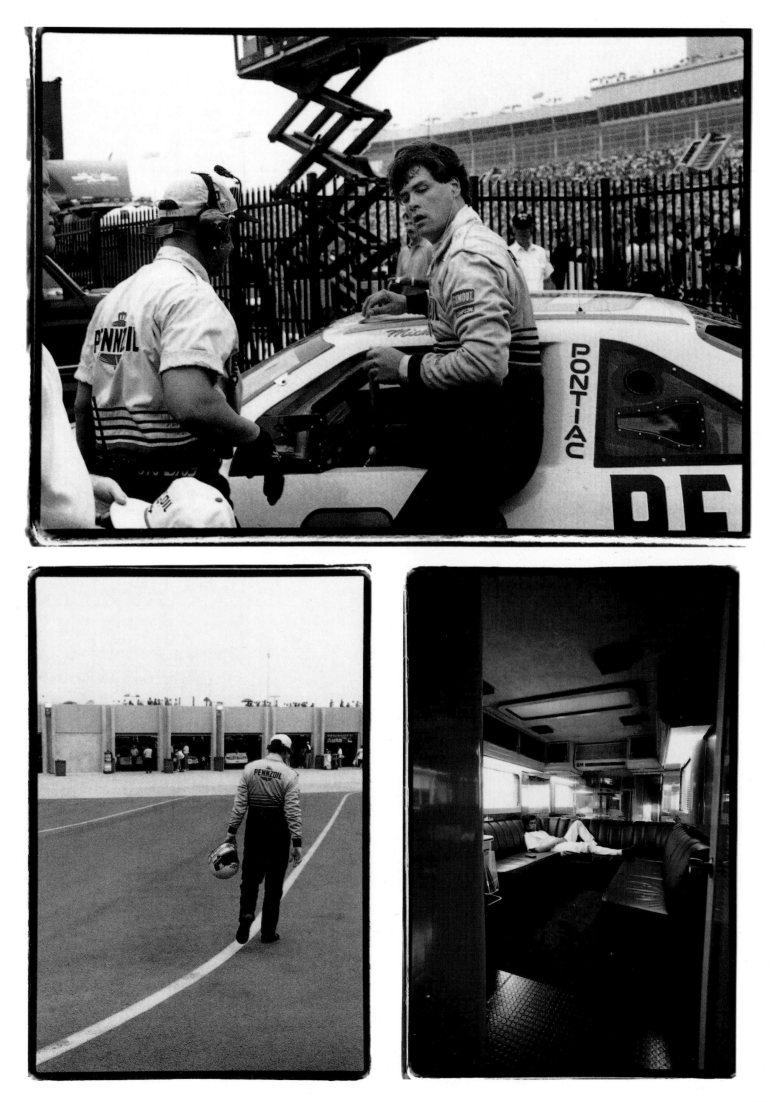

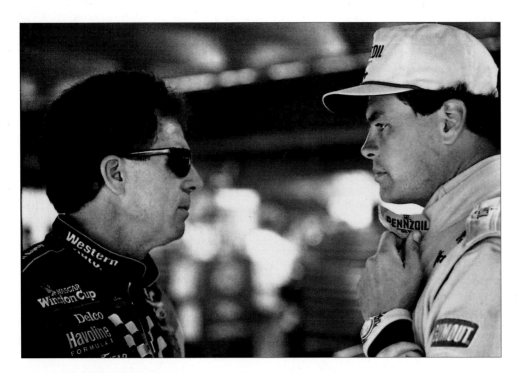

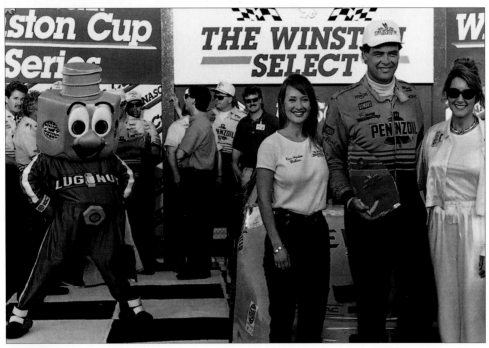

TOP: The brothers Waltrip. CENTER: Michael Waltrip, who has qualified first, for the "pole" position, in the Winston Open (1995) in Victory Lane, flanked by Miss Winston (left), and his wife, Buffy (right). Behind him, his crew shares the moment, while track mascot "Lugnut" looks on. BOTTOM: The Michael Waltrip Pennzoil point-of-sale, life-size likeness with seven of the fifteen cars at the flesh-and-blood Waltrip's disposal. The lineup is in the 40,000-square-foot Pennzoil shop located in Mooresville, N.C. The car is owned by a company called Bahari. The obvious sponsor is Pennzoil.

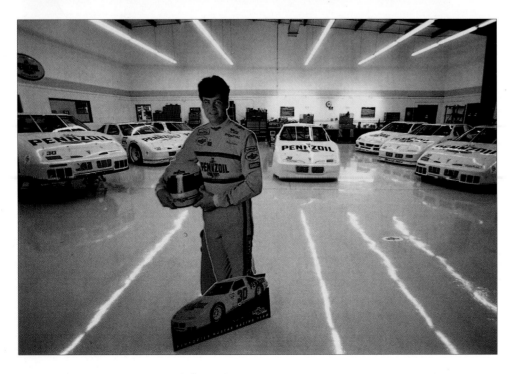

TOP: A racing engine on the Pennzoil dynomometer, where it can be run at 8,000 rpms to determine horsepower and check for fluid leaks. BOTTOM: With the metal off, the side-cage is revealed. The drivers are very well protected, especially if the contact is glancing and they keep moving as they receive further impacts. Sudden stops like head-ons or end-to-side "T-bones" are when drivers can get badly hurt. The gas tank is rubber so it doesn't rupture easily in a collision.

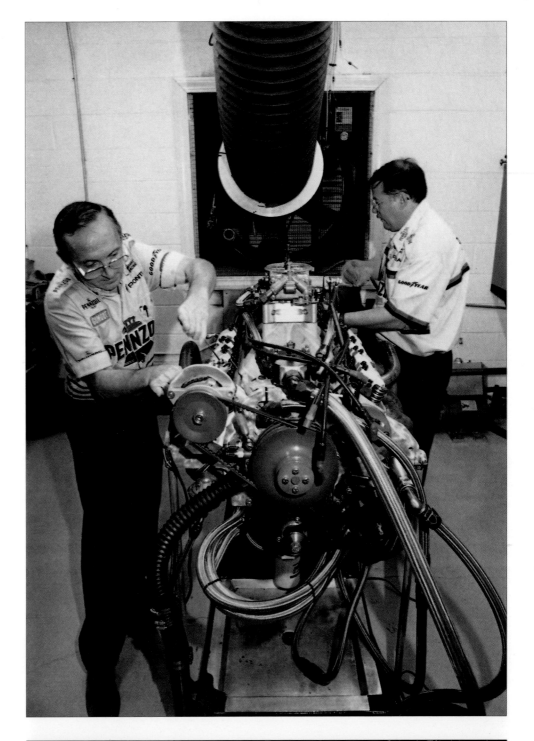

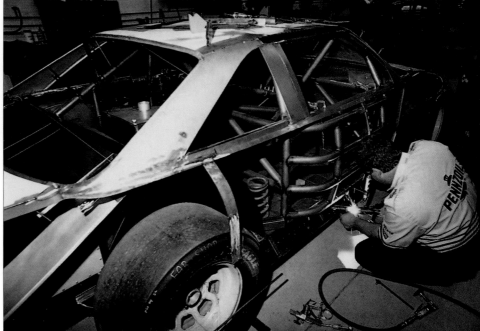

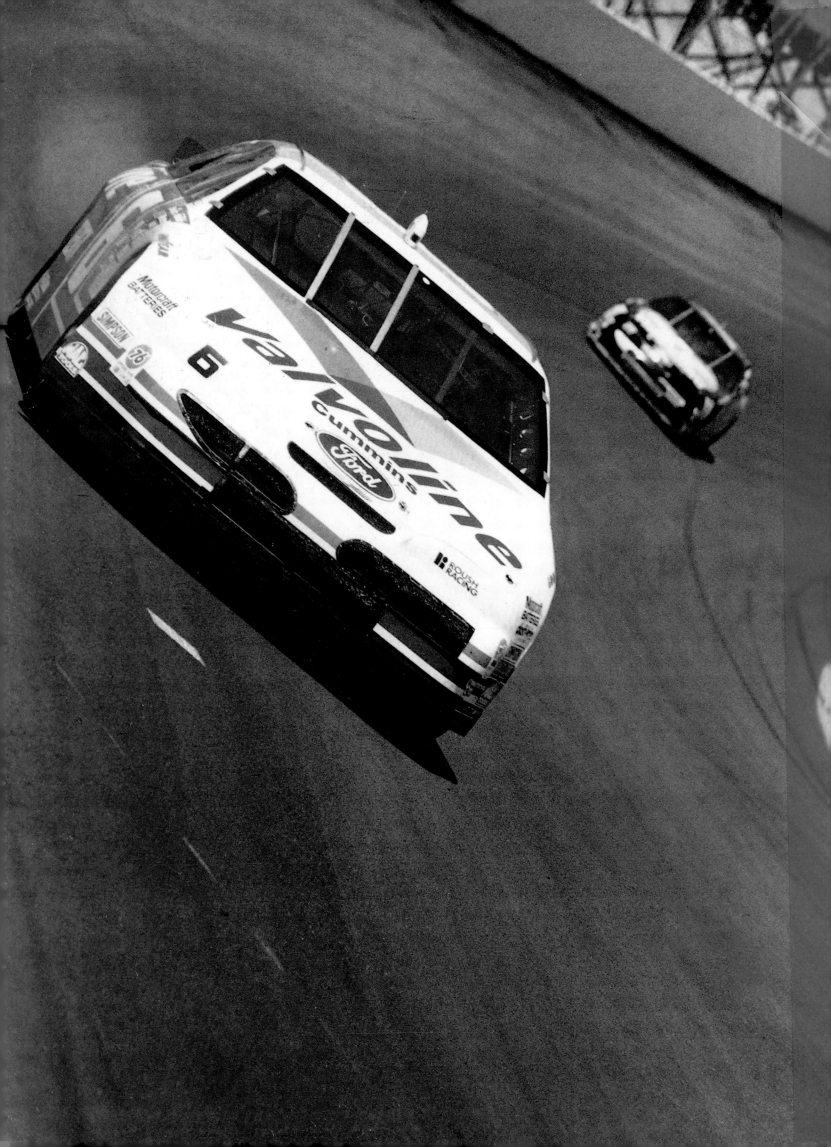

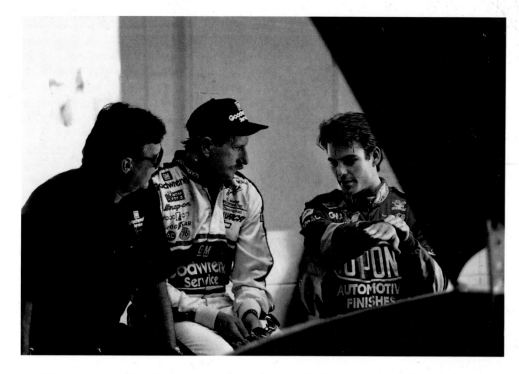

OPPOSITE: Mark Martin's car **coming at you at 175 mph out of a corner.** The little nub on the roof is a small TV camera that puts the viewer on board. RIGHT: Jeff Gordon replays a moment on the track for Richard Childress (left) and Dale Earnhardt. Handcuff a race car driver and he can't talk. Jeff is probably driving the car in the back. (I always use my left hand for my car.) Dale and Richard are paying attention because they also drive Chevrolets and maybe they can learn something from the point Gordon is making. BELOW: Owner Joe Gibbs (in glasses and Chevy cap) with driver Bobby Labonte (finger raised) in Victory Lane. Gibbs has helped auto racing immensely. In January he won the Super Bowl with the Washington Redskins. A month later he was in Daytona as a Winston Cup car owner. Gibbs, a Hall of Fame coach, has always had a love for the automobile. When Joe began talking about leaving football and going racing, Norm Miller, head of Interstate Batteries, offered him a sponsorship. Gibbs built a team and won the Daytona 500 with Dale Jarrett, the Coca-Cola 600 with Bobby Labonte. Football or cars, it doesn't matter. Joe Gibbs knows how to win.

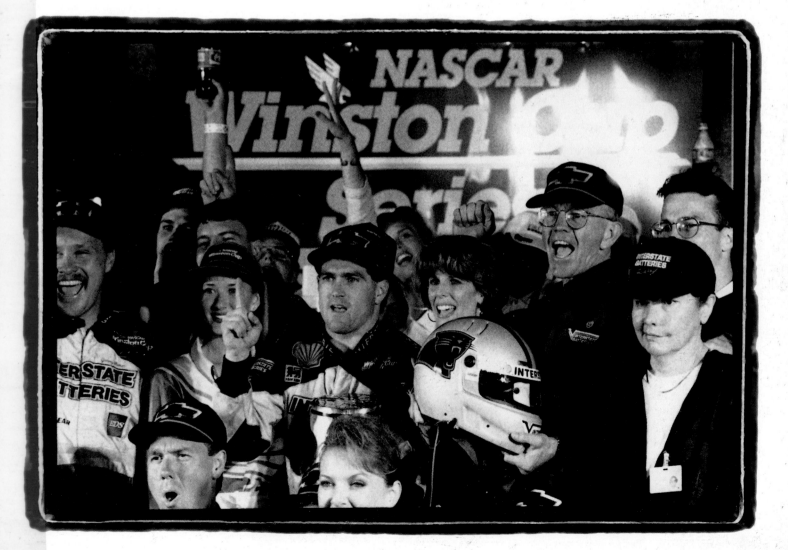

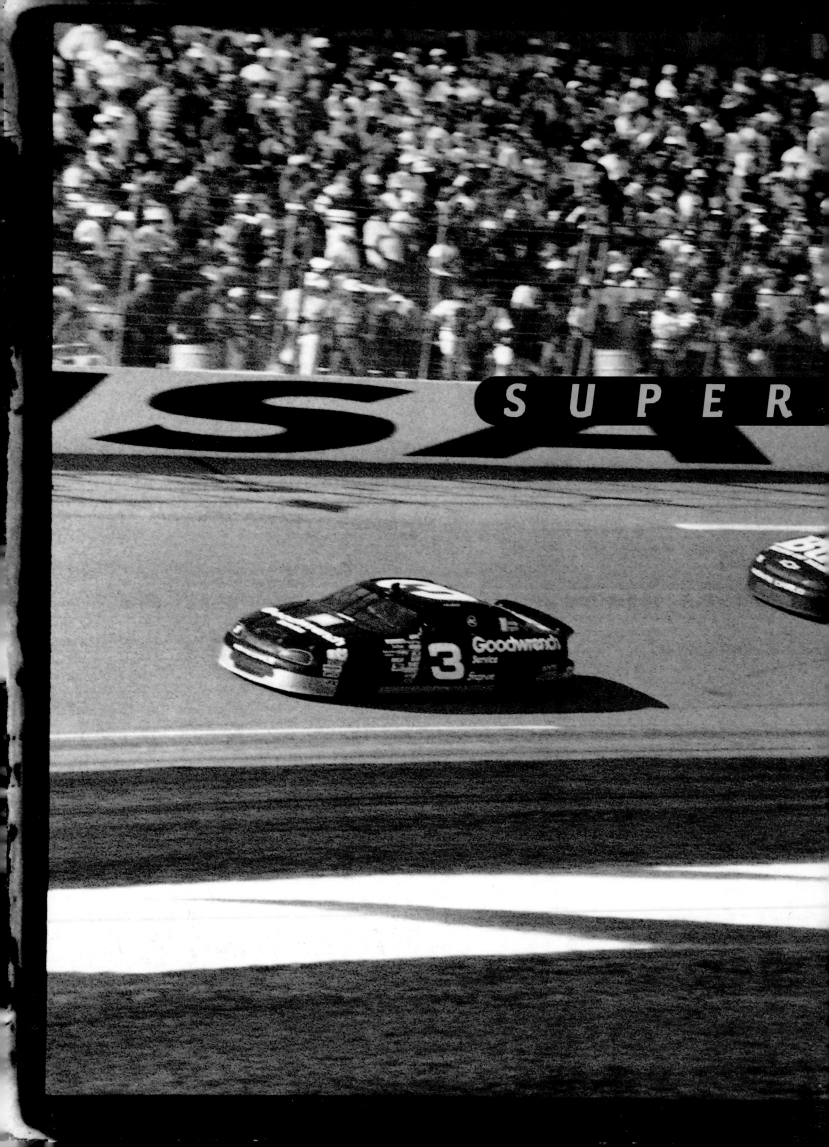

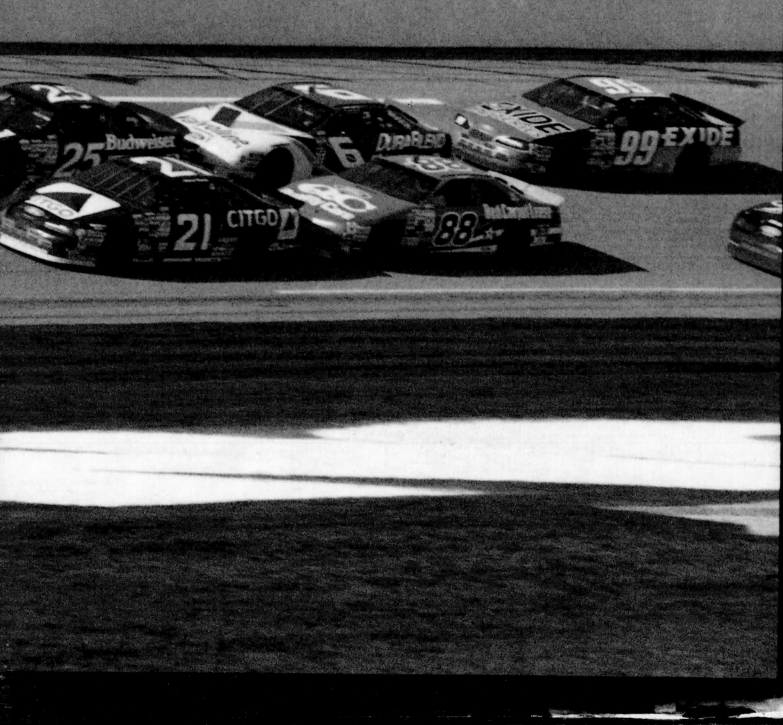

SPEEDWAYS

There are two super speedways, Daytona and Talladega. They call Daytona International Speedway the birthplace of speed. Indianapolis takes issue with that because racing at Indy began in 1909. But it was on Daytona Beach's hard-packed sand that Sir Malcolm Campbell drove his handmade "Bluebird" to a new land-speed record of 276.8 mph in 1935.

After World War II, organized racing began on the beach. They would race 2 miles north, turn onto A1A, a paved road, race 2 miles south on A1A, and turn back onto the beach on an access corner they built. It was 4.5 miles around the odd circuit. The qualifier for those races was a timed flying mile. The cars would come past the timer wide open and keep the pedal down until they passed a second timer a mile away.

In 1959, the late Bill France, Sr., who was president of NASCAR and ran the beach/highway circuit, opened a proper racetrack. It is what we now call a "super speedway," a 2.5-mile D-shaped oval. The corners are banked 31 degrees, and the gentle curve in front of the grandstand (including the start/finish line) is banked 18 degrees. So the front stretch is really a curve. That's

DAYTONA
INTERNATIONAL
SPEEDWAY

TALLADEGA
SUPER SPEEDWAY

why drivers call Daytona a "tri-oval," because it really has three turns (six corners, technically). The back straightaway is 3,400 feet long and straight as a runway. Cars can race three abreast at Daytona with no problem.

The first race in 1959 was memorable for one reason: there wasn't one caution flag. Everyone was predicting a blood bath, because the cars were big in those days, and they were running 140 mph. But there wasn't a mishap bad enough to bring out that yellow flag. And it was tight racing. They declared Johnny Beauchamp the winner. Three days later the results were changed when they found a photo of the finish. Lee Petty won the first Daytona 500.

The Talladega Super Speedway, also a D-shaped oval, is a little longer than Daytona at 2.66 miles, and the corners are banked 33 degrees. The extra couple degrees of banking allow the cars to run about 2 mph faster than at Daytona. NASCAR's all-time qualifying speed was set at Talladega in 1987, when Bill Elliott qualified just over 212 mph. After that race, NASCAR determined the cars were simply too fast for Daytona and Talladega and mandated restrictor plates under the carburetors, and they're still used today.

Bill France, Sr., begged, borrowed, and stole to build Daytona. The state gave him the land and a lifetime tax-free deal because of the tourist attraction, but he still had no money. He borrowed heavy equipment from the state on weekends to do the work. A road engineer named Charles Moneypenny from Lucia County built the track. He was the only guy France found who would do it for nothing. UNOCAL lent France the fuel when racing started. That's why UNOCAL will always be NASCAR's official fuel. It was a miracle Daytona got built. France used to say that he was bankrupt but he just didn't know it.

Ticket demand continues to increase for the Daytona 500. As you can see on the right, Daytona is trying to accommodate more people. The top two floors will be luxury sky boxes for corporations.

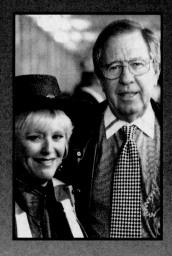

William France, Jr., president of NASCAR, with auto racing's first lady, his wife, Betty Jane. France is also president of the International Speedway Corporation, which includes Daytona, Talladega, Darlington, and Watkins Glen. Bill France continues a family auto racing dynasty.

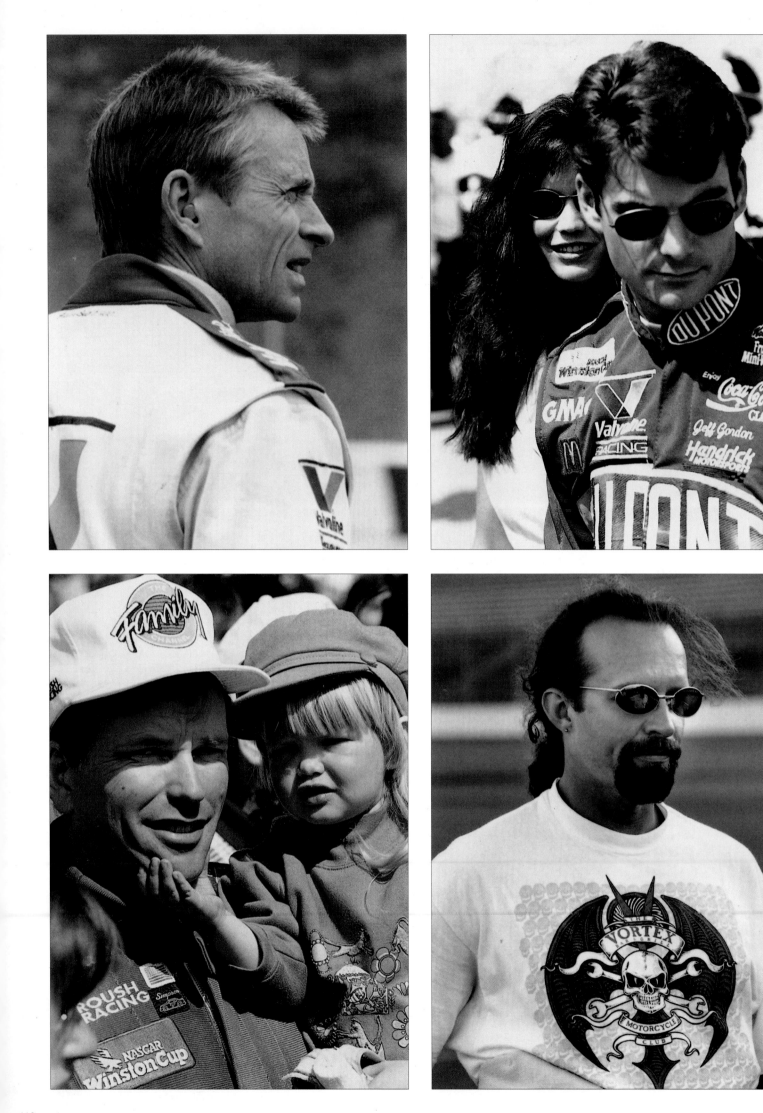

OPPOSITE: Some of the drivers you'll see racing at Daytona today (clockwise from top left): Mark Martin; Jeff Gordon with his wife, Brooke (What a fairy tale this is: A young, handsome fellow comes into the sport, wins the big ones, and rides off with a princess—better than a Tom Cruise movie); Kyle Petty; Ted Musgrave and daughter Brittany. ABOVE: Loy Allen and friend. BELOW: Sterling Marlin continues the legacy of his father, "Coocoo" Marlin, who was a driver. When you grow up around race cars and tracks and start learning how it works as a kid, you have quite an advantage.

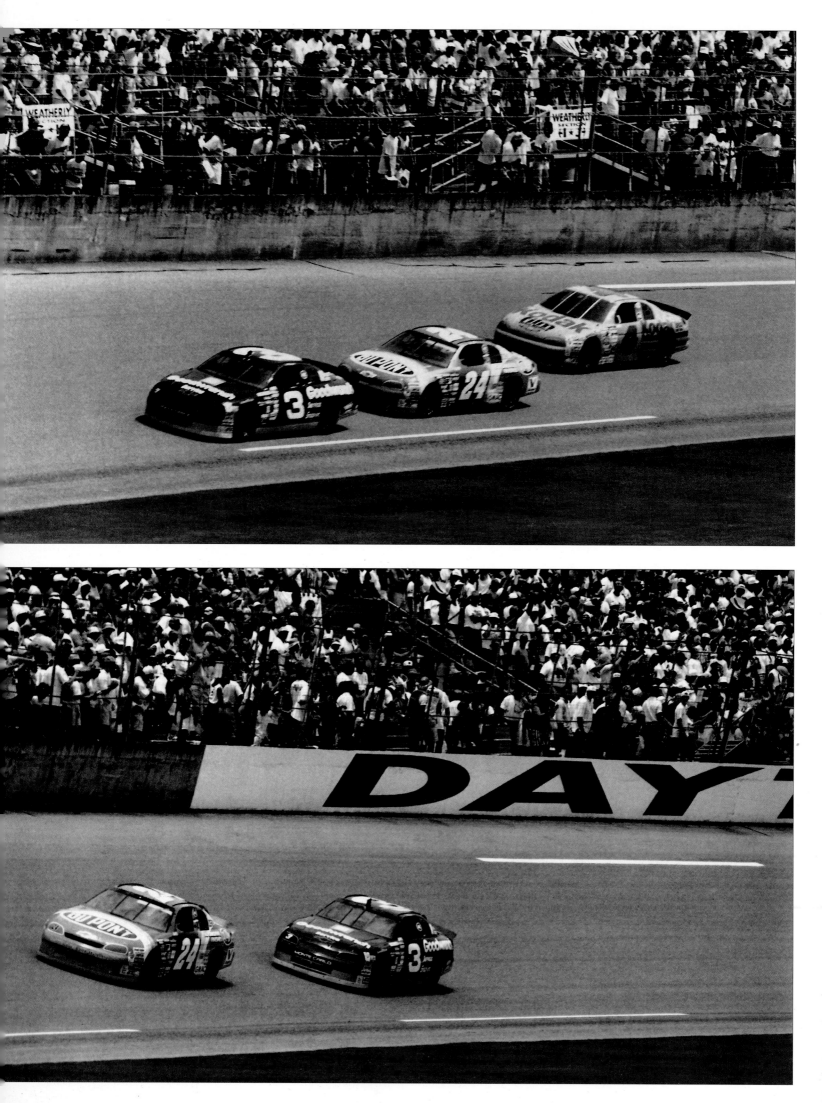

OPPOSITE TOP: "Drafting" is what super speedways are about. Get in close enough to the guy in front, and you're in his "draft," that spot inside the slipstream where his airflow eddies and pulls you along. Drafting, you can maintain speed while saving horsepower. When you want to pass, you stomp on it and "slingshot" past. Here, Gordon (#24) drafts Earnhardt (#3), and Martin (#4) drafts Gordon. Richard Petty's reputation began the day he drafted Fireball Roberts for 500 miles at Daytona, with a car that was nine miles an hour slower than Roberts.' That was back in 1962. Petty couldn't pass Roberts, didn't have the power. But he stuck to him like glue and finished second.

OPPOSITE BOTTOM: Gordon manages to pass, and will eventually win, the July 1995 Pepsi 400. BELOW: The heavy guard rail on the inside identifies this track as Daytona. When they first built Daytona, cars would occasionally spin onto the infield and end up in the lake that was created by the excavation of dirt to bank the track. One driver who was deathly afraid of water used to drive with a life jacket on. Just a couple years ago, Dave Stacy drove his Goody's Dash car into the lake. Now they have dirt all the way to the lake, guarding it from the cars. They also installed a guard rail, similar to the outside wall, near the water, to prevent cars from ever again going splash.

A pit crew at work is poetry in motion. It is one of the most exciting moments in a race, 18 to 30 seconds of pure tension. The guys are changing tires with an air wrench cranking 10,000 rpms, and the gas man is concentrating on getting the fuel in the car, and the driver is staring ahead, counting heartbeats, impatient, ready to blast off the minute the jack lets him down....The jack going down is the signal to the driver the stop is complete. Pit stops are more and more competitive, thanks in part to television, which zooms in on the action, and runs digital elapsed time on screen. The pit crews compete with one another as hard as the drivers do. They videotape every stop and study the tape, looking for ways to be faster. **The driver's fate is in the pit crew's hands several times each race.**

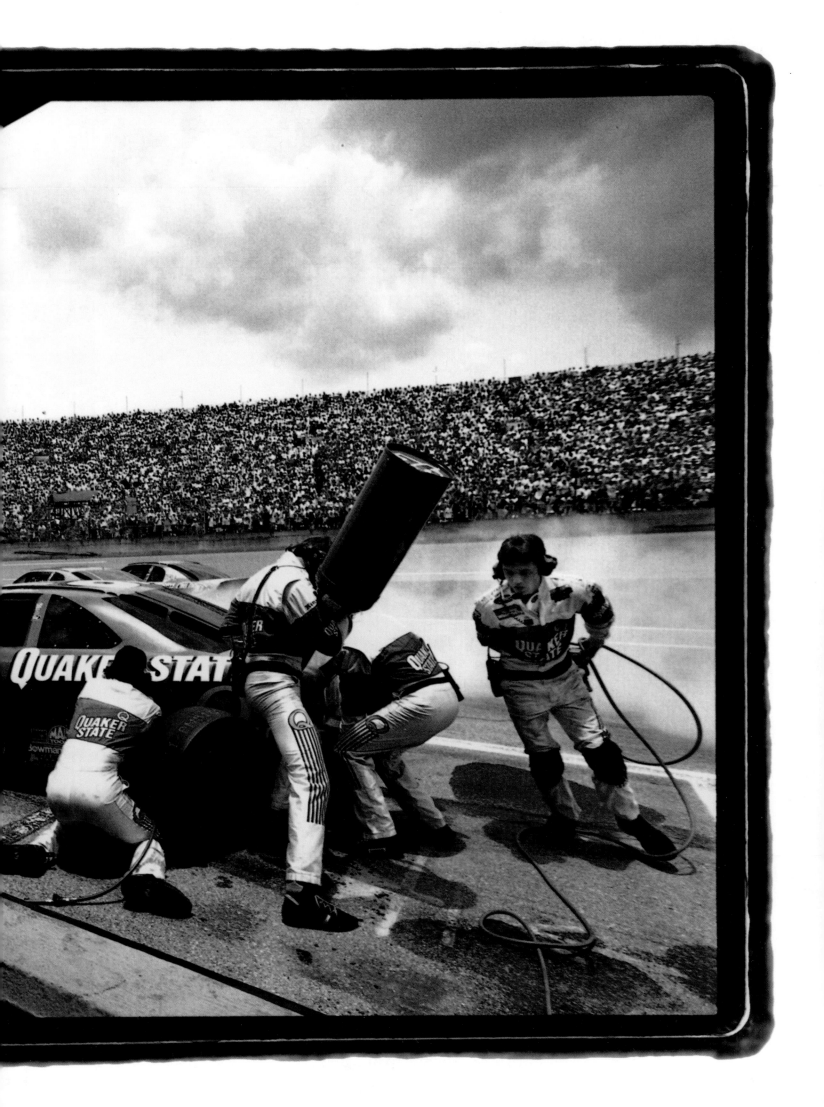

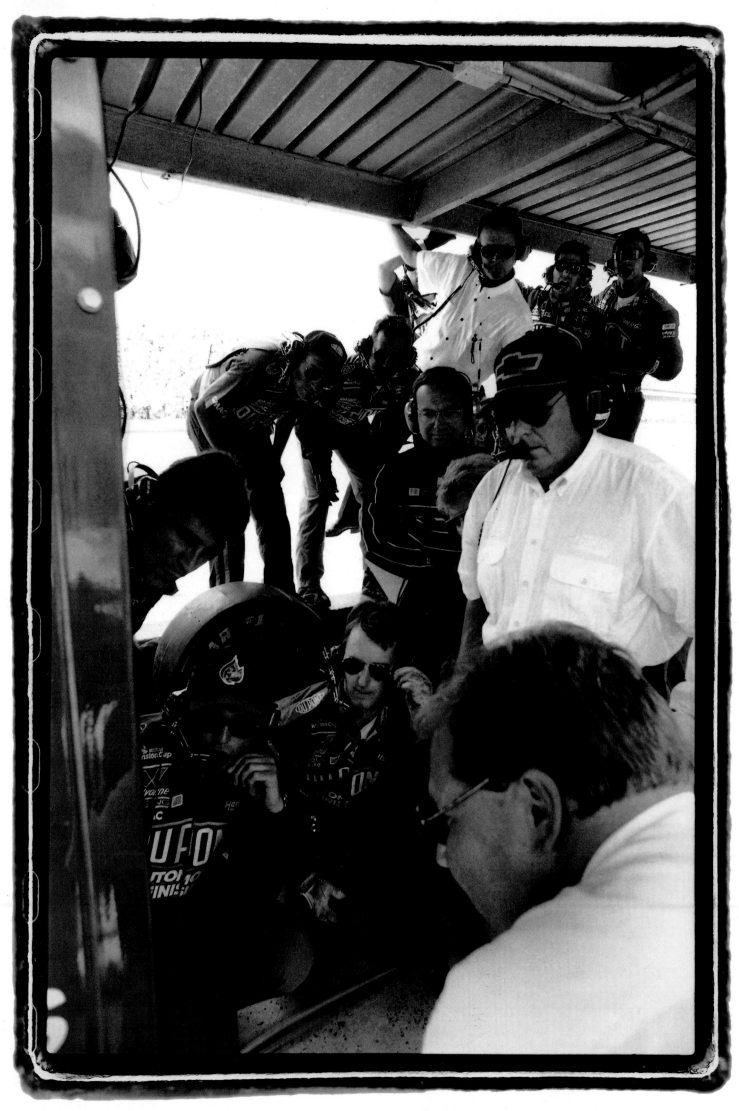

OPPOSITE: Jeff Gordon's crew at the TV monitor in the pits, where they view pit-stop videos and watch the race via satellite dish. There's one lap to go, and it's all in Gordon's hands now. Rick Henrick, in the white shirt and bowtie cap, with the intense expression, is the team owner. Everybody is intent at this point. It's not over till it's over.

BELOW: It's over, and pure joy explodes from the crew. Victory Lane, here we come. There's nothing in the world like this moment.

PAGES 118-119: Infield fans with their flags flying, awaiting the start of the 1996 Daytona 500.

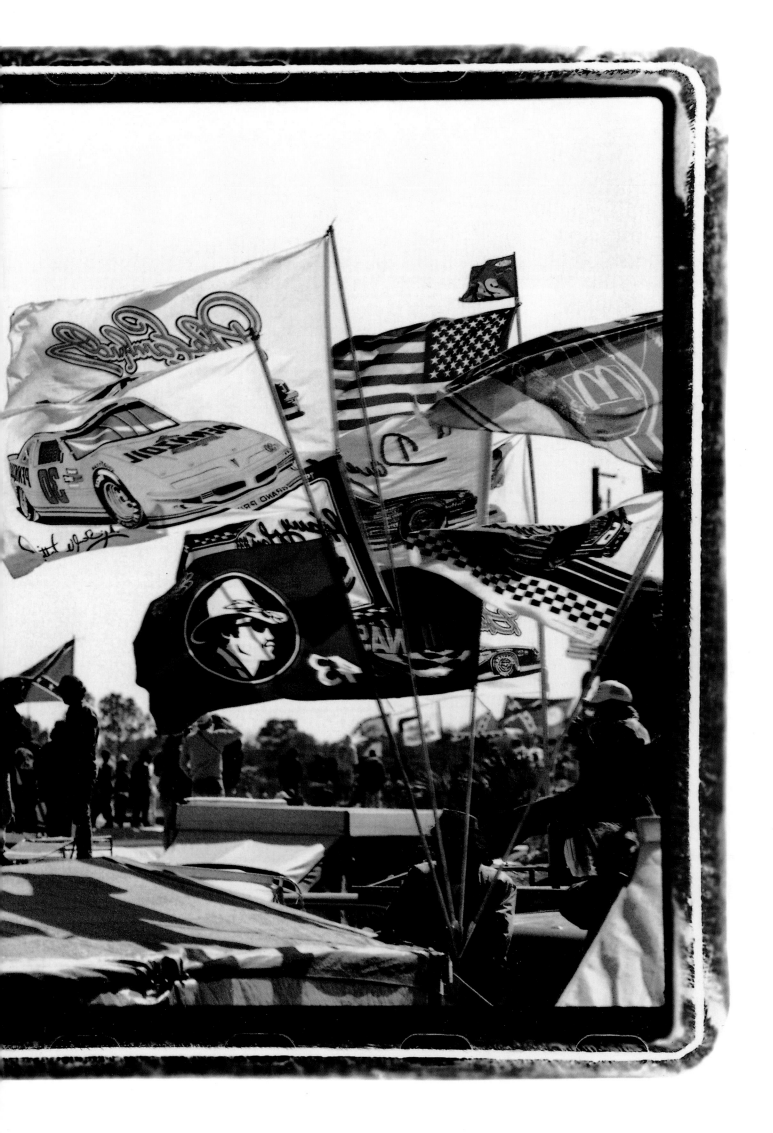

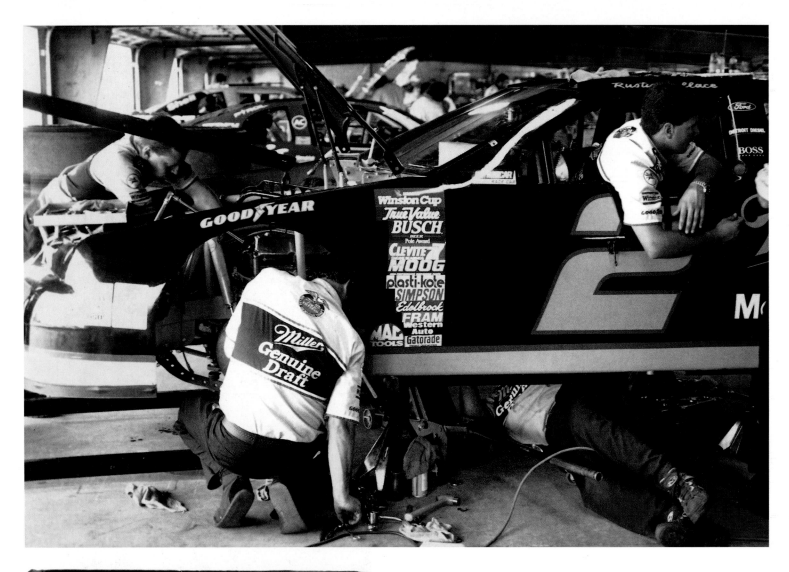

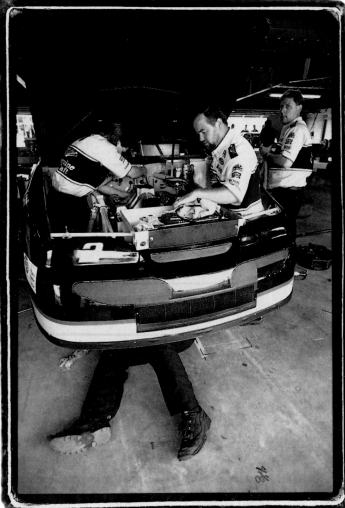

ABOVE & LEFT: The crew working on Rusty Wallace's car. Among other things, they are installing a new engine after Wallace qualified. OPPOSITE: Robert Yates—a premier engine builder on the circuit— looking like a Swiss watchmaker, making a carburetor adjustment on one of his Fords. Yates is a builder/owner now. He owns the #28 car driven by Ernie Irvan, and Dale Jarrett's #88 car. NASCAR prohibits electronic fuel injection. Only the old, reliable four-barrel carburetors are sanctioned.

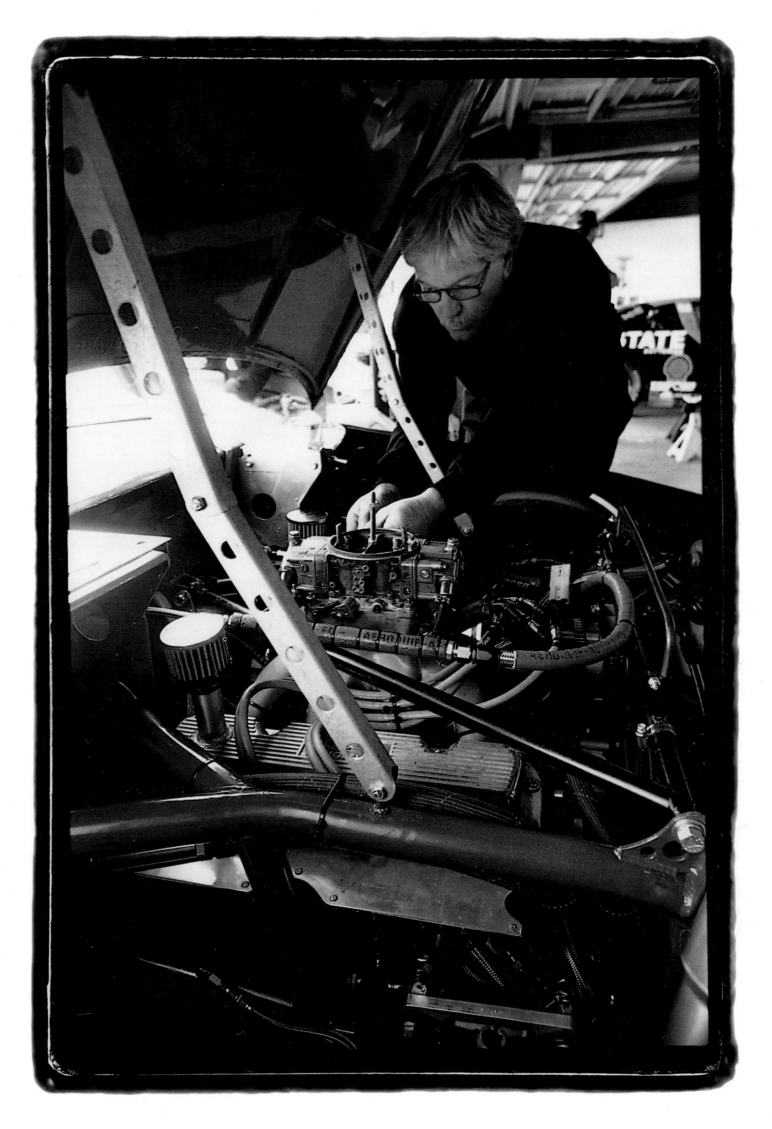

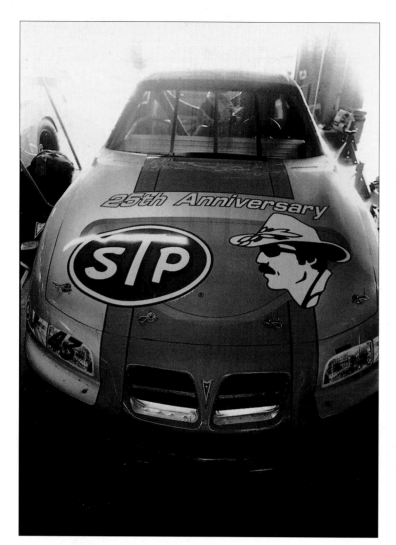

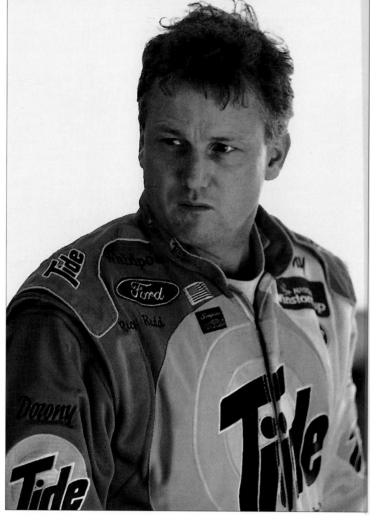

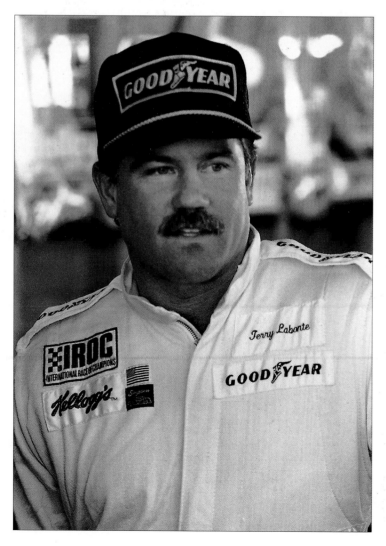

OPPOSITE (CLOCKWISE FROM TOP LEFT): **The** unmistakable profile of Richard Petty on the hood of the STP Pontiac (Petty has been sponsored by STP since they got into racing, in 1971. To celebrate their silver anniversary in 1996, STP cars wore many of the various paint jobs Petty ran with over the years); Ricky Rudd, driver of the Tide Ford; Bill Elliott, driver of the McDonald's Ford, about to qualify; Terry Labonte, who drives the Kellogg's Chevrolet, in his International Race of Champions coveralls. RIGHT: **Ricky** Craven, 1995 Winston Cup Rookie of the Year, autographs a program for a watchful fan. Craven drives the Kodiak Chevrolet. BELOW: Ernie Irvan fastens the seat belt in his Texaco Havoline Ford. You can't keep a good driver down. Ernie almost died in a terrible crash in Michigan, August 1994. But in the fall of 1995, he came back with only a lingering problem with his eyes. The glasses are now required.

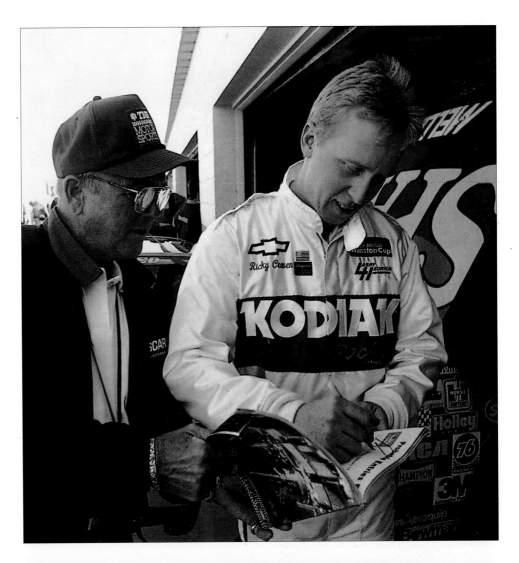

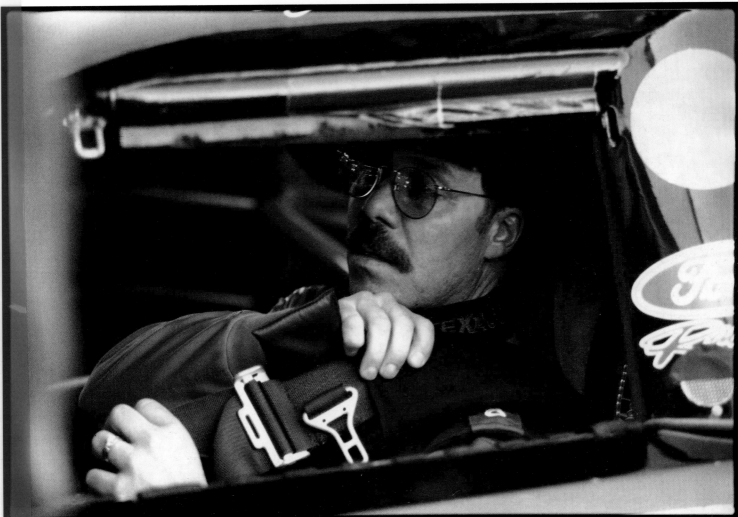

LEFT: The drivers' meeting for the 1996 Daytona 500. If it looks well attended, it is. Standing room only. **You don't miss a drivers' meeting.** And after you're there, you pay attention, because you never know when a rule change might be announced. Attendance is taken. Miss a meeting and whether or not you have won the pole, you will be moved to the rear of the field. BOTTOM LEFT: Dale Earnhardt (right), Richard Childress (center), and the team's new crew chief, David Smith (left), listen carefully. OPPOSITE: An hour or so before the start of the Daytona 500, the cars are lined up, and a gaggle of spectators crowds around for last-minute rubbernecking and wellwishing. Earnhardt's #3 sits in the pole position. Ernie Irvan's #28 is on the outside in row one.

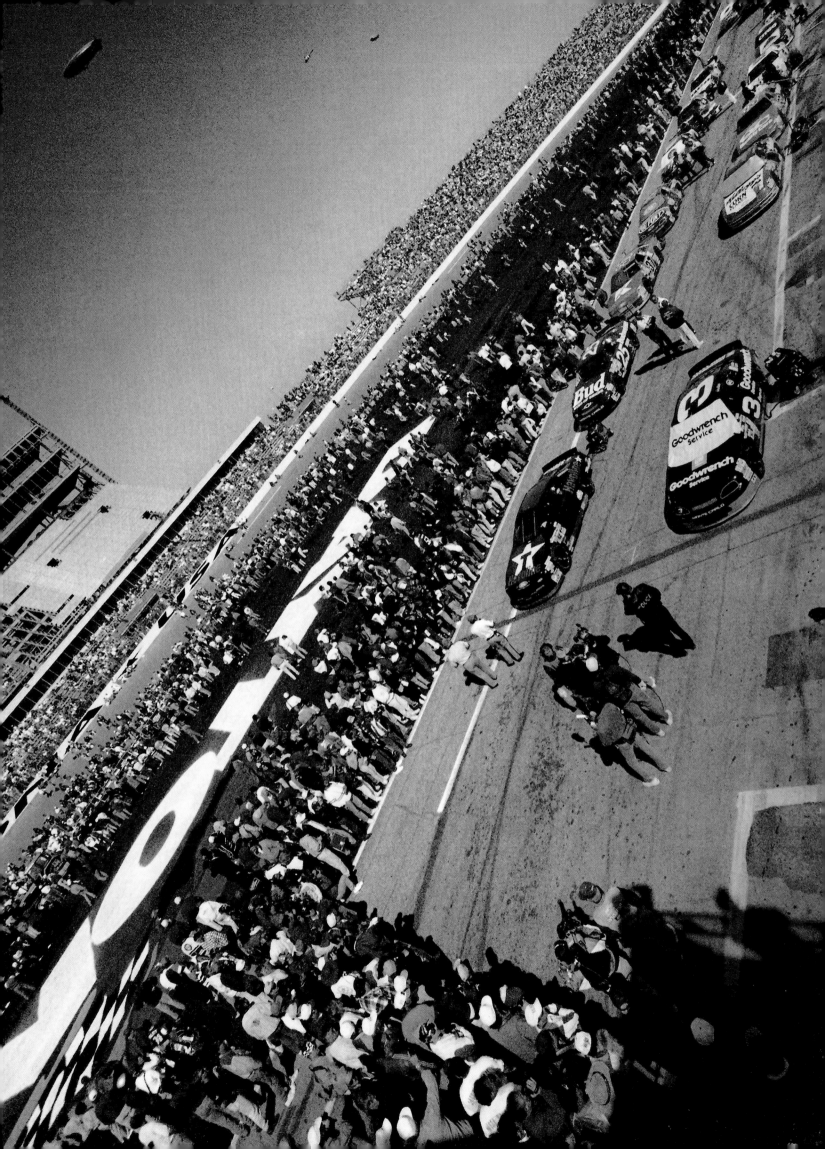

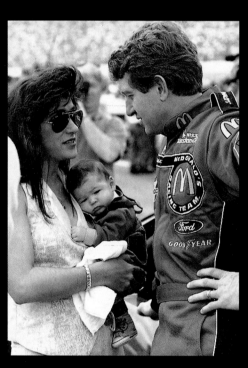

CLOCKWISE FROM TOP LEFT: Sterling Marlin, Daytona winner in 1994 and 1995, ponders his chances. No one has ever won three in a row. Jeff Gordon looking relaxed. Bill Elliott with his wife, Cindy, and their three-month-old son. Dale Jarrett doing a radio interview with one of his three children on his arm. Robert Pressley (Skoal) chats with a crewman from Sterling Marlin's team. Wally Dallenbach, named to drive the Hayes Modem Ford for car owner Bud Moore.

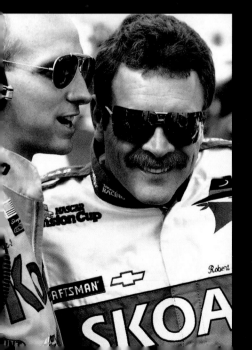

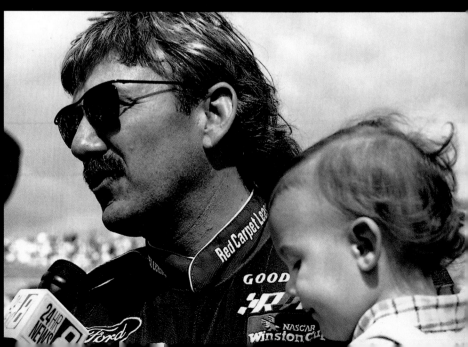

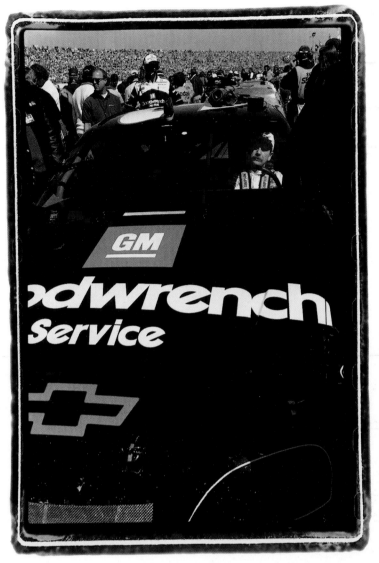

The front row
mounts up: Ernie
Irvan (left) and Dale Earnhardt (right).

Track clear, pits clear, engines started.
Amid the roar, forty-three drivers have a
few stationary minutes to consider the task
ahead. Warm-up is usually about a minute,
less in hot weather, and as much as two
minutes in colder weather.

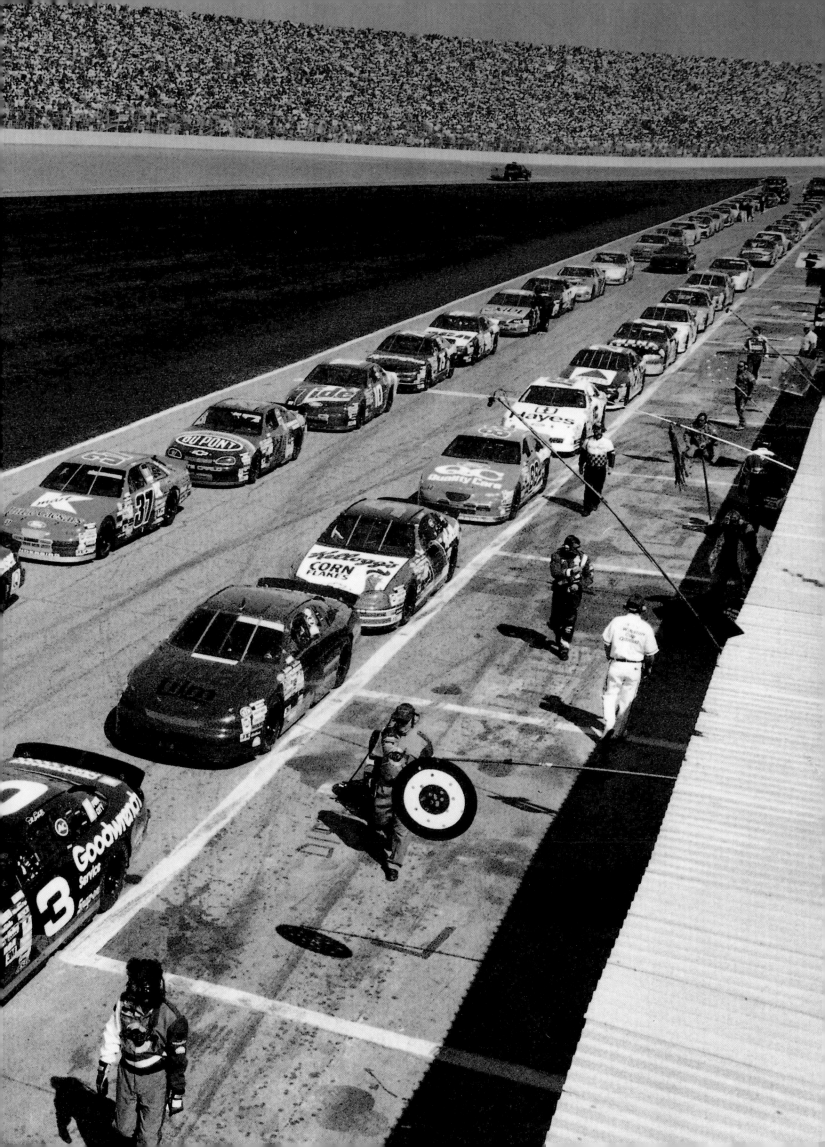

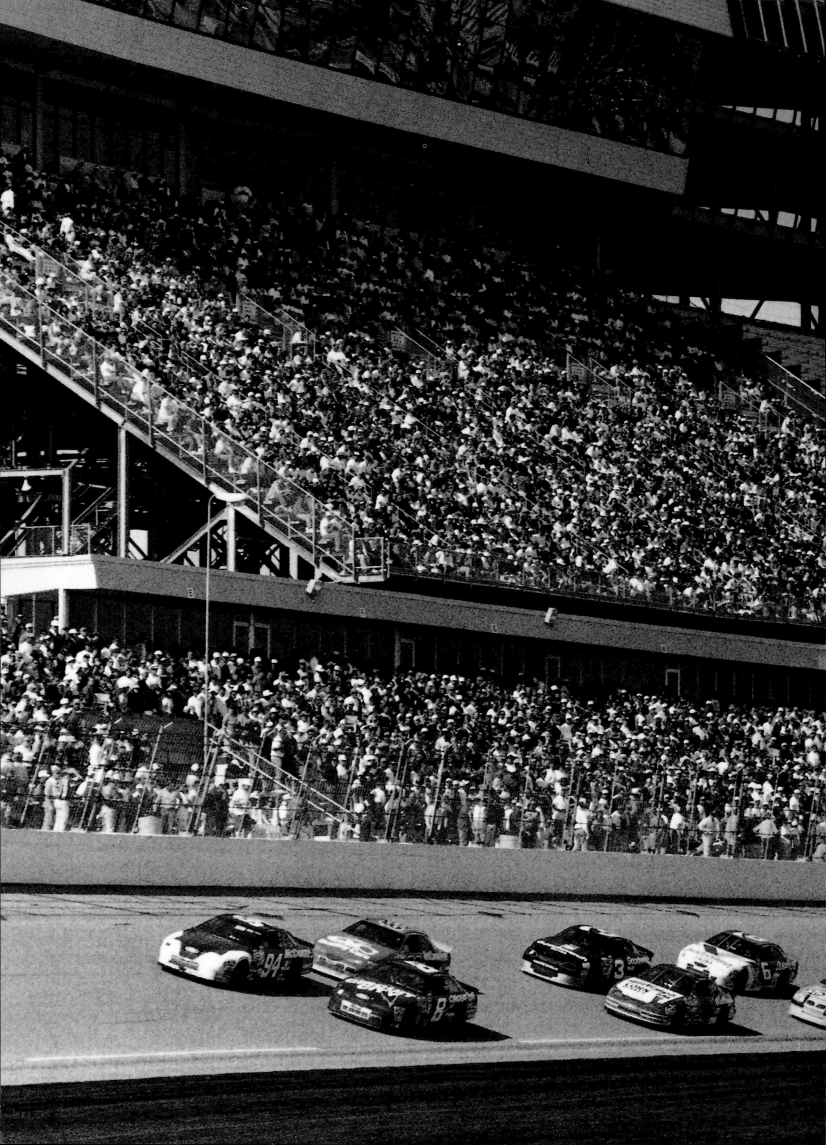

The parade lap begins. With 150,000 people in full cry, **the only thing a driver hears is the roar of engines.**

A driver's-eye view of the first turn at Daytona. It's banked 31 degrees, but from the driver's seat it doesn't look anymore than 8 to 10 degrees. It looks almost flat.

You go into the turn at 200 mph and never touch the brakes.

Above the wall is the catch fence with three strips of heavy cable woven into it. That's to keep cars that might fly through the air out of the bleacher seats.

DAYTONA ★ USA

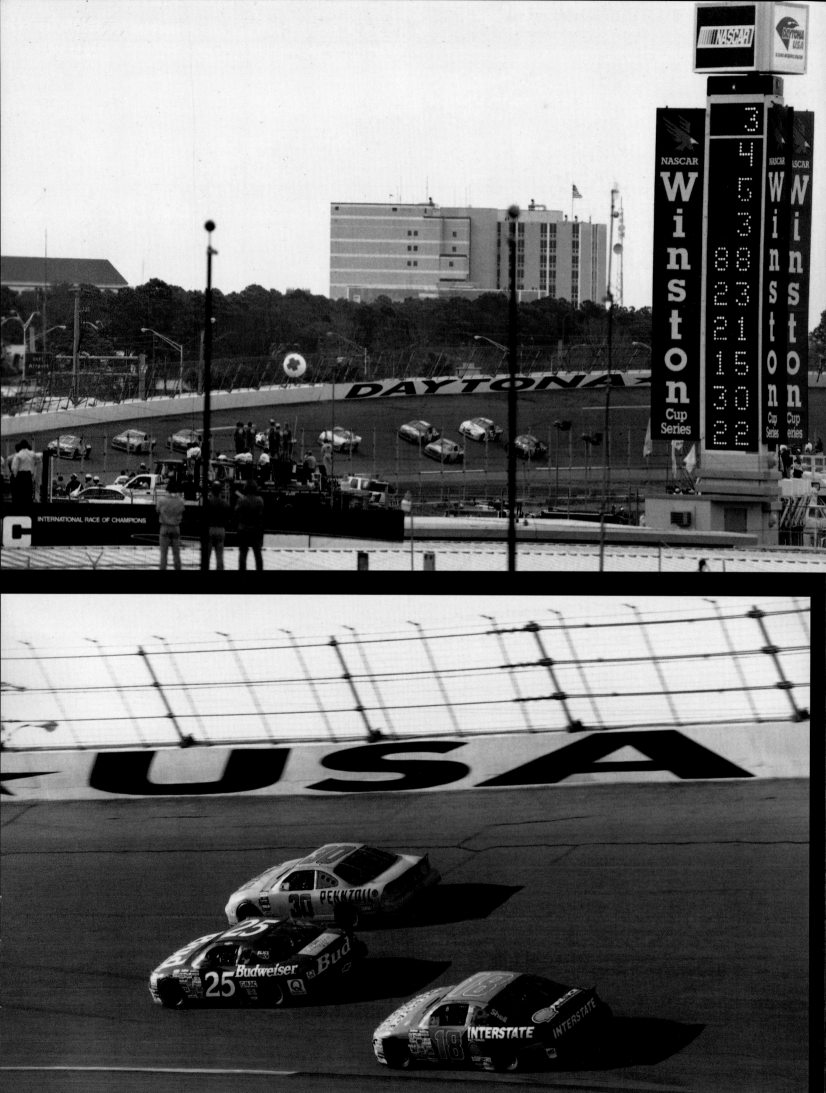

OPPOSITE TOP: The cars exit turn four of lap three, and forty-three accelerator pedals are mashed into the floorboards. They are racing as they pass the grandstand with engines screaming at 7000 rpms. OPPOSITE BOTTOM: Kenny Shrader (#25) and Johnny Benson (#30; Benson replaced Michael Waltrip in car #30 for the 1996 season) are side by side, with Bobby Labonte (#18) tight on the inside. RIGHT: Bill Elliott (#94) leads Loy Allen (#19) and Ricky Craven (#41). BELOW: The first few laps are a blur of sponsor logos in the closely packed field. Flags fly in the infield as spectators pull for their heroes.

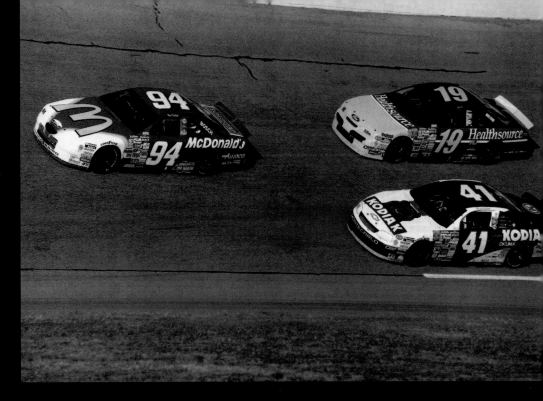

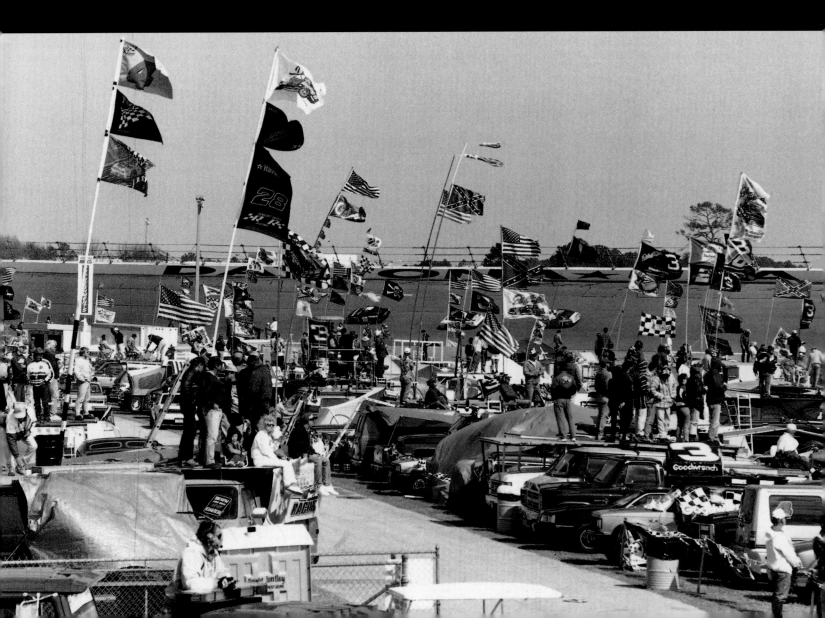

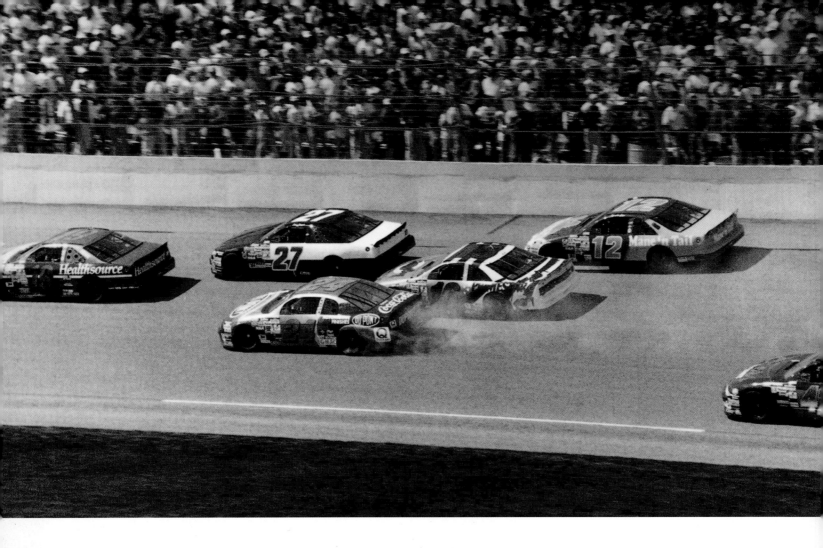

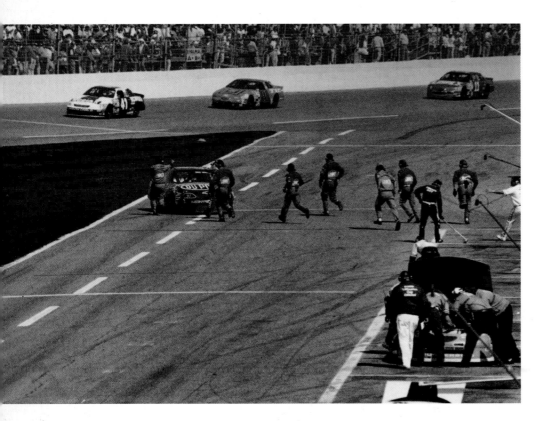

ABOVE: Telltale smoke behind Jeff Gordon's #24 car means trouble. Quite a group here: Loy Allen in Healthsource, Elton Sawyer in #27, Ted Musgrave in #16, Derrick Cope in #12, with Kyle Petty down low in #42. But it's all over for Gordon. Half-a-mile earlier, Gordon made contact with another car and tagged the wall as he came out of turn four. LEFT: The Lowes crew, who get to the scene before Gordon's own crew, rush out to push the disabled car behind the wall. OPPOSITE: Pit Road at rush hour. All the diagonal poles are supporting video cameras. Every pit stop is taped and immediately studied to see what, if anything, went wrong, and how the drill can be improved the next time.

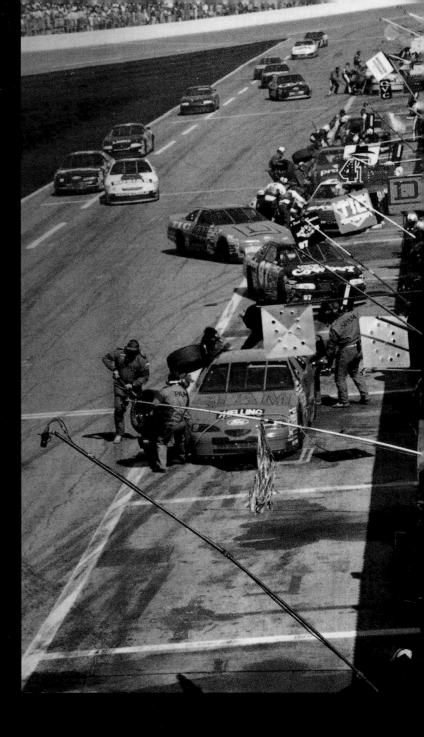

PAGE 138: Loneliness is being on Pit Road by yourself. It's nice to see other cars at a standstill if you have to be there. The signboards make it easy for drivers to know where to stop. They make the signs as distinguishable as possible. The camel is Jimmy Spenser's Smoking Joe car. The big "30" is for Johnny Benson. The "94" is for Bill Elliott. PAGE 139: It looks like football, with the runner following his blockers off-tackle. The timing is that precise in the pits. Kyle Petty's crew is finishing the right-side tire change. The changer (right) is already heading for the left side. The jack man is watching the lugs being tightened. As soon as two lug nuts are tight, he'll let the jack down and rush to the other side.

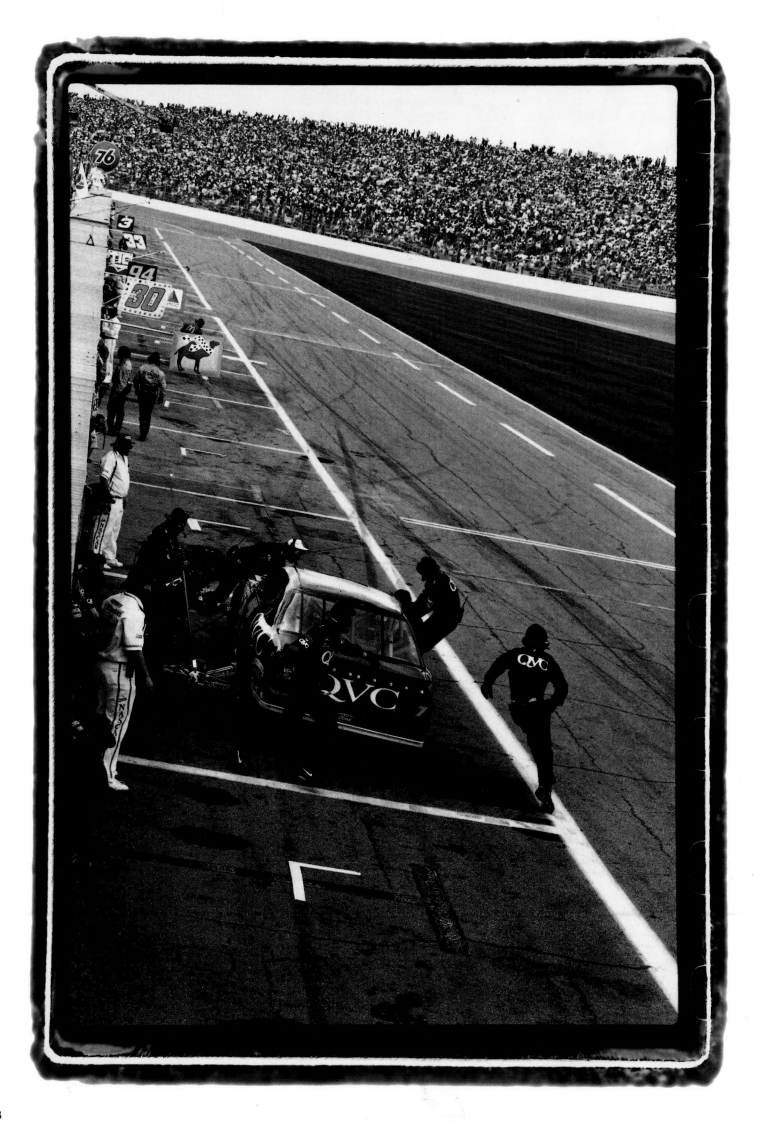

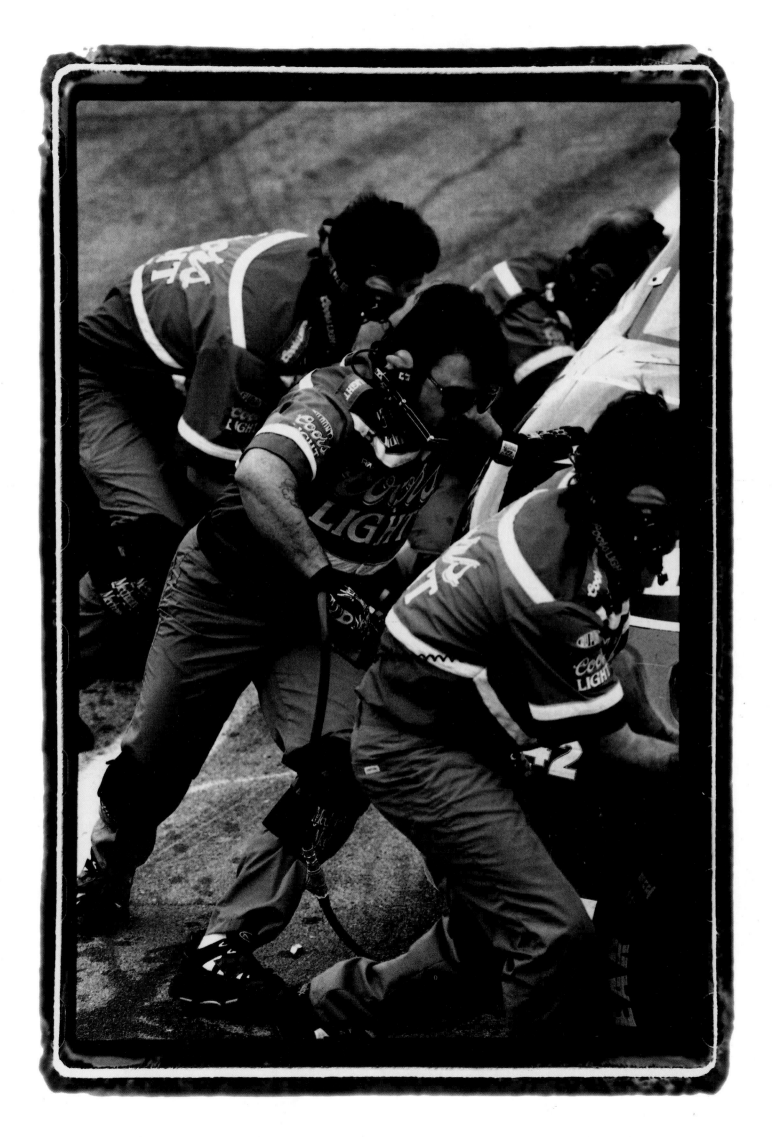

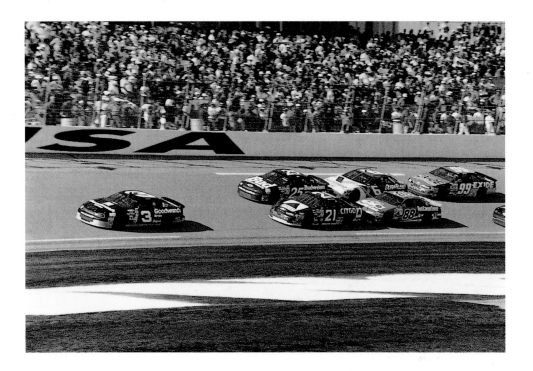

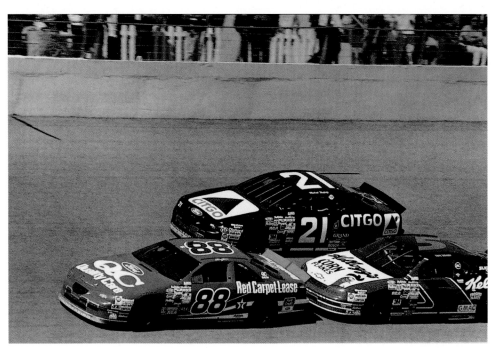

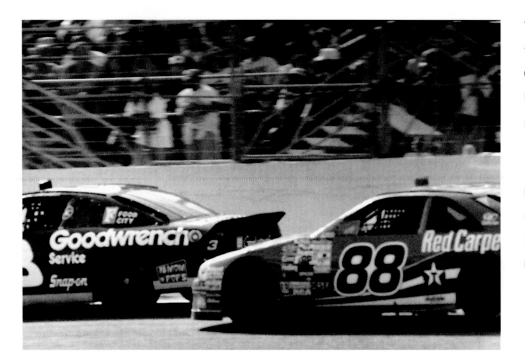

TOP: Earnhardt takes the lead during the race, followed by Ken Schrader (#25), Michael Waltrip (#21; this is his new ride for the 1996 season), Mark Martin (#6), Dale Jarrett (#88), and Jeff Burton (#99). CENTER: A great battle for the lead among Dale Jarrett (#88), Michael Waltrip (#21) alongside, and Terry Labonte (#5), who is on Jarrett's bumper at 190 mph. BOTTOM: Earnhardt hasn't quite broken Jarrett's overlap as they enter turn one.

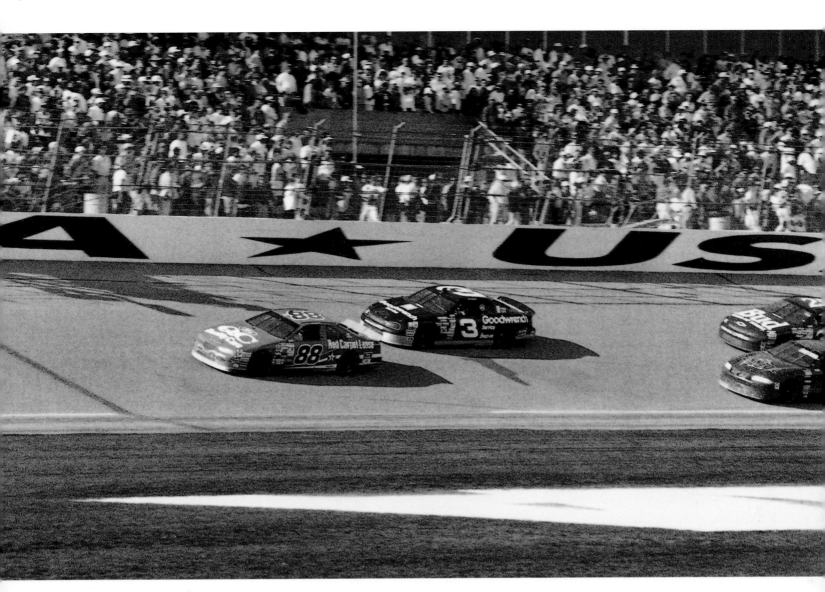

ABOVE & RIGHT: **Dale Jarrett half a car-length before—and just after—crossing the finish line to win the thirty-eighth Daytona 500. Dale Earnhardt, who hammered after Jarrett in the stretch, didn't have the horses to pass. Earnhardt is under something of a Daytona hex. He's won seven season championships through 1995, but in eighteen tries he has yet to win the Daytona 500. Jarrett beat him by .12 of a second. Earnhardt has lost three of the last four Daytona 500s by a total of .89 seconds.**

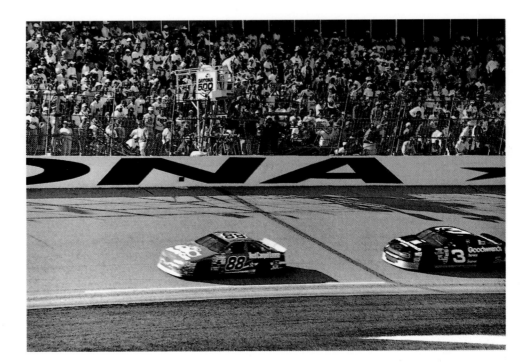

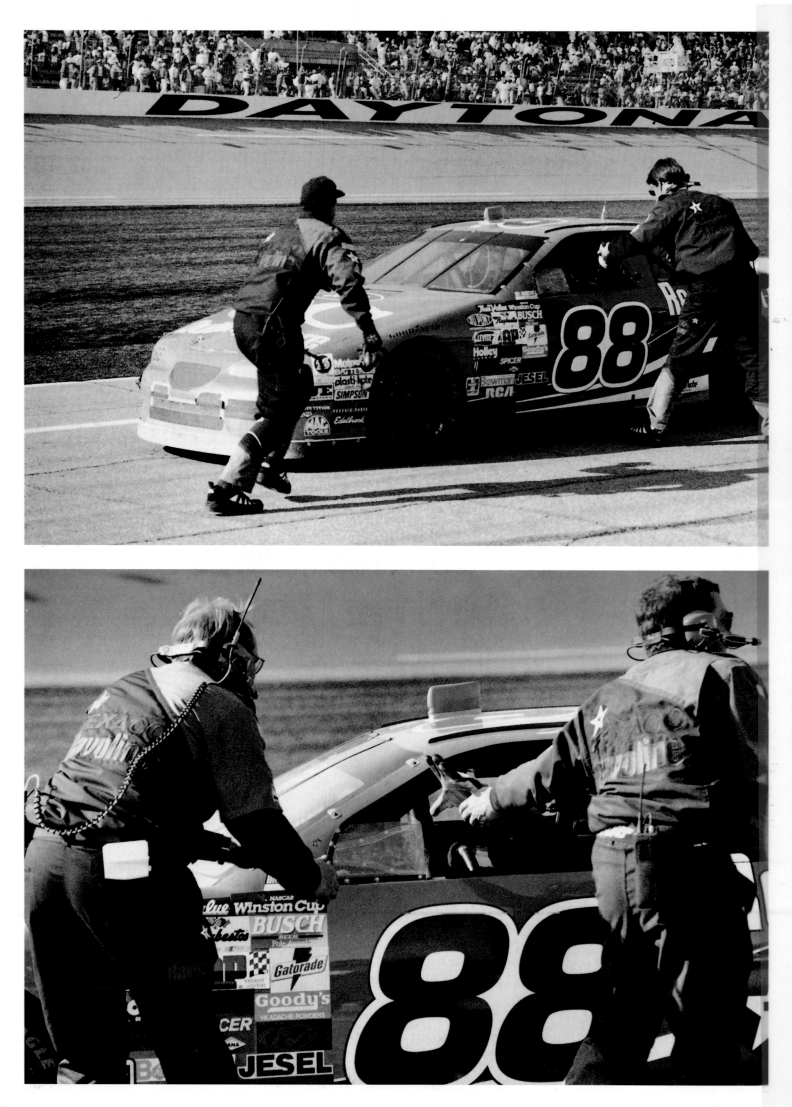

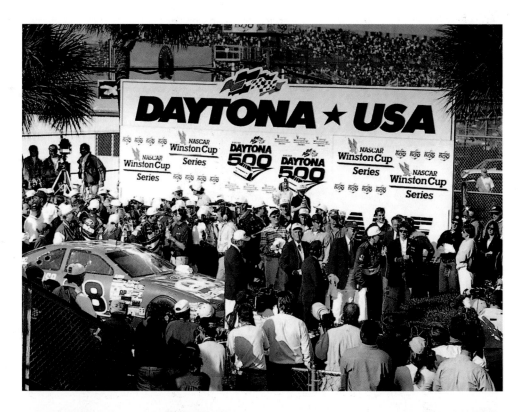

OPPOSITE TOP: Crew men from Dale Jarrett's team run out to welcome the winning driver.
OPPOSITE BOTTOM: Larry McReynolds, team manager for Jarrett's teammate Ernie Irvan, is probably at a loss for words about now. Not much left to do except celebrate.
TOP RIGHT: Daytona's Victory Lane. BOTTOM RIGHT: Jarrett with the trophy surrounded by his happy crew. It's Jarrett's second Daytona win. He took it in 1993, beating—you guessed it—Dale Earnhardt. All these guys are racing veterans, but it is the first race for them as a crew. A brand new "88" team, and they win the Daytona 500. It doesn't get any better.

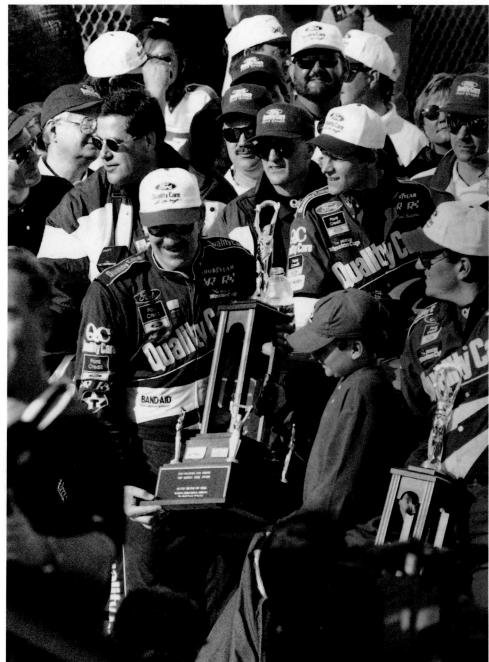

ACKNOWLEDGMENTS

Heartfelt thanks to Barry and Gail O'Donnell in Atlanta
and Dudley and Susan Cocke in Norton, Virginia, whose
hospitality and encouragement helped me to begin; to
Gayle Stephenson of the Atlanta Motor Speedway and
Ron Scalf of the Bristol International Raceway; to Steve
Fine and Bill Colson of *Sports Illustrated,* whose involve-
ment in the project came at a critical time; to Drew Brown
of Cohn & Wolfe in Atlanta, who introduced me to the
inner workings of the Pennzoil racing team and whose
enthusiasm and knowledge of racing were a great help in
realizing this book; and finally to Benny Parsons, who never
once asked me why my photographs weren't in color. –GB

DESIGNED BY JIM WAGEMAN

TYPEFACES IN THIS BOOK ARE
AMOEBIA, BLINDFISH, AND CORNWALL

PRINTED AND BOUND BY
SFERA INTERNATIONAL, MILAN, ITALY